W9-BMO-500

John Man is a historian and travel writer with special interests in China, Mongolia and the history of written communication. He is the author of *Alpha Beta*, on the roots of the Roman alphabet, and *The Gutenberg Revolution*, on the origins and impact of printing. On China and Mongolia, he has written *Genghis Khan*, *Attila the Hun*, *Kublai Khan*, *The Terracotta Army* and *The Great Wall*. In 2007 he was awarded Mongolia's prestigious Friendship Medal for his contribution to Mongol–UK relations.

www.**rbooks**.co.uk

Praise for *Attila the Hun*:

'Shatters the clichés . . . As one's guide into this mysterious world, one could not wish for a better storyteller or analyst than John Man . . . His Attila is superb, as compellingly readable as it is impressive in its scholarship: with his light touch, the Huns and their King live as never before. There is something fascinating and new on every page' Simon Sebag Montefiore

'Attila is known as a savage but there was much more to this great warrior. Man takes his readers on a thrilling ride alongside the man who marauded across Europe, striking terror into the hearts of entire nations' *The Good Book Guide*

'Racy and imaginative . . . sympathetically and readably puts flesh and bones on one of history's most turbulent characters' *Sunday Telegraph*

'There are moments when this book reads a little like a real-life *Lord of the Rings* . . . Meteoric and momentous . . . fascinating reading' *Guardian*

'The warlord's thunderous rise to infamy is enlivened by Man's constant asides, comments and comparisons. His obvious flair for conversational history and clear ability to get the most from well-informed modern sources drives the narrative along at a pace Attila himself would have been happy with. Man is a one man Time Team' *Western Daily Press*

'More like a piece of travel writing than history, as the author shares his imagination and enthusiasm for what he has found in modern day Hungary . . . the powerful heart of this study is Man's fine reconstruction of the battle on the Catalaunian Plains' *Newdirections*

Praise for *Genghis Khan*:

'Absorbing and beautifully written . . . a thrilling account of Genghis Khan's life, death and his continuing influence . . . a gripping present-day quest' *Guardian*

'A first-rate travel book, not so much a life of the Khan but a search for him . . . Man has scholarly gifts as well as acute intelligence and a winning way with words. This is a fine introduction to the subject, as well as a rattling good read' Felipe Fernandez-Armesto, *Independent*

'A fine, well-written and well-researched book' *Mail on Sunday*

'Compelling . . . Man's perspective is as clearsighted and invigorating as that of the Mongol horsemen he travels with . . . this is an eloquent account, not only of a fascinating historical figure and his people, but of the resonance of history itself' *Waterstone's Books Quarterly*

'Enthralling and colourful' *Independent on Sunday*

'This is a great story' *Spectator*

'Fascinating . . . every bit as gripping as its subject deserves . . . vividly captures the warlord's charisma, together with the mixture of ruthlessness, military genius and self-belief which, Man argues, made him the greatest leader ever . . . History doesn't come much more enthralling than this' *Yorkshire Evening Post*

'Man's excellent writing breathes new life into a character whose spirit lives on in China and Mongolia today' *Historical Novels Review*

'Man is an excellent guide . . . well-versed in Mongolian, he has travelled extensively in the country while researching the more mysterious elements of Genghis' life, and this experience shines through the book . . . he writes knowledgeably'
Literary Review

'Fascinating . . . a wonderfully diverting study' *Ink*

Also by John Man

Gobi
Atlas of the Year 1000
Alpha Beta
The Gutenberg Revolution
Genghis Khan
Attila
Kublai Khan
The Terracotta Army
The Great Wall
The Leadership Secrets of Genghis Khan

XANADU

Marco Polo and Europe's Discovery of the East

JOHN MAN

BANTAM BOOKS

LONDON • TORONTO • SYDNEY • AUCKLAND • JOHANNESBURG

TRANSWORLD PUBLISHERS
61–63 Uxbridge Road, London W5 5SA
A Random House Group Company
www.rbooks.co.uk

XANADU
A BANTAM BOOK: 9780553820027

First published in Great Britain
in 2009 by Bantam Press
an imprint of Transworld Publishers
Bantam edition published 2010

Copyright © John Man 2009

John Man has asserted his right under the Copyright, Designs and Patents Act
1988 to be identified as the author of this work.

This book is a work of non-fiction.

A CIP catalogue record for this book
is available from the British Library.

This book is sold subject to the condition that it shall not,
by way of trade or otherwise, be lent, resold, hired out,
or otherwise circulated without the publisher's prior
consent in any form of binding or cover other than that
in which it is published and without a similar condition,
including this condition, being imposed on the
subsequent purchaser.

Addresses for Random House Group Ltd companies outside the UK
can be found at: www.randomhouse.co.uk
The Random House Group Ltd Reg. No. 954009

The Random House Group Limited supports The Forest Stewardship Council
(FSC), the leading international forest certification organisation. All our titles
that are printed on Greenpeace approved FSC certified paper carry the FSC
logo. Our paper procurement policy can be found at
www.rbooks.co.uk/environment

Mixed Sources
Product group from well-managed
forests and other controlled sources
www.fsc.org Cert no. TT-COC-2139
© 1996 Forest Stewardship Council

Typeset in 11.5/14.5pt Sabon by Falcon Oast Graphic Art Ltd.
Printed in the UK by CPI Cox & Wyman, Reading, RG1 8EX.

2 4 6 8 10 9 7 5 3

For MP, with thanks

Truth is a perishable commodity; considerable care must be exercised when shipping it across the world.

Peter Fleming, *Brazilian Adventure*

A note on sourcing . . .
The quotations in this book are mostly either from Yule–Cordier or Moule–Pelliot, which is a conglomerate of many texts. Sometimes I give the source, but often not, because to track every quote would be to clog the book with footnotes, kill the narrative and repeat established works of scholarship.

. . . and spelling:
Genghis is pronounced Chingis in Mongol, and should be spelled like that in English. I retain Genghis out of deference to tradition. The same for Xanadu, which is Shangdu in Chinese; but Xanadu is traditional in English, thanks to Coleridge.

CONTENTS

ACKNOWLEDGEMENTS

Thanks to: Siqin Brown, SOAS, for translation and insights into Mongol–Chinese relations; Paul Craven, Steppes Travel; Cheng Dalin and 'Emma', Beijing, for help on Yuan-dynasty Beijing; Ben Godber, Expedition, London, for making the bones of the Pleasure Dome; John Hare, Benenden, for bringing the Takla Makan to life; Stephen Haw, for vital guidance on places, language and ecological matters; 'Helen', Renmin University, Beijing, for wonderful interpreting; Richard John Lynn, for his Xanadu verse translations; Tom Man, of Perioli-Man, Oxford, for putting flesh on the Pleasure Dome; Jim Millward, Georgetown University; 'William' Shou, Beijing, for my introduction to Xanadu; Tu-mu-le / Tömöröö, Zhenglan Qi; 'Ekber Tursun, Kashgar, for taking me to the edge of Marco's China; Prof Wei Jian, Renmin University, Beijing, for unique insights and inspirational guidance; Frances Wood, British Library; Lijia Zhang, Beijing, for friendship. And, as always, Felicity Bryan, Gillian Somerscales, and the Transworld team: Doug Young, Simon Thorogood, Sheila Lee, and Phil Lord.

INTRODUCTION:
OF TRUTH, TOLD AND
HIDDEN

MARCO POLO IS PERHAPS THE WORLD'S MOST FAMOUS traveller, and his account of his journey from Venice to the court of Kublai Khan, ruler of the world's greatest land empire, is the most famous travel book ever written. His *Description of the World*, or the *Travels* as it is usually entitled in English editions, is famous for three good reasons: because it was the first to open Central Asia and China to the West; because of its scale; and because of its essential truth.

But there's another, hidden reason for its fame. It is a real-life fairy story. An ordinary boy is plucked from home by his father and taken to an unknown region, where he is presented to the richest and most powerful man in the world, who, marvellous to relate, becomes his mentor, and as a result he acquires wealth and stature and finally, by turning his story into a book, a sort of immortality.

Put like that, it sounds incredible. Indeed, since there were no other sources to corroborate what Marco said,

many at the time assumed he exaggerated or had made it all up. As his first biographer, Giovanni Battista (usually shortened to Giambattista) Ramusio, explains:

> Young men came daily to visit and converse with the ever polite and gracious Marco, and to ask him questions . . . all of which he answered with such kindly courtesy that every man felt himself in a manner his debtor. And as it happened that in the story, which he was constantly called upon to repeat . . . he would speak of his revenues as amounting to ten or fifteen millions of gold; and in like manner, when recounting other instances of wealth in those parts, would always make use of the term millions.

So it came about that they nicknamed him 'Milione' – Marco 'the Millions' Polo – and it stuck[1]. Italians still call his book *Il Milione*, and the courtyard where his house once stood in the heart of Venice is the Corte del Milion. It's a fair comment. His memory was vague, and he made mistakes, and pretended, and exaggerated. But at heart there was honesty. Kublai Khan's China really was a land of millions.

Not that most Europeans would have known one way or another. In the thirteenth century they knew virtually nothing about the world beyond their homelands. Maps

[1] Some scholars believe this is a mistake, that 'Milione' was the nickname of another family line, which also included a Maffeo, Niccolò and Marco. The arguments are summarized in de Rachewiltz, *Marco Polo Went to China.*

represented beliefs more than information: the Last Judgement and the Garden of Eden were as prominent as land masses and oceans, and the ill-formed shapes of imagined distant lands were populated by monsters – men who fed on the smell of apples, and the Sciopod, whose single giant foot shaded him from the sun. The three continents of Europe, Asia and Africa appeared either as neat segments of a circle or unshaped blobs. No sign, anywhere, of China, let alone Mongolia.

So, for Europeans, Genghis Khan's Mongols sprang out of the dark. Initial hopes that the approaching hordes were Christians coming to help crusaders fight the Muslims were quickly, and cruelly, dashed with Genghis's devastating descent through Central Asia and into Persia between 1219 and 1223. Terrified Europeans seized on the name of one group of Mongol subjects, the Tatars, and called them Tartars, people who had escaped from Tartarus, one of the regions of hell, where the worst of souls – such as disobedient children, traitors, adulterers and faithless ministers – were penned inside a wall of brass, hidden by a cloud of darkness 'three times more gloomy than the obscurest night'.[2] In 1241, Russia, Poland and Hungary fell. European leaders dropped their customary rivalries to exchange pleas for help and offers of cooperation in resisting the onslaught – and then suddenly the Mongols were gone, drawn back home by the death of the khan, Genghis's son Ogedei.

[2] Lampriere's *Classical Dictionary*, 1797.

Now Europe knew they were there, and needed to know more about them. The news was not encouraging: two papal envoys to the Mongol capital, Karakorum, in 1246 and 1253–5, brought back uncompromising demands from the Mongol khans. Other envoys went to meet the Mongols in the Middle East, and as a result the West began to accumulate detailed, realistic information about the Mongols in Mongolia and in their new mini-empires in southern Russia and Persia.

Meanwhile, in the Far East, a new world was emerging – Kublai's empire – of which the West knew nothing. Information should have come with the exchange of goods, for Mongol rule had opened several trade routes between Asia and Europe. But traders were mainly interested in trade, not travel and social comment – and certainly not in making the long trip eastward themselves. There were plenty of middlemen from whom goods could be bought; so why waste months and risk life and limb going to fetch them yourself? The journey overland meant eight months of toiling across mountain and desert; and the sea route was even worse. It would be another two hundred years before anyone sailed round southern Africa, so the voyage to the East could take up to two years, in constant danger from pirates, storms, and the collapse of hulls bound by ropes (a hazard mentioned by Marco Polo). No one wrote up the experience.

So the first western visitors of note to Kublai's realm were the Polos: the brothers Niccolò and Maffeo, and young Marco. It was only after his death that Kublai

became famous in Europe, and that was almost all thanks to Marco and his book.

But both man and book are like will-o'-the-wisps – and the closer you look, the wispier they get. Marco tells us hardly anything about himself or his experiences en route. There are none of the agonies and fears felt by the two explorer-priests who went overland to Mongolia before him, who starved, froze and feared death many times. What did Marco feel? How did he escape this or that robber band, suffer and recover from such-and-such unnamed diseases? Was he on foot, on horse, or in a wagon? He doesn't say. He does not even seem to have a very clear purpose. This is many books in one: part geographical description, part guidebook, part merchants' handbook, without enough detail to serve well as any of them but with plenty of incidental detail on social behaviour and history and legends and military matters and places that Marco heard about but never saw. Some claim him as a closet missionary, in his dismissal of all non-Christians as idolaters and his admiration of Kublai for his nominally Christian virtues. But that doesn't work either, for he has nothing positive to say about Christianity and praises Kublai for his tolerance of *all* religions. And the book, ghost-written with a writer of romances long after the event, should really be called the *books*, plural, because the original vanished, leaving about 120 manuscripts in many different languages, none the same as any other.

So much is omitted. According to a note by a contemporary, a friar named Jacopo d'Acqui (i.e. Jacob,

from present-day Acqui Terme, in northern Italy), Marco was 'asked by friends on his death bed to correct the Book by removing everything that went beyond the facts. To which his reply was that he had not told one-half of what he had really seen.'

Of all the omissions, one in particular may have been of deeply personal significance. As we shall see, he gives more than the odd hint that he appreciates beautiful women. Yet at an age when he would normally have been married, he was made to endure years of travel, which turned into years in the service of the khan. Are we to assume that he remained celibate? Surely not. As anyone, man or woman, but especially man, travelling in Mongolia today knows, Mongolian women are very different from their Chinese counterparts. In looks, they seem to span all Asia, with hints of Russian, even European features. This range seems to include more than its fair share of startling beauty, which combines with equally startling self-assurance and lack of in-hibition. And Marco saw women of all sorts. When he arrived at Kublai's court, he must have seemed like a gift from the Blue Heaven: 21, well travelled, exotic, well off, perhaps already speaking reasonable Mongol, and basking in imperial favour. How could the young women at court, chosen for their beauty by the hundred for the pleasure of a sovereign, fail to be fascinated? And it would have been quite in order for Kublai to approve a match. This, I suggest, was in part what he meant by not telling the half of it.

And what of the bits he did record? The book is so

riddled with inconsistencies and distortions that some scholars have suggested, as many of Marco's contemporaries did, that the whole thing was a fabrication, in the style of a medieval romance or collection of fictitious 'travellers' tales'. But there are few total fictions; the more we learn, the truer it gets. No one could possibly have made up the details that Marco reports, or gleaned them from the experience of others, because there were no others. As an expert in Chinese history, topography and natural history, Stephen Haw, points out, almost all of the places, plants and animals have now been identified (mostly by Haw himself, who has travelled extensively in China and works mainly with Chinese sources).

One example among many: Marco says that Kublai chose concubines from a group he names as 'Ungrat, who are very handsome'.

> Now every year an hundred of the most beautiful maidens of this tribe are sent to the Great Kaan, who commits them to the charge of certain elderly ladies dwelling in his palace. And these old ladies make the girls sleep with them, in order to ascertain if they have sweet breath, and are sound in all their limbs. Then such of them as are of approved beauty, and are sound in all respects, are appointed to attend the emperor by turns.

The clan concerned, traditional marriage partners of Genghis Khan's clan, is now transcribed as Qonggirad

(the Q being a *kh* or *ch* sound, as in Scottish 'loch'), or Ongirat. Given that Marco's book was written in Franco-Italian, 'Ungrat' is not a bad attempt at the Mongol. Only someone familiar with Mongol traditions and with the language could have known this. His portrait of Kublai Khan, therefore, is rightly seen as a prime historical source.

At every turn, it is worth looking for the truth lying behind Marco's obscurities, omissions and errors. It was for this reason that I followed his footsteps across north China, to the site of Kublai's first capital and then his summer base – Xanadu, as it is best known in English, after Coleridge's famous poem:

> In Xanadu did Kubla Khan
> A stately pleasure-dome decree.

Since that image came to Coleridge in a dream, many people are still surprised to learn that Xanadu is real. Shangdu ('Upper Capital'), as it is in Chinese, is indeed a wonderful place, but not in the way Coleridge dreamed. The site is a six-hour drive from Beijing, up on to the grassland plateau that was once part of Mongolia.[3] Lying in a huge space of gentle hills and far horizons, it was never a place of towers; its low buildings were set in grassy parkland, nested within three sets of walls. Today mounds of earth, some still faced with

[3] Check it out on Google Earth by going to 42.21.30 N and 116.10.45 E.

bricks, emerge like veins from grasslands that are ice-bound in winter and glorious with wild flowers in early summer. There is a small river, but none of the measureless caverns, forests, romantic chasms, torrents or caves of ice mentioned by Coleridge. That opium-tinged vision owes more to the landscape of north Somerset, where Coleridge was staying, than north China.

So forget Coleridge: the reality has quite enough of beauty and truth to repay many visits. My consultant, Wei Jian, Professor of Archaeology at Beijing's Renmin University, worked there for fifteen years. Once, in Mao's China, visits were discouraged, partly because of official xenophobia, partly because Kublai's Mongol dynasty, the Yuan, was a foreign one, and not in favour. Now everything has changed. The Yuan are increasingly seen as a vital part of Chinese history, and China is wide open. Anyone now can go to Xanadu and see the base of the palace where Marco, a callow 21-year-old from Venice, with no assets but his curiosity and charm, first met Kublai, 61, emperor of China, Mongolia, Tibet and the Western Regions, with the rest of the world (as he believed) about to fall into his embrace.

1
WHEN WORLDS COLLIDE

ONCE UPON A TIME, I WORKED WITH THE GREAT HISTORIAN A. J. P. Taylor. Part of his skill lay in selecting the telling details that explained events and brought them alive. He also liked quirky footnotes. I was surprised by one stating that a certain king – Edward VII or VIII, I think – liked to have his trousers creased horizontally, naval fashion, rather than vertically. When I asked Taylor why he had included this odd and inconsequential detail, he said, 'You never know.' I was young, he was eminent, I dared not ask him what on earth he meant; but it made me wonder at the role of chance in history. What if Cleopatra's nose had been a little smaller, or if the shrapnel that wounded Hitler on the Somme in 1916 had struck him in the head and not the thigh? The stuff of history is made by powerful forces and astonishing characters, but also by pure luck, without which no one

would ever have heard of Marco Polo, and countless writers would be short of a subject.

In 1253 two ambitious young Venetians, Niccolò Polo and his brother Maffeo, set off to make their fortunes.[1] Niccolò left his wife pregnant with Marco, her first and only child. Marco, whose book is the only record of these events, does not even give us her name – an omission typical of a narrator interested in travel, but not in personal details. We must be prepared to tolerate such gaps, or fill them in ourselves. So let us imagine the young Signora Polo, in the summer of 1253, still unaware of her condition, consoling herself with her mansion (on the corner of two small canals, two minutes' walk from the Rialto Bridge), her servants and Niccolò's reassurance that he would be away only a few years and would surely return with riches enough to repay the family's investment many times over.

The Polo brothers' idea was to base themselves in Constantinople, seat of Catholic Rome's rival sect, eastern Orthodoxy, and for a thousand years capital of what had been the eastern section of the Roman empire, now known as Byzantium. Their wealth was not in golden ducats, but in 'merchants' wares', which they proposed to trade for jewels. Perhaps, the following year, a letter arrived from the family in Venice telling of

[1] Some editions say 1252. There is no telling which is correct. Marco was notoriously inexact, which has led to endless controversies among scholars as they struggle to match events in the book to known historical events. The date that makes most sense is 1253.

Marco's birth. It's possible, because they had with them Venetian servants who could have acted as messengers. But the news, if it came, must have been good: mother and child doing well, nothing to draw Niccolò home. He focused on business, to the exclusion of domestic matters.

Why Constantinople? Because Venice, once a village in a bog, was now a place of canals and palaces and 150,000 people, with an empire, and Constantinople was virtually a Venetian colony. Fifty years previously, Venice's doge, the fanatical Enrico Dandolo – astonishingly energetic despite being in his eighties and blind – had led his city-state into the Fourth Crusade, and into an adventure of duplicity and pillage directed almost exclusively against his own allies and fellow Christians. For Rome, the aim was inspirational: to create a Christian version of the Roman empire, first by seizing Constantinople, thus unifying divided Christendom, and then – of course – by retaking the so-called Holy Land from its Muslim rulers. Venice would supply a navy – at a price. But Dandolo had a secret agenda of his own: to cut the ground from under rival city-states, in particular Genoa and Pisa, and extend Venice's own reach in the eastern Mediterranean – all funded by loot from Christendom's richest city. So much for Christian unity. On 17 July 1204 the old, blind Dandolo somehow led the assault, leaping from his beached galley to plant the banner of St Mark on the sand. The city fell, the emperor fled and, after a nine-month interregnum, hell broke loose. In the words of Venice's eminent

historian John Julius Norwich: 'Never in history had so much beauty, so much superb craftsmanship, been wantonly destroyed in so short a space of time.' French and Flemings broke into the cathedral of St Sophia and used horses to carry off bits of the altar, throne, pulpit and doors. Venetians, more discerning, sent home works of art by the hundred. Among them were four great bronze horses which Constantine, the city's founder, had placed on the starting gate of the Hippodrome almost nine hundred years before; for centuries they would stand on the loggia above the main door of St Mark's Cathedral as a symbol of Venetian power (those you see today are replicas; the real ones are in a museum inside). From the spoils, Dandolo repaid himself the 50,000 silver marks still outstanding for supplying the navy in the first place. He also won for Venice three-eighths of the whole of Byzantium and the same fraction of Constantinople, the right to trade in imperial dominions, and the total exclusion in the Mediterranean of Venice's great rivals, Genoa and Pisa. This was an empire within an empire – ports and islands by the dozen down the Adriatic coast and around Greece, all of Crete, and access at last to the Black Sea and its northern peninsula, Crimea, the gateway to the great trans-Russian rivers of the Don and Volga.

Crimea: that was where the two Polo brothers turned their gaze next. Six years of profitable trade in Constantinople had turned their wares into jewels, which they now planned to use to purchase trade goods in the Venetian base across the Black Sea, where they

would have contact with another empire that had apparently sprung from nowhere, out of the unknown depths of Central Asia. This imperium, and the explosion of mounted warriors on which it was based, had nothing to do with luck, for it had been created by one of the most astonishing and influential characters of all time: Genghis Khan. For the previous 50 years, ever since Genghis's rise to power in 1206, the peoples around the edge of his expanding empire – Chinese, Muslims, Indians, Europeans – had watched and suffered aghast. It was as if, in the late nineteenth century, Geronimo at the head of his Apaches had united the many Indian tribes, seized Washington, made an empire of all North America and claimed the world. A Mongol in the heart of Beijing, which fell in 1215, or at the gates of Vienna (1241) was as unlikely as an Apache in the White House in 1880.

By 1260 Genghis had been in his secret grave for over 30 years, but his heirs ruled from China to southern Russia, and were still intent on expansion, in accordance, as they believed, with the will of Heaven. Four grandsons ruled their own mini-empires, in Russia, Persia, Central Asia and north China, though the boundaries were vague and other grandsons were trying to stake out their own estates in shadowy border lands. It is one of history's more remarkable facts that in the second half of the thirteenth century a traveller could ride from the mouth of the Danube to the Yellow River on Mongol territory, a distance of 6,000 kilometres, and with the right connections pass from camp

to camp all the way, with the certainty that every host would owe allegiance to the golden clan of Genghis, by direct descent or appointment. It was not an easy journey, across oceanic steppes and deserts and through mountain passes with thin air and icy winds, but it was said that a virgin carrying gold would be helped on her way in safety, if she had imperial blessing.

Crimea, to which the Polos now turned, had been taken by the Mongols in 1238. Ever practical, Genghis's successors had seen the advantages of preserving the two trading bases, Soldaia (today's Sudak) and Caffa (Feodosiya), dominated by Venetians since the disgraceful sack of Constantinople in 1204, and left the Venetians to get on with trading, as long as they paid their dues to their Mongol overlords. Here, the brothers planned to exchange their jewels for raw produce much in demand further west – wheat, wax, salted fish, Baltic amber, Siberian furs, slaves. But it was not as easy as they hoped. Many other merchants were in the same line of business; and the Genoese, though much reduced, still competed for trade. Practice was sharp, competition cut-throat, brawling frequent. Seeking some easier way to turn a profit, the Polo brothers looked east, 1,000 kilometres away across the gently rolling grasslands of southern Russia, to the new Mongol capital of Sarai.

After a brief stay in Soldaia, they set off for Sarai with all the confidence of youth, travelling in style and safety, with their Venetian servants to guard their store of jewels, and unaware of the maelstrom of trouble ahead.

Sarai, a steppe city of tents and wagons and horses, was on a tributary of the lower Volga, 50 kilometres from where the great river breaks up into the delta that feeds into the Caspian. Old Sarai, as it is known, was where Genghis's grandson Berke ruled his inheritance, which stretched from north of the Black Sea across present-day Kazakhstan – an area about the size of the USA, almost 10 million square kilometres. Later the Mongol rulers here would be known as the Golden Horde – 'golden' because Genghis's 'golden clan' hung gold on their royal 'palace-tents', called in Mongolian the *orda* (from which English speakers get 'horde', meaning an unruly mass of marauders, as in 'the Mongol hordes'). The Horde would dominate Russia for 200 years, a time that Russians still call 'The Tartar Yoke'. But at the time, Berke's future was not certain. Having turned Muslim, the better to manage the local population, he had fallen out with his cousin Hulegu, conqueror of present-day Iraq, because in 1258 Hulegu had devastated Baghdad and executed the caliph, supreme head of Islam. Civil war was looming, even as the Polo brothers arrived in Sarai, hoping to start up business with a powerful monarch who had links across all Eurasia.

It worked. In a deal of which we have no details, they were welcomed, and a year later the jewels had been turned into goods that doubled their value. It was time to return, via Constantinople. Back home in Venice, Marco would have been seven.

At this moment chance intervened, twice.

First, the Greeks and Genoese together retook Constantinople from the Venetians, killing some, mutilating others, and barring the Greek islands and the Bosphorus to all Venetians. Unable to use the sea route back to Venice, the Polos were stranded. There was another way: overland, through the Caucasus and western Persia. But just when the first door closed, so did the second one. Berke used his new Muslim faith as an excuse to turn his army loose on his non-Muslim cousin. For the Venetians in Sarai, there was only one escape route left: an even longer way round, eastward, through the heart of Central Asia.

So in the summer of 1262, well able to afford a caravan of horses, camels and wagons, off they went across steppe and desert for two months and another 1,000 kilometres, until at last they reached Bukhara, the great entrepôt on what would later be called the Silk Road. From here they planned to swing south and finally west, skirting Afghanistan, travelling through Persia and Syria, until, perhaps, with luck, they would reach the Mediterranean. It would have been a stupendous, 2,500-kilometre journey, and might well have been the end of them. As it happened, war between Mongol cousins prevented them going anywhere, and they were trapped in Bukhara for the next three years.

Doing what exactly? We have no idea. For sure they would have become familiar with its recent history – a Muslim boom, followed by a Mongol bust, and now another boom thanks to Muslims and Mongols together. Four decades earlier, this city of 300,000

people had had many glories, notable among them a royal library of 45,000 volumes and the 50-metre Kalyan Minaret, built on earthquake-proof foundations in the shape of an inverted pyramid. Its sages and scholars made it 'the dome of Islam in the east'. Then the Mongols had come, with catapults and flaming naphtha bombs. The city had experienced many assaults – by armies, fire and the restless earth – and many reconstructions, and it survived again. The Kalyan Minaret stood firm, as it does today. Under a surprisingly humane governor, Bukhara recovered – 'nay,' wrote the Persian historian Juvaini, in his flowery style, 'it reached its highest pitch and . . . today no town in the countries of Islam will bear comparison with Bukhara in the thronging of its creatures, the multitude of moveable and immoveable wealth, the concourse of savants, and the establishment of pious endowments.' The canals bringing water from the Oxus (today's Amudarya), the restored palaces, the bazaars, the eleven gates, the stone-paved streets – all these the Polo brothers would have known. After three years, making the most of the city's revived fortunes, they had turned yet another profit.

Now what? The quarrels between Genghis's heirs showed no signs of ending. Travel in any direction seemed risky. At this point, 1265, luck once again directed them.

Five years before, Kublai, another of Genghis's grandsons, had established himself as Khagan – khan of khans – in his capital, Xanadu. But his position too was

shaky, because he was fighting off a rival claimant to the throne, his youngest brother Ariq. He had sought help from the third of the surviving brothers, Hulegu, in Persia, sending off an embassy to Baghdad. Now, with affairs in China sorted out in Kublai's favour, the ambassador was returning, passing through Bukhara on his way, secure in the knowledge that his status assured his safety. The unnamed envoy was astonished to learn of the presence of two wealthy Europeans, arranged a meeting, and was even more astonished to discover that they spoke good Mongolian (as they should have done, after four years of exposure to the Mongol world). He invited them to join him.

'Sirs,' he says, in the Moule and Pelliot translation of the *Travels*, 'if you will trust me, you will have great profit from it and great honour.'

In what way, exactly?

'Sirs, I tell you that the great lord of the Tartars never saw any Latins and has great desire and wish to see some of them; and so if you will come with me all the way to him, I tell you that . . . he will see you very gladly and do you great honour and great good . . . and you will be able to come safely with me without any hindrance.'

This they did, in a year-long journey made possible by the fact that the whole of Eurasia was under Mongol rule. Marco gives no details of this trek, because his information was second-hand, and anyway this is a mere prologue to his own journey.

The Polo brothers were indeed well received by Kublai in his working capital Xanadu. The khan at once

saw the potential importance of his new guests. They were not the first westerners to make contact with the Mongols – several diplomatic missions had already gone back and forth – but those had gone to Mongolia, not China. For Kublai, this visit was something new, with huge potential. First, he was intrigued by Europe, which 40 years before had lain at his family's feet and which one day, as Heaven had decreed, would like all lands acknowledge Mongol overlordship. Second, he was attempting to juggle the conflicting demands of Buddhist and Daoist sects, and was eager to find some other religion or ideology that might act as a counterweight to both. Kublai was no stranger to Christianity, which, being the religion of all Europe, had to be a powerful force. For a couple of centuries, the heretical Christian sect of Nestorians had been active in his realm. Indeed, his mother Sorkaktani had been a Nestorian; and there had been no better example, for she was one of the most influential people, let alone women, of her time. A non-Mongol, a member of the Turkic-speaking Kerait tribe, Sorkaktani was the wife of Genghis's son Tolui and the mother of two emperors (Kublai and his predecessor Mönkhe) and the ruler of Persia, Hulegu. From her Kublai had learned an important lesson: never let one religion dominate, or you will alienate the others. She had even funded one of Bukhara's 'pious endowments'. A Christian giving money for a Muslim *madrassa*! *There's* a lesson in tolerance and generosity. Now fate had brought him two Catholic Christians who might help balance

the demands of Nestorians, Buddhists and Daoists.

So Kublai charged his visitors with two requests for the Pope: first, 100 priests, educated men well able to argue the truth of their religion and 'rebuke the Idolaters'. Then – so Ramusio's edition of the book claims – he, Kublai, and his followers would all convert to Christianity, 'and their followers shall do the like, and thus in the end there will be more Christians here than exist in your part of the world'. (What a crazy, impractical idea. But from a Christian perspective: what a noble challenge! What a world-changing prospect!) Second, Kublai asked for some holy oil from the sepulchre of Jesus Christ in Jerusalem. Why? Perhaps to confer the power to quell unruly subjects. A contingent of 100 priests coming all the way from Europe bringing their most powerful and revered potion would be no end of a boost to his reputation.

The two brothers, having been blown eastward by chance, headed for home overland with promises to fulfil. With them was a Mongol guardian, who fell ill and let them continue without him – not that it mattered, because they had an official safe-conduct pass made of gold allowing them to use the post-roads and horses which carried people and messages across the empire.[2] Nevertheless, according to Marco, it took them

[2] The passport was known as a *paiza*, or *páizi* (牌子) as it is today: a tablet (of authority), nowadays also a trademark. In a system inherited from the preceding Jin dynasty, there were seven ranks of *paizi*, which could be issued by high officials, army commanders and members of the royal family. Recipients could transfer them at will, so the system bred huge resentment among civilians who had to fulfil the requests.

three years to get to the Mediterranean, which he says was because of bad weather. More delay occurred in Acre, the crusader stronghold that is now Akko in northern Israel, where the travellers discovered that the pope had died and, the church being engaged in a long wrangle over the succession, a new one had not been appointed, leaving no one to receive Kublai's requests. The papal ambassador in Acre, an eminent churchman named Teobaldo Visconti, at once saw the significance of the brothers' mission and persuaded them to wait, just in case the cardinals in Italy could come to a conclusion. After a few weeks they gave up, and in 1269, after an absence of sixteen years, they arrived back in Venice.

What a homecoming it must have been, though Marco records no meetings, celebrations, questions or recriminations, only this: Niccolò's wife, Marco's unnamed mother, was dead. When did that happen? The previous year, or years back, soon after he was born? At a guess, her death came some time after her husband fell off the edge of the known world in 1262, when Marco was eight.[3] Marco, we must suppose, had been seen through his teenage years as a virtual orphan by tutors and relatives. They must have done a good

[3] That Niccolò left when his wife was a month or two pregnant is mentioned only in some versions of the text. But it seems a fair comment, given that his father was away for 16 years and Marco was 15 on his return. This does not fit with an insubstantial claim made across the Adriatic that Marco was actually born on the Dalmatian island of Korčula, which holds an annual festival in Marco's honour.

job, because two years later, in the summer of 1271, when the two brothers decided to set off again for Xanadu, via Jerusalem to pick up the oil, they had Marco, an unworldly 17-year-old, in tow.

2

ACROSS THE HEART
OF ASIA

MARCO WAS NOW THE JUNIOR MEMBER OF A HIGH-LEVEL mission. With their *paizi* in hand, his father and uncle were assured of a safe run across Asia. But they also had support from Teobaldo Visconti in Acre, and a connection through him to the new pope, once elected. So Acre was their first stop. After a quick trip to Jerusalem for some holy oil, the three Polos set off for China. This was around the beginning of September 1271. That's certain, because on 1 September, by an astonishing stroke of luck, Visconti himself was appointed pope under the name Gregory X. No sooner had a messenger arrived in Acre with the news than another galloped off to bring the Polos back. The new pope, anticipating all Asia being opened to Christianity, quickly wrote them a letter to Kublai, and also gave them two priests – rather fewer than the 100 requested;

anyway, as it happened, both of them backed out not long into the journey when they heard of vague dangers ahead. Still, the Polos now had credentials from both Asia's ruler and Europe's spiritual head, and so armed, they finally left for Xanadu.

Or perhaps not. Marco says the journey took three and a half years, an average of under 5 kilometres a day. That can't be so. His father and uncle had spent several years en route first time around, but most of that was in Sarai and Bukhara; the actual travelling time was around a year, which seems about right, considering that relay stations were typically about 40 kilometres apart. The two other travellers who had already gone from Russia to Mongolia did so in six or seven months.[1] What took the Polos so long? Marco says 'bad weather and severe cold', which sounds pretty lame, considering they could have covered the distance easily in a year if, as he says in virtually the same breath, they travelled 'by winter and by summer', i.e. non-stop.

Probably they were delayed right at the start by war and rumours of war. The Mongols were now fighting each other with disturbing regularity. And the Egyptian sultan, Baybars, spent his reign fighting both the crusaders and the Mongols, rushing up and down the coast of Palestine to do so. In a note on Baybars, Marco's great Victorian editor and commentator Henry Yule remarks, 'More than once he played tennis at

[1] Giovanni di Pian di Carpini in 1245–6 and William of Rubrouck in 1253.

Damascus and Cairo in the same week.' A man like that, with a demon serve and a fast horse, must have made travellers nervous, which was probably why the two priests got cold feet, why the Polos took a long time starting, and why they then chose to avoid trouble, skirt the familiar overland route, and head first north and then south-east.

Their route led through eastern Turkey to present-day Armenia, through Iraq, into Persia (now Iran), and southward to the port of Hormuz, today's Bandar-e Abbas. More travel guide than diarist, Marco likes to give the impression of having seen every place he writes about, so it's hard to make out his exact track – so hard, in fact, that some scholars have doubted if he went this way at all; but he surely did, for otherwise why choose to mention these places, rather than, say, those on the northern route taken previously by his father and uncle? Nor is there much clue about their means of transport – horses to start with, then camels, no doubt.

His account, as usual, veers wildly between hard fact, hearsay and legend, often with no way to distinguish one from the others. There is a long and tall story about the caliph ordering Christians to use their faith to move a mountain, to achieve which they sought the help of a cobbler so full of Christian virtue that, after entertaining 'sinful thoughts' about a beautiful woman, he had put out his own eye with an awl. As Marco might have said, What can I tell you? 'The mountain rose out of its place and moved' and the caliph converted to Christianity, 'but in secret'. In which case, of course,

who would know? Baghdad gets a mention, but only in the context of Hulegu's assault thirteen years earlier (true), which had reduced it to a shadow. Marco says Hulegu completed the conquest by imprisoning the caliph, telling him to eat his own treasure, and starving him to death (false: the caliph was executed, though the details were not recorded). Then he tells of hearing a version of the story about the Three Wise Men who brought gifts to the new-born Christ, but with a Zoroastrian addition about fire-worship: the Christ child gives the Magi a magic stone, which they throw into a well, into which divine fire descends; this they bring home and place in a church, where it is worshipped.

But it's always worth looking for fact, for mixed with the folklore are lists of provinces, mentions of local products and accounts of real dangers. Describing a cruel and wicked race of robbers called 'Caraunas' or 'Caraonas', Marco speaks of their 'certain devilish enchantments whereby they do bring darkness over the face of day', which enables them to trap every living thing out in the open; 'and the king of these scoundrels is called Nogodar'. Even Marco himself 'was all but caught by their bands in such a darkness', escaping the slaughter with a few others by fleeing into the safety of a nearby village. You may think the mention of magical darkness casts doubt on the whole episode. But the robbers were real. They were the first- and second-generation descendants of warriors sent from Mongolia to garrison Afghanistan in the 1230s. From there these

warriors raided into India, capturing huge numbers of prisoners; most of the men were sold as slaves, many of the women kept as wives. From them sprang a new generation of frontier troops known as Qaragunas,[2] from the old Mongol for 'dark' or 'black'. They evolved into freebooters, medieval equivalents of Cossacks, feared by the populace for their extreme violence and for that same reason occasionally employed by Mongol leaders, when they could control them. In Marco's time three contingents, nominally of 10,000 each, were loose in Persia, each swinging unpredictably between loyalty, rebellion and pillage. Top dog among the Qaraguna warlords had indeed been a certain Negüder, whose name, after his death in about 1262, remained attached to his group. The Negüderis and other Qaragunas remained a potent force for another century, their descendants forming today's Hazara and Mogholi minorities in Afghanistan. Those who know Khaled Hosseini's *The Kite Runner*, both the book and the film, will recall the narrator's best friend, the much-abused Hassan, who is insulted by everyone for his Mongoloid features: 'People called the Hazaras *mice-eating, flat-nosed, load-carrying donkeys*.' It may frustrate modern readers that Marco evades, exaggerates and fails to detail a hair's-breadth escape, but there's no doubting that parts of his book tell truths that echo down the corridors of time. The problem is sorting out the true bits.

[2] Later, the *g* weakened to a sort of glottal stop, forming Qara'una, thus Marco's Carau(o)na.

From western Iran, Marco and his party wove over mountains and across searing hot plains to Hormuz. This being high summer (1272), the heat was appalling, especially when a vile desert wind blew. To escape it, he says, people would immerse themselves in water. Those exposed to it risked death, and Marco records hearing of corpses being cooked as if in an oven, so that when others came to retrieve them 'the arms parted from the trunks'. Others have noted the effects of the *simoom* (from the Arabic for 'to poison'), a sand-filled wind that takes temperature up to the mid-fifties Celsius, and causes death by heat-stroke. It sounds so grim you wonder why anyone lived in Hormuz. Yet it was a major port, one of a dozen around the coasts of the Middle East and north-east Africa, where spices, precious stones, silk and gold arrived from India and from which perfumes, ivory, iron, glass and pepper (among many other items) were exported. The people ate a good diet which included dates, tuna and onions. The fact is that Marco liked to focus on extremes. Hormuz/Bandar-e Abbas is not *that* appalling: the summer temperature averages a mere 37°C, with only fourteen rainy days a year, which is why today it is still a major port, with some 350,000 people, despite the occasional *simoom*.

What were the Polos doing there? Presumably hoping for a boat to India, until something put them off. The sight of the open sea, perhaps. Or the ships: 'wretched affairs . . . for they have no iron fastenings, and are only stitched together with twine made from the husk of the

Indian nut,' by which he means coconuts. They were sealed with whale-oil. Naturally, for the little Arab ships, the 1,500-kilometre voyage to Gujarat was a 'perilous business . . . and many of them are lost'. Or perhaps it was fears for their health that stopped them. It is possible they were there for some time, perhaps over winter (1272–3), because Marco refers to sowing grain in November and harvesting in March. He becomes very concerned about the state of his stomach. Hormuz's date-and-spice wine caused 'repeated and violent purging' until you got used to it. Loose bowels, seasickness, storms and a ship held together with bits of string: there's enough there, I think, to make them change their minds.

Returning to Kerman – 350 kilometres, another month – and heading north then east, Marco picked up the story of the Assassins, the extremist Muslim sect whose policy of murdering enemies, Muslim and non-Muslim alike, had included a plan to assassinate the Mongol emperor Mönkhe. It was this plot, or rumours of it, that drew in the vast army which had wiped out first the Assassins, then Baghdad and finally a good deal of Islam itself.

The Assassins, a sect of Nizari Shias, were based in Alamut, a fortress high in the Elburz mountains south of the Caspian. Tradition claims that its name derives from a local phrase meaning 'eagle's nest', because it stood on a peak towering above a single approach path, which itself could be entered only from either end of a narrow ravine. But Alamut, the ruins of which are still

there, was 700 kilometres off Marco's route, and reality was already drifting into legend. In Marco's version, Alamut's stark valley has become a beautiful garden, filled with gilded pavilions and painted palaces, where honey, wine, milk and water flow in conduits. Damsels play and sing. Its imam (the Old Man of the Mountain, as Marco calls him; in fact his name was Hasan) keeps a group of lusty teenagers, who are drugged (with opium, in one version), carried into the garden, and when they awake pampered in every way. All is play, love and pleasure. 'The damsels were around each one always, and all the day were singing and playing and making all the caresses and dalliance which they could imagine . . . so that these youths had all that they wished.' Another draught of the sleep-inducing drug, and the young men find themselves back in the real world, bereft, and willing to do anything to regain the joys of Paradise. Marco uses the term assassins – 'Ashishin', hashish-users – helping to spread the belief already widespread among the crusaders that the Assassins used the drug to prepare themselves for murder. But hashish was widely used, not a Nizari secret. No Nizari source mentions it. More likely, the term was an insult applied to this despised and feared group, simply as a put-down for behaviour that struck outsiders as both appalling and irrational.

Two weeks out of Kerman, approaching the Afghan border, the travellers found themselves in a gentle region of well-stocked towns and villages. Marco's spirits rose. The inhabitants, he noted, were very handsome,

'especially the women, who are beautiful beyond measure'. He has already introduced the subject of sex in his account of the Assassins. He knows his audience. There is nothing of the puritan in him. Though not interested in taking a close look at the Muslim faith – idolaters all, in his dismissive word – he likes women, of any race or creed. Not much further on, in Kashmir, he remarks that 'the women are very beautiful for dark women'. These seem little asides, but they should be seen as evidence, however slight, of an interest – a drive – a passion – that would run through his life in Kublai's China.

On then across northern Afghanistan, an area devastated by Genghis because its notoriously warlike inhabitants had opposed him. Balkh, the ancient capital of the region, famous as the birthplace of Zoroaster, once defended by 13 kilometres of walls, lay stricken by the events of half a century before. In 1220–1, the Mongols under Genghis had reduced it to ruins, twice, in circumstances recorded by Juvaini: he

commanded that the population of Balkh, small and great, few and many, both men and women, should be driven out on to the plain and divided up according to the usual custom into hundreds and thousands to be put to the sword; and that not a trace should be left of them fresh or dry. For a long time the wild beasts feasted on their flesh, and lions consorted without contention with wolves, and vultures ate without quarrelling from the same table as eagles . . . And they cast fire into the

garden of the city and devoted their whole attention to the destruction of the outworks and walls, and mansions and palaces.

Apparently universal carnage and destruction was not quite universal. Juvaini was as prone to exaggerate as Marco. When Genghis returned to Balkh the following year, having decided not to invade India, 'he found a number of fugitives who had remained hidden in the nooks and crannies and come out again. He commanded them all to be killed ... and wherever a wall was left standing, the Mongols pulled it down and for a second time wiped out all traces of culture from that region.' When the Daoist monk Changzhun came this way in 1222, summoned to meet Genghis in Afghanistan, he found it wrecked and deserted: 'Its inhabitants had recently rebelled against the Khan and been removed; but we could still hear dogs barking in the streets.' And still something remained. Marco, though remarking on the city's decline, could call it 'a noble city and great'.

This was a land famous for cultivated valleys, and for its ruby and lapis lazuli mines. Marco tells of Alexander the Great, of jewel-rich mountains, of fast horses, of high mountains and their health-giving purity, and of the women, who pad themselves with layer upon layer of cotton trousers, 'to make themselves look large in the hips, for the men of those parts think that to be a great beauty in a woman'.

*　　*　　*

From north-eastern Afghanistan a 200-kilometre corridor reaches up between the snowy peaks of the Hindu Kush, the Pamir and the Karakorum ranges. North lies Tajikistan, which used to be part of the Soviet Union, and before that Russia. South lies wildest Pakistan. The corridor, which follows the Wakhan river, is like a knife hacking through a tangle of mountains, habitats, and rival nations towards China. Only 16 kilometres across at its narrowest, this strange peninsula of Afghan territory came into existence as the result of the Great Game of diplomacy, espionage and proxy wars between the Russian and British empires in the late-nineteenth-century heyday of imperialism. At the time, in the 1890s, Britain had the upper hand in Afghanistan, while Russia wanted most of the rest of Central Asia. A deal was done, along a frontier defined by the upper reaches of the famous river known to the ancient world as the Oxus and today as the Amudarya. Russia got the north, which meant two of today's 'stans' (Uzbekistan, Tajikistan). The British got the south, most of it, or rather their protégés the Afghans did. That left an unclaimed remainder, the thin no man's land through which ran the Wakhan. It should really have been taken into British-ruled India. But that would mean a frontier shared with Russia, and the British had visions of Cossacks charging through the only accessible pass, the Chitral, so the idea of a British–Russian border was out. The solution was to give it to the Afghans, or rather force it down their unwilling throats. This also made geopolitical sense, because access up the Wakhan

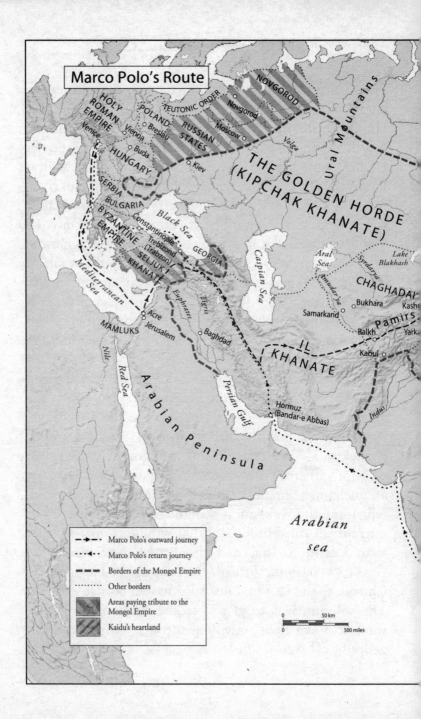

Marco Polo's Route

HOLY ROMAN EMPIRE
Venice
Vienna
POLAND
Breslau
TEUTONIC ORDER
Buda
HUNGARY
RUSSIAN STATES
Moscow
Novgorod
NOVGOROD
Kiev
SERBIA
BULGARIA
BYZANTINE EMPIRE
Constantinople
Trebizond (Trabzon)
GEORGIA
SELJUK KHANATE
THE GOLDEN HORDE (KIPCHAK KHANATE)
Volga
Ural Mountains
Black Sea
Caspian Sea
Aral Sea
Lake Blakhash
Syrdarya
Amudarya
CHAGHADAI
Bukhara
Kashe
Samarkand
Balkh
Yark
Pamirs
Mediterranean Sea
Acre
Jerusalem
MAMLUKS
Nile
Red Sea
Euphrates
Tigris
Baghdad
IL KHANATE
Kabul
Hormuz (Bandar-e Abbas)
Indus
Arabian Peninsula
Persian Gulf
Arabian sea

Marco Polo's outward journey
Marco Polo's return journey
Borders of the Mongol Empire
Other borders
Areas paying tribute to the Mongol Empire
Kaidu's heartland

| 0 | 50 km |
| 0 | 500 miles |

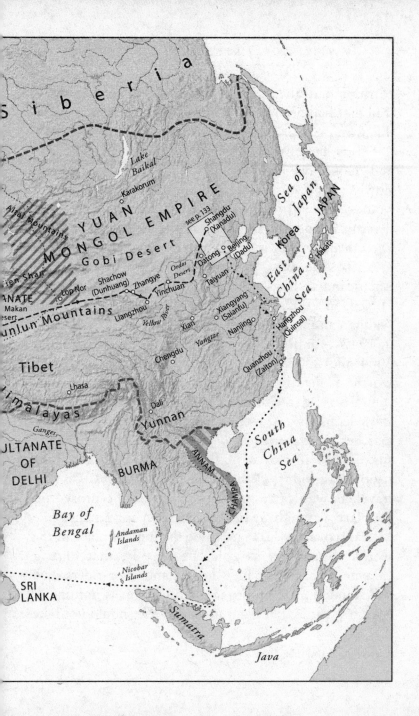

see p. 133

corridor had always been from Afghanistan, along a trail that had been in existence long before Marco came this way.

This is, and always was, one of the world's toughest and most awe-inspiring places, where time moves slowly, outsiders are rare, and reports rarer still. Indeed, Marco seems to have been the first westerner to describe it, and also the last until the nineteenth century. Even then, visitors were few and far between. They still are. 'To the best of our knowledge,' wrote two American explorer–writers, John Mock and Kimberley O'Neil, in 2002, 'no Westerner has visited the upper Wakhan and the source of the Oxus since H. W. Tilman in 1947' – until they went themselves, several times in 2004 and 2007.[3] Here, a 6,000-metre peak is hardly worth a mention. Glaciers grind down from icy summits, and melt-waters carve steep valleys where snow leopards and wolves hunt ibex. Marco's account matches the experiences of other travellers before and since, for in 1,500 years little changed. Persians call the region Bam-i-dunya, the Roof of the World. Chinese travellers who came this way in the sixth century said the place was midway between Heaven and Earth, while Marco remarks, ''Tis said to be the highest place in the world.' It can get so cold, people say, that once a caravan of camels, mules, horses and their riders died still standing, frozen into ice-statues. This is not one of Marco's stories; I heard it in China. We should not take

[3] www.mockandoneil.com.

it literally, any more than we should take Marco literally when he says it was so cold up there that no birds flew. At the right time of year, the lakes – especially the main one, Sarikol as it is today – swarm with birds. The seventh-century Chinese pilgrim and scholar Xuanzang (Hsüan-tsang) recorded both the extreme conditions and the wildlife:

> The traveller is annoyed by sudden gusts of wind, and the snowdrifts never cease, spring or summer. As the soil is almost constantly frozen, you see but a few miserable plants, and no crops can live. The whole tract is but a dreary waste, without a trace of human kind. In the middle of the valley is a great lake [the Sarikol] . . . an endless variety of creatures peoples its waters. When you hear the murmur and clash of its waves, you think you are listening to the noisy hum of a great market in which vast crowds of people are mingling in excitement.

Imagine Marco riding up over the rocky terraces and fans of gravel washed from the Pamirs, while to the south towered the roller-coaster peaks of the Hindu Kush. He followed the Wakhan upwards, below a land of glaciers and perpetual snow. Here, as he noted, lived a huge sheep, with horns that measured over 5 feet (1.5 metres) in length each, the animal which in 1840 was named in his honour *Ovis Poli*, the Marco Polo Sheep.[4]

[4] Actually, *O. Poli*, sometimes but wrongly spelled *Polii*, is a sub-species of *O. ammon*, the argali.

These were so common, and such easy prey for both hunters and wolves, that locals piled their immense horns so that they stuck out of the snow to mark the way. He describes the high plain, with its superb summer grazing, though he fails to mention the low stands of willow, birch and buckthorn, with its orange-yellow berries. He records the great lake described by Xuanzang and the river running from it (the Pamir, which becomes the Amudarya). At that altitude, he noted, fire was less effective, not as he thought because of the cold but because of the lack of oxygen, which he did not notice because his slow climb allowed him to adapt. In fact, he quite liked these austere heights, because 'the air in those regions is so pure and residence there so healthful' that the sick climb up to be healed.

At this point he slips in a startling piece of information: that he knew from personal experience how good the Pamirs were for health, because he had become well again himself, having been sick 'for about a year'. Does he mean that the whole party was delayed for a year? It's impossible to tell, because the Polos have fallen out of time. At a guess this is the summer of 1274, because travelling through the high Pamirs in winter would be courting death. More likely he had been suffering some sort of chronic complaint, like a permanently upset stomach, that was cured by the mountains' thin air and pure water.

The few inhabitants of this wilderness lived (as their successors still do) as herders in a score of scattered villages or in round felt tents; here Marco's party would

have found shelter, as the occasional trekkers do today. Their hosts spoke their own 'peculiar language', as Marco noted – Wakhi, a member of the Pamir group of the Iranian family. To Marco, these people were simply 'Mohammedans'; possibly they were Ismailis, peaceful co-religionists of the Assassins, because that's what they are today.

Traditionally, there are three routes up and over the twisted ranges known to geographers as the Pamir Knot, where tectonic forces rammed India into Asia 70 million years ago and heaped rock into chaotic tangles. The Wakhjir pass, over which Marco almost certainly went, lies at just over 16,000 feet (almost 5,000 metres), a height at which those unaccustomed to it may need oxygen. Impassable for the six winter months, it is open only part-time for the other six. No crossing is easy: there is no road even now. It is a gravelly saddle between peaks, that's all. Not that outsiders can actually cross, because it is not a legal crossing point. '**Warning**,' say Mock and O'Neil in bold. 'If you attempt a cross-border route without explicit permission for that route, you are subject to being shot at, taken into custody, and accused of crimes.' Marco, untargeted and unaccused, did not think the crossing worthy of note.

He had no idea that within sight lay the solution to a question that no one had yet asked: where was the source of the Oxus, today's Amudarya? For centuries, nobody cared. Peoples, empires and cultures rose and fell either side of the river downstream, while upstream

in the knot of mountains that Marco crossed its course was a mystery. The Great Game changed all that. In the 1880s, when Russia and Britain established their frontiers, it was thought that the Oxus – still known by its classical name – rose in Lake Sarikol.[5] In fact, it was further east, somewhere in the glaciers and snowfields dividing the Great from the Little Pamirs. These are not distinctions that need concern us now, but they were of great concern then. (The 1911 *Encyclopaedia Britannica*, still at that time being produced in London, devotes 6,000 words to the Oxus; now it has about 1,000, referring to the river as the Amudarya, with the Oxus as a mere cross-reference.) The source of the Oxus, like the source of the Nile, set imperial pulses racing, and for the same reason: the source fed the river, the river defined areas of political interest.

It was the future viceroy of India, George Nathaniel Curzon, who found the answer in 1894, just in time for Russia and Britain to sort out their borders.[6] He came over the top on horseback from what is now China:

> From the top of the Wakh-jir Pass the descent is rather steep and stony towards the Oxus valley, which is visible far down below, a blue line of shingle bed winding away between lofty ridges . . . Descending to the shingle bed, which varies from 100 to 350 yards in

[5] See Wood, *Journey to the Source of the River Oxus*.
[6] Curzon, 'The Pamirs and the Source of the Oxus'.

width, the channel being divided into several branches of from 6 to 18 inches deep, I rode up it to the source. There the river issues from two ice-caverns in a rushing stream. The cavern on the right has a low overhanging roof, from which the water gushes tumultuously out. The cavern to the left was sufficiently high to admit of my looking into the interior, and within for some distance I could follow the river, which was blocked with great slabs of ice, while there was a ceaseless noise of grinding, crunching and falling in. Above the ice-caves is the precipitous front wall or broken snout of the glacier, from 60 to 80 feet in height, composed of moraine ice, covered with stones and black dust.

Is the cave still there, and still the river's source? On 3 August 2004 John Mock and Kimberley O'Neil set off to find out.

From our campsite at the base of the Wakhjir Pass, we headed farther east-southeast up the valley towards the snowy glacier filling the valley's head. The rocky river-bank was dotted with more Marco Polo sheep horns, further evidence of the animal's abundance here and its unlucky fate from rockfall or hunting by hungry Kyrgyz during winter. Within an hour, we caught our first glimpse of a black cave in the glacier's mouth . . . Forty-five minutes farther we were at the cave (37°02′27.2″N, 74°29′28.8″E), a dark gaping hole at the glacier's terminus whence flowed icy waters, the source of the Oxus River. We made it! To the best of our knowledge,

no Westerner had been to the source of the Oxus since
Curzon in 1894.

Marco had seen Lake Sarikol and the upper reaches
of the Oxus, and could not have known the significance
of either. Now, unaware of what else he might have dis-
covered, he started the descent that would take him
down into China's western regions, and to the point
where I was able to cross his path.

3

INTO CHINA

ONCE OVER THE HIGH PAMIRS, MARCO HAD CROSSED THE natural frontier to Kublai's realm. Like a comet at the extreme edge of China's gravitational influence, he was now beginning the long, slow fall towards Xanadu, the sun which at the time (though not for long) was at the centre of Kublai's empire. There was nothing yet to relieve the 'barren desolation', which was how Sir Aurel Stein, the great Hungarian–British explorer and archaeologist, described the descent from the Wakhjir pass in the summer of 1900. Stein,[1] like the other great explorers of his day, was dogged, brave, brilliant and extremely anti-social, which was why he was able to spend much of his life trekking back and forth over these remote regions. 'I have been in love many times,'

[1] Stein, *Sand-Buried Ruins of Khotan*, ch. 4.

wrote his contemporary and rival Sven Hedin, 'but Asia remained my bride.' Stein's too. He will be reappearing many times in the coming pages, haunting Marco, a ghost behind a ghost.

The way led past a small lake and gently downhill, following a stream that wove over aprons of rock and gravel washed from the snow-clad peaks on either side. This being high summer, for no traveller would attempt a winter crossing, patches of snow alternated with soil made boggy by melt-water. Scattered tussocks gave way to thick, coarse grass.

You may wonder if the route would have been the same in Marco's time. In detail, almost certainly not, for earthquakes constantly remould the surface features of these young mountains.[2] Lakes vanish, rivers change their courses, cliffs fall, small valleys reform. But large features – 6,000-metre mountains, the valleys that divide them, ridges many kilometres across – seldom change on historical timescales. There are no active volcanoes here to remake landscapes.

You may also wonder if he took this route at all, since he does not mention any landmark between the high Pamirs and Kashgar. True, there are other routes, but they are few, and harder, and with even less chance of finding food and shelter and spare animals. Why would his guides – for guides there must have been – have not taken the easiest route? I can imagine possible reasons – to avoid bandits, or an unreliable local chieftain, or a

[2] My thanks to Stephen Haw for pointing this out.

small war, or a flood, or an avalanche, any of which the guides might somehow have known about in advance. Yet if they did, they clearly failed to explain their reasoning to the Polos, because if they had Marco would surely have mentioned it, since one reason for describing his route in the first place was to give accurate information. So let's assume he breasted the Wakhjir pass, as common sense suggests, and take him on from there, into a geographical void from which he emerges well inside China. We must fill the gap as best we can.

Some 80 kilometres from the Wakhjir the track turned north at a point where the stream joined a river running from another pass, the Khunjerab, leading over the Karakorum range from what is today northern Pakistan. With the snowy ranges falling back on either side, Marco's party, with its guides, porters, horses and yaks, should have followed the river, single file along a narrow track, such as you can still see today winding up and down over side-channels and glacial moraines. In his day it was known as the Jade Road, jade being much in demand as a symbol of power, as an aid to immortality, as a medium for carving. It remained much the same for the next 700 years. Now all sense of the old road has gone because it has become the fast and easy Karakorum Highway, the world's highest paved road, opened in 1986 after 20 years of brutally tough engineering by teams from China and Pakistan.

It is strange that this region, as remote from Beijing as from Baghdad, owes anything at all to China. It was a

land of many peoples: Kazakh, Tajik, Kyrgyz, Uighur. Not long before Marco's arrival it had been ruled by Khitans from Manchuria, who had been driven from their homeland around 1125. Their new estate came to a sudden end in 1218, blotted up by the Mongols in a blitzkrieg advance. Hence Marco's bald statement that this region 'constituted a kingdom in former days, but now is subject to the Great Khan [i.e. Kublai]'; and since China inherited the boundaries staked out by Genghis and Kublai, it remains Chinese. If you ever try to cross the Wakhjir pass without a permit, and in the unlikely event that you are spotted by a border guard, he will probably be Kazakh, Tajik, Kyrgyz or Uighur, but he will yell a warning in Chinese, and either shoot you with Chinese bullets or arrest you in Chinese, under Chinese law, all thanks to the Great Khan.

Marco makes no mention of this stretch of the journey, but we can see what he should have seen through the eyes of Aurel Stein:

It was a novel sensation, after the weeks passed in narrow gorges and amidst snow-covered heights, to ride along these broad, smiling slopes gently descending from the foot of the mountains. Wherever water reaches them from the side valleys, the ground was covered with a carpet of flowers and herbs which scented the air quite perceptibly. Well-watered and free of snow, the grass was now lawn-green, fine grazing for a group of ponies lustily enjoying the delights of freedom and rich pasture.

Far ahead, glowing beyond the corridor of mountains like a rising moon, loomed 'the glistening mass of a great snowy dome'. It was Mustagh Ata, the Father of Ice Mountains, still 80 kilometres away, but already a light guiding Marco northward for the next few days. First, though, much closer, came 'a strip of delightfully green sward' and 'carefully-terraced fields' and finally ramparts: Tashkurgan, the Stone Fortress, the first town in China.

'Whether it was the bright surroundings or the historical interests associated with the place,' wrote Stein, 'the sight of the walls of Tashkurgan rising higher and higher above the flat filled me with emotion . . . they marked the completion of a considerable part of my journey and my entry upon the ground which was to occupy my researches.' Anyone reaching here from the West in the last century, or in the thirteenth, or any time in the previous 1,300 years or more, might have felt the same. For, as Stein says, it seems as certain as it can be that Tashkurgan was the trading town mentioned by the second-century scientists Ptolemy and Marinus of Tyre as standing on the border between East and West, between China and almost everywhere else, where merchants from both sides met to exchange their wares. It was the keystone in the most southerly of the several routes that in the nineteenth century became known as the Silk Road. Its name should be as evocative as those of the other great Silk Road emporia: Bukhara, Samarkand, Dunhuang. Yet who nowadays has heard of Tashkurgan?

In my pursuit of Marco, this was the start of my researches, my first town in China, as it may have been his, though my course was the reverse of his, and partial: I came from the other direction, and did not get beyond Tashkurgan, because the Karakorum Highway heading south was closed to outsiders. The borders with Afghanistan and Pakistan were as sensitive as sun-burned skin, what with the Beijing Olympics coming and fears of extremists eager to stir up the local Muslims.[3]

Marco, though, has vanished from our sight. The route along which he should have come is full of interest – the fortress town, a vast peak, a grim and difficult defile – but he says nothing about it. He often implies a visit to places he never saw (like Samarkand, 700 kilometres out of his way), yet here were things he probably saw but fails to mention. Whichever way he came, it is hard to imagine he heard nothing about Tashkurgan and its nearby peak, Mustagh Ata.

Here is an idea of what he missed, or ignored:

Tashkurgan, May 2008. It was a glorious, still evening, with the surrounding peaks glowing like polished saws in the setting sun. I had time for a short walk before dark – not enough time to see the citadel, the Stone Fortress itself, which is what Tashkurgan means. The town is not large: a few broad cross-streets,

[3] Not without cause: two Uighur separatists killed sixteen policemen near Kashgar in the run-up to the 2008 Olympics.

stalls, a school, barracks, some cheap hotels. With Ekber, my lanky Uighur guide, I walked past a pillar topped by the statue of an eagle, then along a straight road lined with poplars that led down from the high ground on which the town and its fortress stands to the valley floor.

Ahead was an incongruous sight, considering the altitude and the snowy ridges to east and west, for here was the world's biggest water garden, lawn-green grass woven with a dozen streams, all side-channels of the slowly flowing Tashkurgan river. A dozen round tents of white canvas were dotted about, as if ready for a huge garden party.

It was not quite so arcadian in close-up. The soggy ground was made bumpy as a sheet of Braille by the roots of some tussocky grass, and the tang of something coarse and sweet hung in the air.

'Is that the smell of cooking, Ekber?' I stopped to scoop a handful of water from a clear, spring-fed pool.

'No. Yak poop.' He spoke in clipped sentences, always to the point, in remarkably colloquial English, solely as the result of chatting with tourists. He had been all over China, but never abroad. 'And cigarettes. And the goats.'

'Those are *goats*?' Half a dozen bundles of hair dotted the grass by the tent ahead of us, where a man in jeans was on his knees wrestling with a round object. The goats were knee-high, the size of large dogs.

'Micro-goats,' said Ekber. 'The yaks are small too. It is the altitude. Nature decides everything.'

We had been spotted. A very tall woman in a pink shoulder-to-ankle dress and a big blue-and-yellow pill-box hat came out of a tent and switched on a loudspeaker, which began to blare drum-and-flute music, the tune dancing around one note like a mountain stream round a rock. As we approached, she turned, and revealed the most monumental nose I had ever seen. It was hooked, like a broken megalith. Yet it didn't seem outlandish, because her face was as statuesque as the rest of her: the eyes deep-set, the cheekbones prominent, the jaw firm, the expression haughty, all combining to frame the magnificent feature at the centre.

'Wow. Is she, I mean, do lots of Uighurs look like that?' I muttered.

'Tajik. She is Tajik. You mean her nose. Yes, Tajiks are famous for their noses. They are called "eagle noses". You saw the eagle statue on the pillar? For Tajiks, it is their bird, their ancestor. For us, it is wolf. For them, eagle. Pamir – that means "eagle" in Tajik. Eagles, eagles. They are proud of them, and proud of their eagle noses.'

Not just the noses. Later, in town, the streets were full of women with similar powerful faces – the older ones gnarled by the harsh climate – and similar elegance, with flowing clothes hiding and revealing the discreet flash of bronze or gold decoration. And everywhere hats, men and women alike. This, it turned out, was hat country, with a huge range of styles, but predominantly fur-trimmed pill-boxes, over which the women draped white Islamic headscarves.

The tall woman in pink turned to the kneeling man, who I could now see was stretching a goatskin over a frame, making a drum. 'Also we make drums out of snakes,' said Ekber. At 24, he clearly had a talent for storing and dispensing data by the terabyte. That and an easy manner made him exactly what I needed.

'That would be quite a snake. They have snakes up here?'

'No. We have no such kind of big snake. They live in Guangdong province' – the territory that surrounds Hong Kong – 'No poison. They circle, they squeeze . . . ah, yes, I remember: python.'

Well, there would have been no python-skin drums when Marco might or might not have come through in 1273 or –4, because Kublai's conquest of the south was still in full swing and would not be complete until early in 1276. But he would have seen and heard the drums, the flutes, the hats, the flowing dresses and the noses all the way over the high Pamirs, which skirt the southern border of today's Tajikistan. He was not fond of the Tajiks. These worshippers of Mohammed were thieves, robbers and murderers who 'stay a great deal in taverns with beaker to mouth, for all the day they like to drink'. You may well ask: If what he says was true, what about the Islamic prohibition against alcohol? The answer is that the Qur'anic ban was not considered total, and anyway Islam had not yet completed its progress among the Tajiks.

Over this great apron of green loomed the grey, twilit mass of the fortress – decaying, broken, but with such

remnants of past grandeur that I could not help a prickle of resentment at Marco for not describing it. Ekber and I climbed into it the next morning, early – early being a relative term. The official Beijing time was seven-thirty; but Beijing was far away, it was five-thirty by the summer sun, and few people were about. I apologized to Ekber, walking fast to warm up in the high, cold dawn.

'No problem. I am used to early starts, for training.'

Striding beside me in a yellow track suit, he listed his sports – basketball, soccer, climbing and the high jump (personal best: 1.8 metres). Then he spoke of his life, and of the hopes raised by the new China for an intelligent and ambitious young man. He was already fluent in Uighur, Tajik, Chinese and English. Now he was applying for a scholarship to study anthropology or archaeology in Sweden.

We came to the fortress's main gate, a rickety metal frame with a notice in English announcing this to be 'The Ancient Stone City. 1,300 years of history. Classified as a key cultural relic site and protected by the National People's Congress.' But the People's Congress was as distant as Beijing, and there was no protection. We climbed up the bare hillside, past a huddle of flat-roofed houses and yak-stalls built of undressed stones. It was obvious where the stones had come from: the fortress itself. The inside looked like the aftermath of a nuclear strike. Wind, rain, cold and earthquakes had stripped the walls bare of all stone cladding, leaving them insecure and cracked. Stones and

small boulders by the truckload lay across what had once been the courtyards of barracks and living quarters. Earth-brick cores a metre or two high jutted up at random, with hardly a trace of a room, and none at all of roofs and ceilings. Pits opened in the ground here and there, like shell-holes, dropping into what had once been cellars and the foundations of gates. It was hard to tell fortress from inner city, inner city from outer city.

I assumed the incomprehensible litter of stones and uneven ground was the work of centuries. I was wrong. Aurel Stein explains:

A line of massive but crumbling stone walls crowns the edges of a quadrangular plateau of conglomerate cliffs, roughly one-third of a mile in length on each of its faces. A small portion of the area thus enclosed, on the east side facing the river, is occupied by the Chinese fort. Its high and carefully plastered walls of sun-dried bricks stand undoubtedly on far more ancient foundations. Outside them now all is silence and desolation. The rubble-built dwellings, whose ruins fill part of the area, were tenanted as long as the insecure condition of the valley made it impossible for the scanty cultivators to live near their fields. Since peace has come to Sarikol new villages have sprung up. When the earthquake of 1895 shook down most of the dwellings, there was no need to rebuild them, and the stronghold has become deserted.

So the decay was recent. The fortress and its town had been here for centuries, constantly repaired and restored. In Marco's day it would have been a place of safety, in which to eat, sleep and rebuild. Only in the last century did the work of repair cease, and the fortress go into terminal decline.

The outer walls were better: several metres high, with the remains of walkways beneath the broken-toothed battlements. I climbed for a better view, and gazed in wonder. To the north, beyond the fortress's walls, lay the ruins of the old town – hardly anything but ridge upon ridge of earth and stones. To the east, the huge pasture; the wandering streams; a score of white tents picked out by the rising sun; the early-morning mist; and all around, the mountains, rugged as crumpled cardboard, and snow-capped. Nothing could have showed more clearly what a superb site this was for a frontier-town and fortress. The valley is only a few kilometres from side to side. Anyone up here could see travellers, or armies, coming from either north or south, with time enough to prepare an appropriate response, a feast, an official delegation, a defence.

'Ekber, this place is a treasure. It should be a major tourist attraction.'

'Should be, but is not. It is far from Kashgar, and there is the problem of altitude.'

Why? We were only at 3,600 metres. High enough to chill the summer nights – my fingers were as cold as my icy camera – but not high enough to make you gasp, surely.

'Look. We are surrounded by mountains up to 6,000 metres, the northern part of the Tien Shan, the southern Karakorums, the western Kunluns, no trees, grass always short, so we lack oxygen, and it is a long way to any hospital.'

The 260-kilometre way northward to Kashgar – a few hours for Ekber and me in our car, a week or so in previous centuries – begins easily, the road drifting downhill over an immense plain strewn with a rubble of rocks, brought from the mountains by the occasional flood. Wind whipped up a veil of reddish dust. We followed a river, which carved through glacial moraines. If time could be compressed, this would be the setting for a geological film sequence, as follows:

We open high in the mountains. Glaciers bulldoze soils and rocks from mountains, grind them into a slurry, melt them and wash them into the valley in immense aprons, which are then cut off by the river, leaving unstable cliffs. The detritus of pebbles and rough soil turns the river into liquid sandpaper, and as the slope increases it gathers itself for the assault on the mountains ahead.

First, though, emerging over a lower range is Mustagh Ata, the Father of Ice Mountains, which, of course, is also the father of the grandest glaciers and the biggest moraines. This thing is astonishing, in its size, its shape, its sheer bulk. At 7,546 metres (24,757 feet) it ranks only 43rd in the world, but it stands alone, both literally, for it has no neighbours to compete with it, and

in other ways as well. It doesn't look its height, because it reaches so far sideways. There is no sharp peak, as you would expect from mountains of a similar height and age in the Himalayas. At first glance, it is more ridge than mountain, as if the earth had flexed a muscle. Wait, and look again. Perhaps you cannot see the bulk of it all at once, because snow and ice blind you, or clouds blur its outline. But when you see it clear, you realize the shape is not so simple. The old Jade Road and today's Karakorum Highway lead you close, over gravel plains where a few camels nibble at scanty grasses, and you see that it is not one mountain, but almost two, split by some prehistoric cataclysm. The cleft which leaves the north peak several kilometres from the southerly one is now filled by the greatest of its fourteen glaciers, which looks like white scar tissue healing the mountain's wound. 'When it was all together,' said Ekber, 'it must have been the highest in the world.'[4]

[4] A footnote for mountaineers: It took a while to pioneer a route to the top. The great Swedish explorer Sven Hedin tried four times in 1894. Aurel Stein was next in 1900, driven off after three days by grim weather and exhaustion. In 1947 two British climbers, Eric Shipton and Bill Tilman, got to within 200 metres of the top before a snow-storm stopped them. When a joint Soviet–Chinese team discovered the best route in 1956 – up the gentle south slope – it turned out that Mustagh Ata is the easiest to climb of all mountains over 7,500 metres. Now, every year, between 200 and 300 groups tackle it in expeditions of three to five days, depending on fitness and conditions. The mountain's popularity does not diminish the dangers. Four people died up there in 2007. But for the very fit, in the best conditions, it's hardly a challenge at all. The record up and down from base camp is 11 hours and 20 minutes, the huge advantage of the gentle slopes being that, once up, you can ski down.

Not far northward, the route – today's road, probably Marco's path – winds past a collection of hills that seem to belong on the moon: light grey, rounded as pillows, and veiled by a mist that turns them into ghost-mountains. At first glance I thought they were covered with snow, except that the cover was on the lower slopes more than the upper ones. Closer to, I understood. The road passes a dried-up lake made of sand so fine that the wind whips it into gossamer curtains, which drift like mist over the mountains, coating them with a fine grey dust.

Beyond the ghostly range, the road breasts a pass and drops from the highland plateau of plains and mountains into a gorge, the Gez defile.[5] Again, if we wish to see what Marco saw, we must recall the pack animals, narrow tracks, bridges and camp sites – all the paraphernalia with which travellers tackled the defile for many centuries before the coming of the road. The river gathers itself and tumbles through a tangle of red and brown rock, under-cutting cliffs, sawing away at rock falls. Narrow terraces make tiny pastures for yaks, goats and sheep. High above, glaciers glisten. An ice-cap clamps like a hand over a mountain-top, with glacial fingers reaching down steep side-valleys. Below, the river plunges between boulders, sometimes vanishing underground.

At one point, on the opposite bank, little stone houses stand at the edge of a stone-walled field. That, said

[5] It and its river, the Gez, were also known until the last century as Yamanyar.

Ekber, was what the old caravanserais looked like a century ago, or a millennium. There would have been something like it every 30 kilometres or so, which was about as far as travellers could go in a day. A trail led past it, as always over old moraines and stony 'fans', spewed out by glaciers. 'Great serrated coulisses of rugged rock, several thousand feet in height, descend from the main mountain spurs on both sides,' writes Stein. 'Along the face of one of them the road is carried by a gallery . . . [which] gave a roadway of at least 4 feet breadth.' Today, the gallery has gone, but sometimes, if you can park, you can still see an old trail, a single-track path running along the stone-scattered, dusty slope of the mountainside, occasionally shored up with stones. Before the coming of the road, the track wove back and forth across the river over bridges, as Stein recalls:

The river is compressed here by mighty rocks to a width of some 45 feet, and the chasm is spanned by a wooden bridge 6 feet broad, quite a creditable specimen, I thought, of Chinese engineering . . . The opposite bank for more than a mile further down was formed by a high and precipitous wall of rock wholly impassable to man or beast. After some three miles, we recrossed by a similar bridge to the right bank, and could have continued our march there with ease had it not been that the bridge across the swollen glacier-stream . . . had been washed away. The stream was wholly unfordable, and it was necessary to climb up for some three miles to the mouth of the huge Koksel glacier from which it

issues. It was a trying detour, for the whole valley is blocked by enormous old terminal moraines. When at last the present end of the glacier was reached, it was with difficulty that we dragged up the ponies to the top of that mass of ice rising in a bank at least 150 feet above the river. It was fortunately thickly coated with glacier mud and detritus, and in half an hour we had safely got the first pony across.

Such detours were common. Winter snow made high paths impassable, summer floods broke bridges and washed away tracks. A section that might be crossed in a day or two in good weather might take several days following a storm. The track wound along river banks, up and down passes and through gorges, until the mountains fell away to lowland plains, which stretched to the dusty horizon.

The sight of a desert poplar made Ekber lyrical. 'That tree, it is like magic. The roots go down maybe thirty metres. It can last three thousand years – one thousand to grow, one thousand to live, one thousand to disappear. If you cut a little into it, you get drops of water. We say, if someone drinks that water, he will live for a hundred years. That's why Xinjiang is a long-life area. My grandfather lived until he was a hundred and five, my grandmother until she was ninety-nine. We have an old man of a hundred and three who got married and had a son. It is true. It was in the papers.'

There is magic too in the places where water flows or seeps up from springs. At an *ashkarna*, a tree-sheltered

tea-house in the village of Opal (or Upal), we watched tricycle-carriers laden with produce and shaded by canopies that gave them the look of pedal-powered four-posters. Marco surely came this way, because it was on the main road, and famous for its healthy lifestyle. People had always lived well here. For instance, Mahmud Kashgari, said Ekber, and was shocked by my blank stare. Kashgari! The first dictionary of Turkish! How could I not know Kashgari, the greatest Uighur writer? How could Marco not have heard about him? He had worked here almost two centuries before Marco's arrival until his death at 97. Another long life. Food was good and plentiful, even in harsh areas. Take the desert date-tree, with its special fruit. When harvested in the autumn, the dates can be dried and ground to make pastry. 'It's light, easy to carry,' said Ekber, sipping his tea. 'Four or five bites, a good drink of water, and you are ready for a long journey. It is also good for diarrhoea. If someone gets diarrhoea on a camel, it is difficult.'

I imagine so. The only related experience I had had was riding a camel that itself had diarrhoea, which it dealt with by flicking its tail. The effect was nature's equivalent of shit hitting a fan. I could well understand that vice versa would be worse – for me, that is, not for the camel.

4

APPROACHING THE KHAN

AND SO, AFTER A GAP IN WHICH MARCO FAILS TO MENTION a host of things worth mentioning, he mentions Kashgar, China's last city-sized outpost, or first depending which way you are going. He has nothing much to say about the place, and what he says is either tedious or rude, as you might expect from an 18-year-old untrained in reportage. Beautiful gardens, vineyards, fine estates, cotton fields and Nestorian churches define the top end of the social scale, while at the bottom the local Muslims, the Uighurs, are 'a wretched, niggardly set of people', who 'eat ill and drink more ill'. It sounds as if he, or perhaps his father and uncle, noticed a few things of interest to traders, then hurried on.

In fact Kashgar was worth a detour, and so were its inhabitants. The Uighurs were a sophisticated people with a reputation as scribes and secretaries; they had

voluntarily submitted to Genghis, who had ordered their script to be adapted to write Mongol. Marco's one or two hundred words (depending on the edition) do no justice to a town that was a crossroads for religions, peoples and trade. In the old city of what is today Kashi, the medieval throng of stalls suggests what might have assaulted Marco's senses – the clang of blacksmiths, the smells of cooked meats and newly baked bread, the glitter of worked bronze, wood-workers chipping and smoothing kitchen implements, the tea-makers, the fruit-sellers, the old men chatting on the steps of mosques. But let's not be judgemental. Young Marco had no idea that he would one day be dictating his experiences. Anyway, perhaps his brief report of Kashgar was only hearsay. Or perhaps he recalled nothing of note because things were made easy by local guides and troops pressed into their service by the golden *paizi*, the combined passport and requisition document given them by Kublai eight years before. Perhaps his party even bypassed Kashgar altogether by taking the 160-kilometre short cut along the Tashkurgan river to the Yarkan, which leads to the town of the same name (Yarkand as it used to be, today's Shache); that would have saved them 150 kilometres and four or five days.

Marco had little idea of politics, either. Kashgar, he says, 'is subject to the Great Kaan', his future boss, Kublai. This is a little odd, because the next town on his route, Yarkan, is not subject to Kublai, he records, but to his rebellious first-cousin-once-removed, Kaidu.

Later, Marco learned a good deal about Kaidu, who was a thorn in Kublai's side for 40 years. Kublai claimed the loyalty of all his family, from the Pacific right across to southern Russia. All, of course, acknowledged that they were linked by their relationship to Genghis. But everything was under strain. For some, Kublai was the nominal overlord; to others, he was a traitor for choosing to be so Chinese. In the West, Islam drew Mongol rulers: some resisted, some converted. In the centre was the ambitious and rebellious Kaidu. Kaidu was the grandson of Genghis's heir Ogedei, scion of the line from which Kublai had seized power. Kaidu could thus claim to be the true heir to the empire, Kublai the usurper. This part of Central Asia, though far from China's heartland, was of vital importance because opposition here would block the westward flow of goods from China and India through the Islamic world to Europe. If the rebellion were allowed to fester, Kublai would be cut off from much of the wealth that underpinned his power. But the Western Regions – today's Xinjiang and beyond – were at the very limits of Kublai's reach.

In 1271, three years before Marco's arrival, Kaidu had been crowned khan of a state 2,500 kilometres across. This region, which Marco referred to as 'Great Turkey', ran from the Oxus (Amudarya) river in the west into Xinjiang in the east, from Lake Balkhash in the north down to the Tien Shan – 1.25 million square kilometres in all, the size of France, Germany and Italy combined.

This was no mean achievement. Kaidu had proved himself smart enough to exploit Kublai's weaknesses and his move into the Chinese heartland. Kaidu was a commander in the tradition of Genghis himself, tough, austere – he didn't touch alcohol – tolerant of religions other than his own shamanism, and also careful to preserve his tax base, the great Silk Road cities of Samarkand, Bukhara and the like. He was very nearly a great ruler, introducing his own currency and running an army with a non-tribal command structure that included rival Mongol and Turkish tribes. His cavalry, reinforced by units of infantry and teams expert in the use of siege engines, was terrific at raids: quick advances, hard strikes, quick retreats.

Kaidu did his best to advance, Kublai did his best to hold Kaidu back. Neither made much progress. Kublai had vast resources, but never enough horses to pin his cousin down. Kaidu could roam all Central Asia, but could never threaten Kublai's heartland. For four decades, the two ill-matched contestants engaged in a long-distance fight, Kaidu the lightweight throwing punches from the northern and western frontiers, occasionally attracting the gaze of his heavyweight opponent, who always had other claims on his attention. There was never a hope of Kaidu actually winning, but his successes highlight the fact that Kublai lacked the reach to hold his vast estate together. In between the two was an ever-shifting frontier, so it is no surprise that Marco, at eighteen, on his first entry into China, did not know exactly whose territory he was in.

Marco told the story of the conflict as best he could, leavening history with a good anecdote:

Kaidu had a daughter, another of those formidable women who punctuate Mongolia's history. Marco calls her Aijaruc or Aigiaruc, which he says is 'Tartar' (i.e. Mongol) for Bright Moon. Wrong and almost right. It is Uighur, or rather its medieval Turkish–Uighur antecedent – Ay Yoruk, meaning Moonlight.[1] She was famous for her fighting ability and independent spirit. 'This damsel was very beautiful,' Marco says, 'but also so strong and brave that in all her father's realm there was no man who could outdo her in feats of strength . . . so tall and muscular, so stout and shapely withal, that she was almost like a giantess.' Kaidu doted on his Amazonian daughter and wanted to give her in marriage, but she always refused, saying she would only marry a man who could beat her in a wrestling-match. Her rule was that a challenger had to put up 100 horses. After 100 bouts and 100 wins, Princess Moonlight had 10,000 horses. Now a fairy-tale prince appears, the son of a rich and powerful king, both father and son being suspiciously anonymous. So confident is he that he puts up 1,000 horses. Kaidu, eager for a wealthy son-in-law, begs her to lose the fight on purpose. Never, she says, he'll have to beat me fair and square. Everyone gathers to watch the match. They wrestle this way and that, without either gaining an advantage, until suddenly

[1] My thanks to Jim Millward of Georgetown University for his help on this.

Moonlight throws her opponent. Shamed, the prince heads for home, leaving his 1,000 horses behind. Her father swallows his anger at the loss of a good match and proudly takes her on his campaigns. She proves a great warrior, sometimes dashing into the enemy ranks to seize some man 'as deftly as a hawk pounces on a bird, and carry him to her father'.

Marco's story is rather too good to be totally true; but it contains vestiges of truth. Although the warrior daughter is not named in the official Chinese sources, the Arabic historian Rashid al-Din mentions her by another name, Kutulun, with a rather more jaundiced explanation for her failure to marry. He says the refusal came from her possessive father, and that people suspected an incestuous relationship. At a guess, Marco picked up his gossipy version from a Uighur-speaker at Kublai's court, where it had changed in the telling from fact to folk-tale. Like many folk-tales, it seems to carry elements of truth about the toughness and determination of Mongolian women, and about Kaidu's traditionalist admiration of the old pastoral-nomadic virtues of pride, bravery, strength and independence.

It is not surprising that Marco avoids politics. His father and uncle no doubt wished to move on as fast as possible through territory that might or might not be Kaidu's, uncertain whose officials might ask embarrassing questions about whom exactly they were travelling to meet.

At a guess, this was early 1275. Somehow, somewhere, they survived winter. Now Marco and his party were

out of the mountains, and on the edge of Asia's dead heart: gravel wastes and range upon range of shifting dunes, trembling in the summer heat, or wiped out by dust storms, or brilliant with winter snow. There are some 1,500 kilometres of desert between Kashgar in the west and Dunhuang to the east, 600 between the Tien Shan and Kunlun ranges to north and south. This is the Tarim Basin, which contains country-sized wildernesses that ring in the ears like the sounds of doom: Taklamakan, Lop, Gashun Gobi, Kumtag. Nothing much grows here but camel-thorn and scattered clumps of grass; nothing lives but sand-flies, mosquitoes and a diffuse population of wild camels. And the occasional wolf. And ticks. John Hare, British explorer and wild-camel expert, describes them:

> The size of a five-pence piece, they live in the saltpans and by the salt-springs of the Gobi and respond to vibrations. An unwary intruder walking near a salt-water source can awaken a mighty army of ticks that has lain dormant for months or even over a year. They emerge quickly and move determinedly towards a potential source of blood.[2]

The Tarim Basin is an awesome, awful place. Its westernmost desert, the Taklamakan, is notorious for its uncrossability. Sven Hedin, the Swedish explorer, described it a century ago, his excellent English twisted into literary obscurity by the horror before him:

[2] Hare, *Mysteries of the Gobi*.

I was alone, absolutely alone, in the midst of a death-like silence, with a sea of yellow sand dunes before, rolling away in fainter and fainter billows right away to the horizon. Deeper Sabbath peace never brooded over any graveyard than that which environed me . . . Our position was desperate. The dunes burst up to heights of 140 to 150 feet . . . We were being slowly but surely killed by these terrible ridges of sand. They impeded our advance, yet over them we must . . . a funeral procession marching to the doleful clang of the camels' bells.

My guide, Ekber, once took a party of hardy Germans across some of it, south to north. He described the experience as we approached a village near Shache where visitors can get a quick, sanitized view of the Taklamakan. There were six of them walking beside six camels laden with food and water and camping gear, aiming to cross 160 kilometres from one track to another, where a van waited to pick them up – only 160 kilometres, over five days, but that was enough. 'The day temperature was in the forties, the sand was sixty-three. It burned you through your boots. Once, as an experiment, I tried to walk with bare feet. After five seconds, my foot was burning. Too hot to sit.'

We drove through an arcade of vines to a large, circular, wooden shelter, the Xipayi Desert Tourism Centre, with tables standing in the shade and fridges full of cold water.

'The second day we walked nine hours, the third day

eleven,' he went on. 'That night I see so many stars. Next morning a camel tried to bite and kick. It took two hours to pack, then it was a sand storm. We couldn't see direction, sun was gone. Even with GPS, after eleven hours walking we lose direction. Next day a little bit cloudy, but we could see the sun. The dunes were thirty, forty metres high.'

I saw what he meant. We were climbing one, though this led to a rickety ladder up a viewing platform, which revealed dunes billowing to the horizon. I could see perhaps 15 kilometres, hardly a drop in this vast ocean, but just about enough to bring Ekber's story alive.

'You climb one, you see a hundred, a thousand. I was quite frightened, but did not tell. That afternoon, we saw a salty lake with a hard crust. I was happy because it was water, even if salty. One of the camels broke through the crust, up to its belly. It shout with very bad sound. I took out knife and cut off all baggage, we all pulled, for half an hour with rope round each leg, but camel weigh three hundred kilos. At last it get one leg out, then two, then it jumped. We went on. I put stick through crust, and if I see mud, we avoid.'

By now, we were back down on the sand, trying to take photographs of a landscape with all contours beaten out of it by the midday sun.

'Next day, we walk fourteen hours. I think: We die here. Then I think: Not so easily, because we still have one hundred litres of water. Next day, I see small piece of camel grass, then after two more hours a bush, then two hours more, a poplar, and another ten kilometres

there is the road. We hugged and poured water all over us, and called the driver on the mobile.'

They had it easy: a map, water, a mobile, a rescue vehicle, and hardly any distance. If 160 modern kilometres was that bad, what would 1,000 have been like to cross in Marco's day?

In fact, it did not have to be actually *crossed*, but rather sidestepped. The route, later known as the southern Silk Road, ran south of the desert and north of the Kunlun mountains. Rivers flowed from the mountains into the desert, where they vanished. Each river had its settlements, where locals produced fruit and vegetables and reared animals. The stretches between them, usually about 30–40 kilometres, were seldom barren, and often watered by irrigation channels. It was only the hinterland that was grim. Well-supplied, sensible travellers had no need to tangle with it.

Marco's road was well trodden, always had been, always would be. He mentions modern towns: Yarkan, Khotan, Charchan (or, to give their Chinese names, Shache, Hotan and Qiemo). As Stein noted in 1900, this dreary route was 'undoubtedly the ancient line that led from the Oxus region to China. Walking and riding along the track marked here and there by the parched carcasses and bleached bones of animals that had died on it, I thought of travellers in times gone by who must have marched through this waterless, uninhabited waste,' among them Marco, and 'many a lesser-known medieval traveller to Cathay. Practically nothing has

changed here in respect of the methods and means of travel.'

Not that Marco's route always coincided with today's, for the dunes march southward, gradually overwhelming towns and waterways. One late-nineteenth-century traveller, named by Yule as 'Mr William Johnson of the Indian Survey', found Khotan 'rife with stories of former cities overwhelmed by the Desert'. Stein lists 22 ancient sites that had vanished beneath the sands, almost all north of his route. Marco mentions another, a place he calls Pem (as it is in some manuscripts, Pein in others, probably a scribal error), in which Yule and Stein recognize a town called Pi-Mo（媲摩）visited by the Chinese pilgrim, Xuanzang, in the seventh century. Probing the mud-built ruins (some 25 kilometres north of today's road, midway between Khotan and Keriya), Stein found pottery, glass, china and a piece of copper made during the southern Song dynasty (1125–1279), suggesting that the place had been inhabited at least until Marco's time. Now it and its name have vanished from memory, and the edge of the desert lies well to the south.

At its eastern end the desert becomes, if possible, even grimmer, a wilderness of sand, gravel, bare rock and salt. It was not always like this. Once, up to the fourth century, the Tarim flowed into a lake that sustained a famous trading town, Lou Lan. Then the river silted up and returned to another old channel, the lake dried out, and Lou Lan became a ghost-town, until it was re-discovered by Sven Hedin in 1921. Remarkably, that

very year the Tarim reverted briefly to its old course, prompting dreams of Lou Lan's resurrection; then, 50 years later, China closed the whole area to test its nuclear bombs.

Marco was happy to play up the dangers of the desert, where travellers had only ghosts for company:

There is a marvellous thing related of this desert, which is that when travellers are on the move by night, and one of them chances to lag behind or to fall asleep or the like, when he tries to gain his company again he will hear spirits talking, and will suppose them to be his comrades. Sometimes the spirits will call him by name; and oftimes shall a traveller be led astray so that he never finds his party. And in this way many have perished. Even in the day-time one hears those spirits talking. And sometimes you shall hear the sound of a variety of musical instruments, and still more commonly the sound of drums.

Others also speak of demon voices, burning winds, visions of marching troops and waving banners, of the bleached bones left by the unwary. These are vague folk-references, I think, to the phenomenon of the 'singing sands', the soft, deep hum made by sand when dunes are whipped by wind with just the right intensity.

This peril too is safely bypassed, because 'in some 28 places altogether you will find good water, but in no great quantity'. Marco's actual route through this place of ever-shifting, unmappable dunes, sand-blasted ruins

and occasional springs has been much disputed. Sharpening the controversy has been his mention of the city of Lop, widely identified with Lou Lan – except that he could not have gone there, because Lou Lan had been abandoned a millennium before. Possibly he passed through or near another abandoned town, Miran, where stupas – domed Buddhist temples – shielded delicate murals and sculptures (many were removed by Stein in 1907 and 1914).

At last, after a final ten-day stretch of 400 kilometres, across gullies gouged out by sudden storms and melt-water, and soft sand driven by wind across brief tracks, and hard sand made bumpy by tussocks that look like half-buried hedgehogs, a long-deserted wall loomed up, built of the only materials to hand – earth and the straw of local grass. A few hundred metres beyond, past an abandoned beacon-tower, rose the fort of Yumenguan – the Jade Gate Pass. Marco's party had reached the far western end of the Great Wall.

This section of the wall had sprung into existence almost 1,400 years before, when Emperor Wu of the Han had thrust westward. Once, it had been magnificent: a line of earth-brick ramparts and watch-towers, plastered and whitewashed, shining in the desert sun, guarded by well-armed garrisons. On either side of the Wall at irregular intervals were beacon-towers, acting as observation posts, rearguards or command posts. The fortress itself had been at the centre of a small town busy with soldiery, merchants, camel trains, officials, food stalls and shops.

But when Marco arrived in 1275 the Wall and fortress had been abandoned for half a century. The barbarians it was supposed to keep out had taken the whole of north China, plus. The Mongol name for it was the White Wall – it still is – but the whitewash had been blasted away by sandstorms. The reed-and-earth defence-work was tattered, its earth layers gouged away by wind, leaving the straw standing out as if the Wall were in need of a hair-cut, which is what it looks like today, only more so. Marco has been berated for not mentioning the Wall, which would be with him for the next 2,000 kilometres, but the truth is there was not much worth mentioning.

Next stop, 40 kilometres of flat, shimmering desert beyond Yumenguan, was Dunhuang, a prosperous, walled place where a river turned sand into wheat fields and apricot orchards. He missed the Mogao caves, the 1,000 cliff temples dug out and decorated by Buddhist priests between 400 and 1100. He had little time for Buddhists, dismissing them as mere 'idolaters', so perhaps he simply ignored or forgot the caves. No, that's not possible: no one who actually saw the 2-kilometre cliff-face, let alone the intricate murals, the hundreds of sandstone statues, the 30-metre rock-carved Buddhas, could either ignore or forget them.

Besides, he was developing a talent for objective observation, which was really where his heart lay, more than in travellers' tales and wild stories. He noted that the inhabitants of Dunhuang[3] were mainly Tanguts.

[3] He called it Sachiu, from the Chinese Shā Zhōu / 沙州 , Sand District.

They had been citizens of Xi (Western) Xia, a kingdom that had been in existence for 200 years when Genghis destroyed it in 1227, which – as Marco says – made them Kublai's subjects. And he did describe in detail some Buddhist practices – sheep sacrifices to ensure the health of children, and cremations, with auspicious days dictated by astrologers, and the burning of food, wine and little paper cut-outs of people and animals that accompany the dead in the afterlife.

There is the same objectivity in his report on the fire-resistant mineral asbestos, which was well known in China but the subject of much wild talk in Europe, along with fables of unicorns, weirdly shaped humans and the splendours of the mythical Christian king Prester John. The area he specifies cannot be identified,[4] but his source was a good one, a Turk called Zurficar (or Çulficar) who supervised the production of asbestos for Kublai. Europeans commonly claimed that asbestos was the wool of a fire-dwelling salamander, which gave its name to the material. Marco dismisses this nonsense. Asbestos was natural, he says, and came from a certain mountain. 'The way they got them [salamanders, as he calls asbestos cloths, lacking any other name] was by digging that mountain till they found a certain vein. The substance of this vein was then taken and crushed, and when so treated it divides as it were into fibres of wool, which they set forth to dry.' The fibres were then

[4] Chingintalas or Ghinghin Talas. The word has inspired much academic dispute, with no resolution.

pounded, washed ('so that the thread . . . stays on top of the water and all the earth which is worthless falls off'), dried and spun into cloth, which was fired to make it white. He had seen it himself. 'And this is the truth of the making of the salamander . . . and all the other things that are said of it, that it is an animal, are lies and fables.'

On then eastward along the line of the decaying Great Wall, to Zhangye,[5] which guards the middle of a narrow funnel of grassland known as the Hexi – 'west of the [Yellow] River' – corridor. As he notes, Zhangye had many statues of Buddha, the largest of which 'are lying down'. At least one of them still is. The Great Buddha Temple is famous for its 34-metre reclining statue. When I wandered into the temple in 2005, it was covered in scaffolding as part of a restoration pro- gramme. I missed the statue for several minutes because it was so enormous and shadowy that I mistook it for a wall, until an enormous beatific smile loomed side-on out of the darkness. This statue dates from the eleventh century, so is perhaps the very one that Marco saw. If so, it would have been in rather better condition, being, like the other giant statues that have since vanished, 'all highly polished and covered in gold'.

There is much, if highly selective, truth in what Marco

[5] Marco's name for it is (variously) Campichu, Campçio and Kampion. Its old name is Ganzhou. Marco says that they spent a year here on business not worth mentioning; but this was later, when all three were working for Kublai. Right now, they were in a hurry.

writes. There is also some deception, because here again he slips in accounts of a few places he did not visit – like Hami, 250 kilometres north-west of Dunhuang; and the Mongol capital of Karakorum, which would have meant a totally impossible diversion of 1,500 kilometres and several weeks across the Gobi.

But the non-diversion has a literary purpose: it is an excuse to introduce the Mongols. It was perhaps an apt moment for Marco personally, because it was somewhere along here that he himself had his first introduction to the emperor's people. He and his party had been in Kublai's realm for over 1,000 kilometres, around a month, during which they would have produced their *paizi* and been provided with horses and escorts. Guard-posts, warned of the Polos' approach, would have noted the progress of these 'Latins', not only the first ever to have come this way from Europe, but also speaking Mongol. Communications were excellent between Kublai's HQ and this unstable borderland, where Kaidu's rebel forces might appear at any moment. Horsemen would have been dispatched with message after message as the Latins made their slow way eastward.

This would have been Marco's first experience of the Mongol pony express in action, a system that impressed him deeply when he learned the details in Beijing. Postroads linked 'Cambaluc' – Khan Balkh, the Khan's City – to every province. Along the way, messengers found at every 40–50 kilometres, or up to 70 in remote areas, 'a station, which they call a *Yamb*'. In modern Mongol the

word is *dzam*, which just means 'road'. At its height in the early fourteenth century, the system had some 1,400 stations across China, each one boasting a 'large and handsome building', with well-furnished bedrooms, and between 200 and 400 horses, making, as Marco rightly says, 'more than 300,000 horses kept up, specially for the use of messengers'. The way-stations and horses were for people: officials with information that had to be delivered in person, officers, ambassadors, merchants on government business. Urgent messages could be carried by riders galloping from station to station, wearing belts hung with bells to warn of their approach, picking up a fresh horse at each one or passing their message on, sometimes in emergencies riding at night accompanied by runners with torches. 'And these men [though perhaps he is confusing the men with the messages] travel a good 200–250 miles in a day', which is astonishing but possible, given an average speed of 16 kph or so. It meant that Kublai could, in theory, send a letter from Xanadu to his cousins in Iraq or southern Russia in about three weeks, a speed unrivalled until the coming of the railway. Moreover, in China the pony express was backed by a system of runners, based at 3-mile intervals, who delivered messages back and forth, with clerks checking runners in and out. Stations at rivers and lakes had boats at the ready. As Marco says, 'The thing is on a scale so wonderful and costly that it is hard to bring oneself to describe it.' If the Polos had followed their original route across the grasslands, they would have had the benefit of the *dzam* network

almost from the edge of Europe. Instead, to avoid trouble, they had come the southern, mountainous route. Only inside China did the Polos, with their *paizi*, have the *dzam* at their disposal.

From Kashgar to Beijing or Xanadu is about 3,500 kilometres, two weeks' travel for a message carried by relays of pony express riders. Soon a royal escort was on its way, as Marco says: 'When the Great Kaan heard that Messrs Nicolo and Maffeo Polo were on their way back, he sent people a journey of full 40 days to meet them; and on this journey, as on their former one, they were honourably entertained upon the road, and supplied with all that they required.' Nothing could have better shown Kublai's excitement at their approach. They were, after all, ambassadors from the pope. If they had been kings he could not have treated them better. Forty days from Xanadu would bring the escort and the Polos together somewhere around Dunhuang, halfway across Kublai's realm (and modern China).

So, with his safety and comfort assured by the Mongols, Marco had reason enough to recall their ways, which is why (perhaps) he now provides a quick survey of their food, patterns of warfare, marriage customs and punishments. He starts with a distorted account of the rise of Genghis Khan, grandfather of his hero Kublai, who therefore emerges in Marco's revisionist opinion as a much misunderstood ruler:

When he conquered a province he did no harm to the people or their property, but merely established some of

his own men in the country . . . and when those whom
he had conquered became aware of how well and safely
he protected them against all others, and how they
suffered no ill at his hands, and saw what a noble prince
he was, then they joined him heart and soul and became
his devoted followers.

Genghis was undoubtedly a leader of genius, but he
was not noted for the generous treatment of enemies.
Marco's opinion would not have been shared by the
Mongol and Turkic groups from whom Genghis forged
his new nation in wars of genocidal ruthlessness: the
Merkits, exterminated for abducting his wife Börte;
the Tatars, traditional enemies who had murdered his
father; the Naimans, the Keraits, the Taychiuts – all
destroyed. Nor would later victims have recognized a
soft side to the conqueror: the north Chinese, the
Tanguts and the Muslims all lost millions in the course
of Genghis's drive for empire. Marco's view is rooted in
his personal experience. There is nothing of the fabulist
or populist here; just the opposite. He asserts what he
sees as the truth in the face of the almost universal
popular opinion that condemned Genghis as a mass
murderer.

The account of the Mongols' rise ends with an
entirely fictitious version of Genghis's death, which
came six years after victory over his greatest local foe.
Marco says he died during the siege of 'Caaju', after an
arrow hit him in the knee. He was then taken to the
Altai mountains for burial, while along the way

the convoy . . . doth put to the sword all whom they fall in with on the road, saying 'Go and wait upon your Lord in the other world!' . . . And I tell you as a certain truth that when Mongou Kaan [Mönkhe, Genghis's grandson, Kublai's brother and predecessor] died, more than 20,000 persons, who chanced to meet the body on its way, were slain in the manner I have told.

This is the sort of reportage that gives Marco a bad name. Genghis lived for 20 years, not six, after his victory in Mongolia. 'Caaju' is a mystery, but in any event had nothing to do with Genghis. There is no other account of a knee-wound. After he died in China in 1227, he was taken not to the Altai but to the Khentii mountains in northern Mongolia. The tale of passers-by being killed can be dismissed. Perhaps it recalls a folk-memory of the secrecy that surrounded Genghis's death. One other source, Rashid al-Din, mentions this brutal policy. But both men were writing well after the event. Marco arrived in China some 50 years after Genghis's death, and Rashid, who never went to China, was writing 30 years later still. Where Marco got his untrue 'certain truth' is anyone's guess: in any event, more from rumour than reliable sources.

But there is much he gets right, or almost right. Take, for example, his account of Mongol religious beliefs, which contains many details he could only have got from personal experience. The highest Mongol deity was the sky-god, Tengri, usually referred to as Blue or Eternal or Eternal Blue Heaven. He was their equivalent

of Allah and the Christian God, which was how Persian and Christian writers referred to Tengri in their own languages. It was 'through the power of Eternal Heaven' that Genghis and his heirs received their authority, as numerous references in the Mongols' foundation epic, *The Secret History*, make clear. Underneath Tengri was the Etügen Ekh, the Earth Mother. The two were often quoted together: as *The Secret History* also says, Genghis was raised by the power of Heaven and Earth.[6] Essentially, Heaven and Earth form a duality. Marco mentions the Mongols' 'high and heavenly god', referring to Tengri by implication though not by name, and adds that 'they have one of their gods whom they call Natigay, and they say that is a terrestrial god . . . Who protects their sons and their cattle and their corn. And they do him great reverence.' Natigay is Marco's attempt at Etügen. Though he suggests wrongly that the Earth Mother was male, his approximation of the name is evidence that he had direct experience of the culture.

And so on to present-day Wuwei,[7] once the HQ of the commander responsible for guarding the Hexi corridor.

[6] In Mongolia's shamanistic tradition, the two subdivide into different attributes or spirits or local manifestations, making 99 Tengri and 77 Etügen. In addition, there were ancestral spirits, represented by small figurines (*onggud*), to which Marco also refers.

[7] Marco's Erguiul, from the Mongolian Erijegu, which derived from the Tangut. This is another of those obscure details that only an eyewitness could have picked up.

Now we are in Gansu, two-thirds of the way across China, and getting into more populated areas. Marco decides to introduce us to some wildlife, such as would be of interest to traders and travellers.

First, a species of shaggy cattle 'as large as elephants'. Well, not quite. These are of course yaks, though he has no name for them because they were unknown in Europe before the eighteenth century.[8] 'They are very good and beautiful to see, for they are all hairy except the back, and they are white and black ... They are so beautiful it is a wonder to see' – so much so that Marco collected some of their hair later to take home.

Next, the musk deer, from which comes the musk that the makers of perfume so desire. The scent is both more penetrating and more persistent than that of any other known substance. Once dried, the extract from a single pod – dark purple, dry and oily – would scent a cathedral. The musk deer, which is the size of a large dog, is, as Marco says, 'a very pretty creature'. He knew. Later, when talking about Tibet, Marco gives an approximation of its Mongol name: *gudderi* – *khüder* in modern Mongol, not an easy word to find unless, like Marco, you acquired your information at first hand. He provides further eyewitness details: when hunters kill a male, they 'find at the navel in the middle under the belly between the skin and the flesh a pustule of blood', which they cut out. Not a bad description of a musk pod.

Heading east from Wuwei, Marco's party followed

[8] Haw, *Marco Polo's China*, pp. 134–5.

the remnants of the Wall, pretty much where the road and railway go today, met up with the Yellow River and followed it round the end of the Helan mountains, to the city now called Yinchuan. In Marco's day it was the former Tangut capital of Western Xia, the kingdom destroyed by Genghis in 1227. Marco was not there long enough to note the shattered royal tombs dotted along the huge, gentle outwash plain that links mountains and river (they are still there today, and are now a major tourist attraction); long enough to pick up a couple of names, but not long enough to use them correctly, or perhaps lodge them in his memory. He took the Mongol name for the town (Egrigaia in his text; Eriqaya in Mongol) and applied it to the region; and the Chinese name for the local mountain range (Calachan/Helan Shan), and applied it to the town. These are, in a sense, positive errors, the sort of thing that makes scholars happy: matching old Mongol, old Chinese and geography to make sense of what Marco says, ending up in complete certainty that the Tangut city was on his route.

He doesn't say where he went next. One possibility was to follow the great bend of the Yellow River as it swings north, east, then south again. That's where one road went, through rich, well-watered lands, with the kilometre-wide river to its right. But this was the long way round, with many river crossings. On the other side of the murky river, swirling with silt from the Tibetan highlands, lay the Ordos semi-desert. Pastoral nomads could live in some of it, and Chinese and Mongols fought over it for strategic reasons, but it was hard to

cross. Today, there is a road, and I have driven it, but the way does not look promising for travellers: poor pastures, bare soils and eroded ravines. To the south of the desert, however, there is another road, where a new motorway now runs between Yinchuan and Yulin. Once over the river – a crossing accomplished in Marco's day by a regular ferry service, today on a fine bridge – the way follows the Great Wall along the desert's edge. It does now, and it did then. Small towns with wells and fields dot the line of travel in a sort of reverse image of the Great Bend, dipping south-east then swerving north-east to recross the river and head on towards Datong. This, I think, was Marco's route. The great French orientalist Paul Pelliot came to the same conclusion when he was writing a series of amazingly arcane monographs, published long after his death in 1945 as *Notes on Marco Polo*. Under the heading 'Tenduc, a city or province on the Great Bend', he writes: 'A land postal road [along the southern route] had long been in existence . . . it seems to me most probable that the three Polos, who were then expected by Qubilai [Kublai], crossed the great bend overland.'

Across the Yellow River, Marco was approaching the north Chinese heartland – Cathay, as Europeans called it.[9] There were 'plenty of towns and villages', deep

[9] Cathay derives from Khitai and the Khitans, people from Manchuria who ruled north China under the dynastic name of Liao (907–1125), before they were expelled by the Jürchens and their Jin dynasty (1125–1234). The name still survives in the Mongolian word for China, Khiatad.

earth, fields of wheat and vegetables, green hills and scattered trees. A week later, in early summer 1275, he was in the military base of Datong, famous since the fifth century for its Buddhist cave-carvings – not that Marco had time to admire them, or even mention the town. Another week of fields and villages, and he reached Xuanhua.[10] He was getting close to his goal now, for the inhabitants were expert in 'a great many crafts such as provide for the Emperor's troops'. This would have been a good business, because Xuanhua was and is on the main road between Beijing and the old border town that used to be known as Kalgan and is now Zhangjiakou. It was the route Kublai had just started to take twice a year on his regular seasonal commute between his two capitals – the heart of modern Beijing and his summer HQ, his 'Upper Capital', Shangdu, or Xanadu.

Their goal was almost in sight.

[10] Then Xuandezhou, Marco's Sindachu.

5

ARRIVAL IN XANADU

XUANHUA WAS IN A LEVEL BASIN BETWEEN MOUNTAINS AND nicely positioned halfway between Kublai's two capitals, Dadu and Shangdu, or Beijing and Xanadu. It was also the military HQ where the Polos' escort could have been changed. At this point the party could have gone in either direction, north-east to Xanadu (250 kilometres) or south-east to Beijing (100 kilometres). It depended on where the emperor was, and that depended on the season. With his new Great Capital, Dadu, still being built on today's Beihai (North Lake) park, Kublai had just begun to spend his winters there. From that very year, summers were to be spent on the cool grasslands of Xanadu. The Polos' arrival must have been in early or high summer, because, as Marco says, they turned towards Xanadu,[1] following the imperial route from palace to palace along the way.

He does not tell us what he saw when he arrived a few days later, but archaeology and poetry do. Imagine a body of horsemen trotting over new-sprung grassland, under huge skies. Out in front is a senior officer, wearing an armoured coat of overlapping leather scales – a formality, given the accompanying guards, all with swords and pikes and bows. In the centre of the bunch are the three Polos, father and uncle thrilled to be returning and Marco, now aged 20, awed by the novelty of the sight. Perhaps the leader turns and says in Mongol: 'Shangdu! That's what *they* call it. To us it's Dzu Naiman Sum, One Hundred and Eight Temples.' On the right is a hill, with an *obo* – a shrine of stones tossed into a pile – on top. Pale in the distance, the horizon is a wave of gently sloping hills, some of them sharpened with more *obos*. Directly ahead, on the open plain, stands a town: a straight wall, 8 metres high, high enough to block everything beyond except for a mass of roofs, bright with blue, green and red tiles, one roof standing proud above the others. The view moved one poet, Yuan Jue, who was in Xanadu when Marco was there, to write:

Footnote from page 103

[1] He refers to it first as Chemeinfu. The spellings vary in other editions: they include Clemeinfu, Kemenfu and -su instead of -fu at the end. These are all versions of Kaipingfu, a *fu* being a county-sized administrative unit. The p>m shift occurred in Persian, which suggests that Marco was more familiar with Persian than Chinese.

These gate towers of Heaven reach into the great void,
Yet city walls are low enough to welcome distant
hills.[2]

There are bastions, corner towers, a main gate. Across the grassland run many tracks, crowded with carts hauled by bullocks, camels and yaks, arriving full or departing empty, for it takes some 500 carts a day to supply Xanadu's 120,000 inhabitants. There may even be a glimpse, on the distant plain, of a patch of white: not sheep, as you might at first suppose, but the emperor's own white horses, by the thousand. The tracks converge to form the Royal Road, which cuts through a morass of felt tents, horses, camels, food stalls and traders hawking their wares, all flowing around an archipelago of earth-walled inns. Random lines from contemporary verses capture the sights and sounds. Tents cloud the grass, and thronging cart-wheels are as dense as stormy raindrops. Ten thousand cooking stoves raise blue smoke. Exotic goods flash in the sun. Some stall-holders chat knee to knee over peony tea, others the worse for local *airag* – a free cup for new arrivals! – yell abuse in their thick local dialects.[3]

Beyond is the main entry, offset to the right of the wall's centre: an arch as high as the wall, fringed by

[2] This and subsequent verses are from *Miscellaneous Songs on the Upper Capital*, with thanks to the translator, Richard John Lynn.
[3] These details are from Wei Jian, with thanks to Siqin Brown for the translation.

bulwarks and topped by a guardhouse with banners waving in the breeze. A huge wooden door stands open. The Polos' guards hold back supply carts and barge through street traders offering textiles, food and drink. The party clatters across a moat, then on over paving stones through the entry. A road leads straight through a line of mud-brick houses for 600 metres to a second wall, a second gate. Beyond that lies the Imperial City, where the emperor, his family and his retainers live in wooden houses with brightly coloured roofs, the eaves ending in circular tiles in the form of dragons, birds and animal heads. And there, stretched out on a 120-metre brick-faced platform, is the ornate two-storey building with the roof they had seen from afar: Kublai's palace.

In the empire that Kublai was building, Xanadu was the keystone.

Kublai, who commanded all China and exerted influence over much of Eurasia, was the wealthiest and most powerful man in the thirteenth-century world – perhaps the most powerful ever until the emergence of modern superpowers; but he did not rest easily. His mother, the astute and ambitious Sorkaktani, had won the succession for his brother, and power had been secured by the execution of hundreds of opponents. Kublai himself had outwitted a rival to gain the throne, the first of several: there would always be rivals, because his power base was China, Genghis's old enemy. Conservatives back on the grasslands of

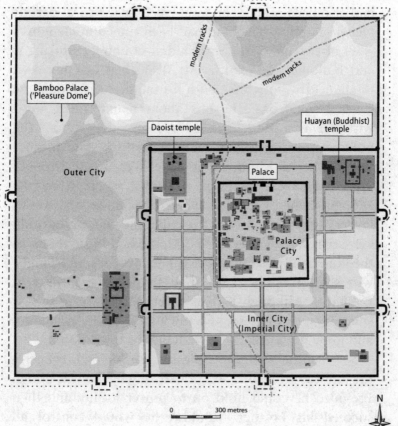

Town Plan of Xanadu

Bamboo Palace ('Pleasure Dome')

Daoist temple

Huayan (Buddhist) temple

Outer City

modern tracks

modern tracks

Palace

Palace City

Inner City (Imperial City)

0 300 metres

N

Mongolia would never be reconciled to the idea that China should be governed rather than pillaged.

But China had been part of Kublai from childhood. His mother had inherited power over much of Mongolia from her husband, Genghis's son Tolui. She had also been granted an estate in China, a rural part of Hebei province. The land had been ruined in Genghis's wars of conquest, but Sorkaktani set about restoring it and building her wealth. At 21, Kublai had his own estate nearby, in which, with his mother as a model, he learned some basic lessons about management. Also with her as a model, he learned something about the political advantages of multiculturalism. His mother was neither a Mongol nor a believer in the Mongol Eternal Heaven. She was a Kerait, taken in by the Mongols when Genghis defeated her uncle, the Kerait leader; and, like many of her tribe, she was a Nestorian Christian. Yet she tolerated both the Buddhism that was the dominant religion in her Chinese estate and Islam (it was she, remember, who had funded a *madrassa* in Bukhara). Although Kublai never learned more than a smattering of Chinese, he had Chinese tutors as a child, and grew up seeing the advantages of toleration.

So when he was preparing himself for high office in the late 1250s, he was well aware of what he was doing. Provided he could hold on to power locally and then succeed his brother Mönkhe, he would control all Mongolia and most of north China; and then, in obedience to the will of Eternal Heaven, he would go on to conquer south China. Of course, his long-term vision

was also to bring the rest of the world under his umbrella, but first things first. Mongolia and north China had never been united. They were two different worlds – grassland and farmland, steppe and city, empty and crowded, nature-worshippers and Buddhist– Daoist ancestor-worshippers. Kublai had a foot in both camps, and he needed to keep the loyalty of both: the Mongol élite who provided his traditional backing and his cavalry on one hand; on the other, the Chinese élite who provided his bureaucracy, his record-keepers, his tax-gatherers, his infantry. He could not keep the Chinese on side from a mobile HQ of tents and wagons; he could not retain the trust of Mongols from a Chinese city. He needed a new sort of capital, something that was both Chinese and Mongol.

His brother, the ruling Great Khan Mönkhe, understood the problem and told him to go ahead. Chinese advisers set out to choose a suitable site. Kublai knew the general area where his base had to be, because there was not a huge range of choices if he was to assert the two cultures equally. It would have to be within reach of Beijing, north China's capital. It would also have to be on grasslands, in traditional Mongol territory.

The grasslands of Inner Mongolia are surprisingly close to Beijing on the map, a mere 260 kilometres, but are in a separate world, even today. You head north-west, away from the city's dense traffic, along the expressway that carries two million tourists a year to the Great Wall. Today's stone Wall was not there in Kublai's day, of course, but the tree-covered ridges and

plunging ravines over which it undulates have not changed. The ancient route through them was once a track along a pass, the Juyong, so narrow that the southbound motorway has to take a separate route. You climb, then drop again for an easy 100 kilometres to Zhangjiakou, which once marked the frontier between lowland China and the plateau lands of Mongolia. Mongols (and foreign explorers) called it Kalgan, from the Mongolian for 'gateway'. This is the easy way to Xanadu – the long way round – the way that was taken by Kublai and his imperial wagon-train; but it was not the most direct way, as we shall see later.

An English doctor attached to the British legation in Beijing, Stephen Bushell, took the long way – the imperial way – in 1872, and left an account of the transition between China and Mongolia that had been true since Marco's time. Facing south from the precipitous edge of the Mongolian plateau, then as now, you see an expanse of low, flat-topped hills, while beyond, in the far distance, run sharp and rugged peaks of granite. Then, towards the north,

> the eye ranges over a prairie with long wavy un-dulations, the first of the grass covered Mongolian steppes. On the fixed natural line of demarcation between settled, agricultural people and nomadic pastoral tribes, we were passing ... from the fertile, well-wooded valleys of Northern Chihli [today's Hebei], rich in corn and fruit, to a 'land of grass', the

support of innumerable flocks and herds, where no tree is visible in a week's journey, and 'argol', the dung of cattle, is the only fuel.

It has all changed now. Bushell saw the start of it:

There are some settlements of immigrant Chinese on the border of the plateau, as well as about the stations of the north-east trade routes, but they earn with difficulty a miserable subsistence by the cultivation of oats, rape and potatoes, which have barely time to come to maturity during the short-lived summer. There is small prospect of encroachment in this quarter. Further east, where the country is hilly and the valleys fertile . . . the Chinese agricultural settlers are numbered by the million, and the aborigines [i.e. the Mongolians] are either being pushed to the north, or compelled themselves to become agriculturalists . . . [In nearby areas] not a single Mongol remains, where two centuries ago the land belonged to them exclusively.

'Small prospect of encroachment' indeed! He should see what has happened since his day, even in the marginal areas on the way to Xanadu. China's northward thrust has reduced Mongol influence to a shadow. The only sense of the historic division lies in the landscape, the long zig-zag haul up on to the farmlands and villages of what was once the Mongolian plateau. You swing eastward, past a huge statue of a hand holding a Mongolian horse-head fiddle. At Zhenglan Qi, a

dispiriting collection of Communist-era buildings with one towering, belching factory chimney, a new railway line brings in yet more Chinese settlers to plough and build in this once-Mongol frontier land.

Just beyond, there are open spaces that would still delight Kublai's soul. Here was Genghis's camp site on his way south to Beijing in 1214 and on his way back from its conquest. That's one reason why Kublai's advisers focused their attention on this spot (there is another, which will emerge in a later chapter). Anyway, it was a rich area back then. 'The mountains are covered with fine trees,' reported a Chinese traveller, Wang Yun. 'Fish and salt and the hundred kinds of valuable natural products abound; and the flocks and herds flourish and multiply, so that the inhabitants have at hand an abundant provision of food.'

Kublai appointed his senior minister, Liu Bingzhong, to mark out a site. Liu was well qualified: a Confucian scholar who had also studied Buddhism, Daoism, philosophy, astronomy and mathematics, he was Kublai's adviser for 30 years. He and his Golden Lotus Advisory Group, following the prescribed rituals of geomancy, identified a place of rolling steppes and distant hills. It was originally called Lung Gang (Dragon Ridge), so Liu and his team first had to cast a spell to evict the dragon and raise a magical iron pennant to prevent its return. There was also a lake in the middle of the plain, which had to be drained and filled in before work could start. Rashid al-Din, Persian vizier to the Mongols and world historian, described how it was done:

Now there is a kind of stone in that country which is used instead of firewood [presumably coal, which Marco also mentions], so they collected a great quantity of that stone and likewise of wood, and filled up the lake and its springs with a mass of bricks and lime well shaken up together, running over the whole a quantity of melted tin and lead.

There was nothing much around to build with – hardly a tree, no stone quarries. Xanadu's main palace, the temples, the government buildings, the sub-palaces and officials' houses all had to be started from scratch, with teams of pack animals and wagon-trains and river boats carting timber and stone from hundreds of kilometres away.

Kublai was wary of calling his new place a capital, perhaps preferring to give the impression this was just a summer camp in order not to challenge the true imperial capital, Karakorum. It was, in fact, designed to recall both Mongol traditions and Chinese precedents. Liu planned eight major monasteries, four at the corners, one midway on each side; and according to one source, the court poet Zhou Boqi, the palace not only had the same design as that of the defeated Northern Song in Kaifeng, 750 kilometres to the south, but used the very same bricks and tiles. For the three years it took to build, and for four years thereafter, the city was known as Kaiping, being renamed Upper Capital (Shangdu) only in 1263. Not long after, when Kublai's attention turned to the rebuilding of Beijing, Xanadu

became less of a capital, more of a place for summer-time administration and relaxation: less of a Paris, more a seasonal Versailles.

The city had a simple structure: three sections, all squares, nested inside each other in the style of other Chinese imperial cities. The outer wall made the biggest square, running for just over 2 kilometres a side, 9 kilometres in all. Marco says it was '16 miles', but he probably means 16 *li*, a *li* being about one-third of a mile or half a kilometre, which is about right. The earth-walled outer sector was in the shape of an upside-down L, in the northern part of which was a park of gently undulating grasslands, where Kublai could play at hunting. In the south-east corner of the big square was a smaller one, the Imperial City, with solid walls some 12 metres thick at the base, 5.6 kilometres in circum-ference, containing brick or wooden-walled houses for workmen, craftsmen and officials, and several temples, all laid out in a grid of streets. And inside this a moat contained a third square, the Inner or Forbidden or Palace City (the names vary), with nearly vertical brick walls just over 2 kilometres around, containing scores of royal residences, offices, shops, grain-stores and barracks, with Chinese-style curled-up eaves and glazed tiles – including the pavilions of Crystal, Auspiciousness, Wisdom, Clarity, Fragrance and Controlling Heaven – all overshadowed by the royal palace itself, the Pavilion of Great Peace. Once completed, twelve years before Marco's arrival, the three walled boxes, together with a halo of tents and herds around the outside, made a

working city for its 120,000 people, most of whom were resident year-round.

> While clouds cover the Main Street sun,
> Winds blow clear the North Gate sky.
> A thousand gutters turn white snow to ice.

Crowding the outer gates were tent-cities for traders and visitors. The West Gate had markets for horses, sheep, cows, even slaves; the East Gate grand tent-pavilions where VIPs could take temporary lodgings. Hidden away among the tents and inns, unseen or unnoticed by Marco, were dug-outs, where the poorest of the poor, those who scratched a living from small plots of vegetables, lived in pits roofed with planks and covered with dried grass.

After the Mongol dynasty fell in 1368, Xanadu was trashed by the troops of the incoming Ming dynasty, and then abandoned. For 600 years it decayed, its great palace, courtyards, buildings and walls eroding away until they were mere mounds, hardly visible in the rolling grasslands. Xanadu became the stuff of folklore and legend, with no one to bring it back to life until the advent of foreign travellers and archaeologists.

Bushell was the first, when he visited the ruins in 1872, and found them

> overgrown with rank weeds and grass, the abode
> of foxes and owls, which prey on the numerous

prairie-rats [field-mice] and partridges . . . The walls of
the city, built of earth, faced with unhewn stone and
brick, are still standing, but are more or less dilapidated
. . . The south gate of the inner city is still intact, a
perfect arch of 20 feet high, 12 feet wide . . . the ground
in the interior of both inclosures is strewn with blocks
of marble and other remains of large temples and
palaces . . . while broken lions, dragons, and the
remains of other carved monuments, lie about in every
direction, half-hidden by the thick and tangled under-
growth. Scarcely one stone remains above another, and
a more complete state of ruin and desolation could
hardly be imagined, but at the same time everything
testifies to the former existence of a populous and
flourishing city.

The weather, wary locals and the decay cast Bushell
into a bad mood. 'All around is dreariness and
desolation,' he wrote. 'Even the natives were rude and
inhospitable – the rarest case among the Mongols.'

The next to survey the place was an American writer,
Lawrence Impey, an expat living in Tianjin (south-east
of Beijing), who took a keen interest in Chinese military
affairs. He was there for a week in 1925 and wrote up
his research in a formal, technical article that is still a
prime source.[4] He recorded the city's wall-within-a-

[4] Impey, 'Shangtu'. I tried to find out more about Impey. He wrote a
locally published pamphlet entitled 'The Chinese Army as a Military
Force' (Tientsin, 1926). I asked Peter Lewis at the American
Geographical Society, publisher of the *Geographical Review*, in which

wall-within-a-wall structure, the seven outer gates, an eighth giving access to the Imperial City, the earth walls, the stone walls, the corner towers, the 40-metre moat, the 25 bastions of the Imperial City and many outlying structures, including a cemetery, which he knew must exist, 'for it was manifestly impossible for them [the inhabitants' bodies] all to have been transported to Peking or their ancestral tombs'.

> The problem was eventually solved by an elusive antelope, in pursuit of which the writer penetrated to a considerable distance the range of hills to the south of the river. Here in a secluded valley he stumbled on a group of ruins that could be nothing else than graves, for there was neither water supply nor encircling walls to denote the existence of a town. Here doubtless sleep some of the worthy citizens and magistrates of Shangtu whom Marco Polo knew and admired.

He noted holes in the palace platform, 'circular openings which were tenanted by rock-pigeons', and could not think what they were for. He was equally baffled by the three caves at the base of the platform. Were they evidence of dungeons or cellars? Had they been lived in, perhaps? It was impossible to say. Excavation might have helped, but 'unfortunately the superstitions of the Mongols would not allow him [the author] to excavate in the vicinity'.

his article appeared. Rather oddly, the *Review* holds no information on him. 'Maybe,' said Lewis, 'considering his speciality, he wanted to keep a low profile.' Was he a spy? If you know, do get in touch.

Twelve years later, a Japanese team arrived. These were interesting times, which are worth a little diversion. Five years before, Japan had occupied Manchuria and made it nominally independent as Manchukuo. In 1933 they grabbed the neighbouring province of Jehol,[5] the border of which ran along Xanadu's river. The approach to Kublai's summer HQ actually straddled the frontier. China was already seething at Japanese aggression, and it was getting worse. In May 1937 the two had clashed at Beijing's Marco Polo Bridge, and Japanese forces were in the midst of seizing Beijing. So Japan, with its eyes set on expansion into Mongolia and Siberia, had good reason to turn its gaze on Xanadu. Kublai had founded the Yuan dynasty; the Yuan had been Mongol; Mongols had always mourned the loss of their empire. If Japan could hijack the cults honouring the imperial founders, Genghis and Kublai, then the Mongols could be brought on side and expansion into their territory would become a whole lot easier. Plans were already in hand to seize the supposed relics of Genghis Khan being kept as objects of worship in the Ordos (as it happened, the Chinese moved first, and whisked them away to safety). It was surely with a similar, though hidden, agenda that a team of nine scholars, under the leadership of Yoshito Harada of Tokyo Imperial University, arrived in Xanadu in July 1937.

Harada planned some proper archaeology, until he

[5] Rehe in pinyin. This former province was divided between Hebei, Liaoning and Inner Mongolia under Mao.

became aware of Mongol sensitivities about inter-ference in this sacred place. He should have realized what he was facing, because on top of the palace mound was a shamanistic *obo* and a little Buddhist shrine. Reminders were close: he and his team were camping in Mongolian *gers* with eleven Mongol guards. 'The reason why we did not excavate these sites, as we so much desired, was because the Mongolians strongly opposed the digging up of the ground, and even the least attempt on our part to do this caused danger of irritating and agitating them.' Impey could not dig for the same reason. Now politics came into the equation. Harada could not risk alienating the Mongols and driving them into the arms of the local Chinese. He and his eight scholars would never have got out alive.

So he contented himself with a week-long survey, recording in detail the mounds and dips and foundations and bits of tile and pottery that defined vanished walls, the Imperial Garden, the Outer, Imperial and Palace cities and the 40 or so buildings. Four years later, Harada was happy to announce the publication of his report 'in spite of the fact that our work was done when the situation was strained'. That was in 1941, when the situation was even more strained, leading up to Japan's attack on Pearl Harbor in December. It was remarkable that the work was done at all, that it was done so well, and that it was pub-lished. No wonder his report is extremely rare – there is only one copy in the UK, as far as I could discover.[6]

[6] In the beautiful new Sackler Library in Oxford.

From then onwards until quite recently, Xanadu had few visitors from outside. Two authors, William Dalrymple and Caroline Alexander, were there briefly in the late 1980s and early 1990s, both inspired by Coleridge's poem.[7] As for serious work on the site, absolutely nothing was done. War and civil war saw to that. Under Mao's Communist regime, China showed no interest, for the Mongol dynasty – established by barbarians from beyond the Gobi – was a chapter they would rather forget, and anything remotely to do with Mongolian nationalism was suppressed, to the extent of killing tens of thousands of people. As Mao wrote in a poem, that proud son of Heaven, Genghis Khan, only knew how to shoot eagles:

> For truly great men
> Look to this age alone!

There was room for only one son in the hearts of the people: the Great Leader himself.

This had been a closed area until the 1990s. In 1996, when I first went to Xanadu, I knew roughly what to expect: the plans made it look very neat. Up close, though, it was not neat at all. There were no signs on the approach roads. My guide, William (Chinese who deal with westerners often give themselves western names), was unfazed. 'Under the nose is the mouth,' he

[7] Alexander, *The Way to Xanadu*; Dalrymple, *In Xanadu*.

remarked, and proved it by asking the way from a couple of farmers. Only a few years before, visitors from abroad had had a hard time. Now, no problems. We were able to drive straight in. There was no fence, no gate, no charge, no custodian to block the way along the track that cut through the Outer City wall. The sky was pure Mongolian blue, the breeze gentle, the only sound a cuckoo. A glorious wilderness of waving grasses and pretty meadow flowers rose and fell gently over the billows made by eroded, overgrown walls. I couldn't make much sense of it.

But others obviously could. Half a dozen men with tape-measures were making squares with posts and bits of string. They were archaeologists marking out the start of an excavation. Their leader was a professor with a mission to explain and the attributes of a TV presenter – slim, good-looking, a voice as mellow and sonorous as an operatic baritone. He briefed me through William, pointing out walls and the remains of buildings and the base of the palace. This whole basin used to be called the Golden Lotus Plain, he said, and I could see why from the profusion of buttercups mixed in with the golds and purples and whites of flowers I didn't recognize. 'It is an auspicious site. To the north is Dragon Mound, with Lightning River to the south.'

'The mountains – they look like breasts.'

He laughed. 'They have shrines on the top, *obos*, piles of stones. There were probably guards and beacon-fires as well. There is a story that those with *obos* are arranged in the shape of the Seven Gods.' He used the

same term as the Mongolians do for the Plough, Ursa Major. 'It is something we have to check. We have much to learn.'

He was busy with his string and measuring tapes, I didn't have much time, and in my excitement I forgot to ask for his card. I walked on my own through the waving grass towards the palace mound, and came across a crude little out-of-place statue – Turkish, pre-Mongol – standing as if on guard, brought here perhaps by Kublai's people, or found here and simply left alone. The ground was strewn with rubble which threatened to twist an ankle if I wasn't careful. The base of the palace was still there, a heap of earth about 120 metres long standing some 6 metres high above the grass. There was no hint of underground dampness, except for what I thought was a well, or possibly a flag-holder. The palace mound was flanked by two others – the remains of three great buildings creating what I took to be a three-sided courtyard. Paths made through the grass by wandering tourists wound to the top at either end. The front was an almost sheer earth face, punctuated by the line of holes noted by Impey, evidence (I thought) of long-vanished roof-beams that held up a canopy. I imagined dignitaries dismounting in its shade, before climbing steps to be received by the emperor himself on his dais. There were also the several shallow caves Impey had noticed dug along the base, the result, I supposed, of people burrowing for treasure.

There is nothing solid on top now, nor down below either. It struck me as odd: a platform of earth had

survived 700 years, despite the fierce summer down-pours and rock-cracking frosts of winter, yet of the building itself there was no trace. Rubble by the tonne, of course, was strewn across the coarse grass. But what of the bricks and tiles? What of the remains of temples and monuments seen by Bushell in 1872? Had the Japanese taken the lot? I picked up some shapeless bits and pieces; there was nothing even to suggest what they had once been. A bit of glazed pottery. A drab grey roof tile. Stones that looked like nothing more than stones. Just rubble – but what rubble: the dust of Xanadu! How on earth would I do it justice?

I thought then that I would grind it all up and have the signs for Xanadu carved into a marble table-top and pour the dust into them, so that I could work on a table that spoke to me of my first visit to Xanadu, to Shàng-Dū:

上 都

The rubble is still in dusty plastic at the back of a cupboard, awaiting the right moment; or for a later generation to find, puzzle over and discard.

I was back in 2004. Change was on the way, as it was everywhere in China. There was a spanking new high-way leading east from Zhenglan Qi, and a sign in both Chinese and English to 'Yuan Shang-du', and a newly laid minor road, leading straight north across pasture to a tourist camp of round, white Mongolian tents. The road skirted the tourist camp with two right-angle

bends and led to a fence, a gate and a little museum, with two or three attendants and an entrance charge. After that, though, I was on my own, as before, and equally baffled by the indeterminate mounds and the scattered rubble. Foreign tourists got no help, for the authorities had not yet appreciated the significance of the place, especially for English-speakers. The few signs were still in Chinese. I was still free to stroll the hummocks and the palace mound, still free to pick up rubble.

Not for much longer, it seemed. The archaeologists had been at work. Along one side of the courtyard stood a line of marble statues, all headless. The lady in the ticket office said they had been found at nearby sites, and had been damaged by the incoming Ming when the Mongols were thrown out in 1368. In the centre of the yard was a glass cabinet containing an immense block of white marble, 2 metres high. It was part of a pillar, a base perhaps. I tried the door. To my astonishment, it opened. Feeling as privileged as a prince and guilty as a schoolboy, I ran my fingers over marble that might have been touched by Marco – brilliantly carved bas-reliefs of intertwining dragons and peonies, symbols of both war and peace. Finds like this, which were easy to stumble across a century ago, hint at the magnificence of the place, and the skill of Kublai's Chinese artists – and the labour involved, for the closest source of marble was 400 kilometres away in the famous marble mines of Quyang in Hebei province. It was also new evidence in that rumbling

academic dispute about whether Marco was ever actually in China. He begins his description: 'There is at this place a very fine *marble* palace.' As a plaque near the palace mound states: 'These things testify to Marco Polo's presence.'

The greatest change was not at the site itself, but in the approach to it. That tourist camp I'd noticed on the way in – the first glimpse of Xanadu – consisted of some 40 small Mongolian tents (*gers*) and three huge concrete ones, with double domes. The camp was the creation of a local businessman, 'Benjamin' Ren. Benjamin was remarkable in several ways: handsome, outgoing, generous, ambitious, and driven by a desire to combine business with ecology. Conscious of the ruinous spread of industry and agribusiness into the grasslands, he conceived a plan to plant forests and save pastures. Backed by a rich Indonesian, he had bought up a county-sized tract of land and planted no fewer than 15 million trees on half of it; the rest he would have put to pasture had he not discovered it was already disastrously overgrazed. Now he was letting it revert to meadowland.

By chance, his land was right by Xanadu. Speaking good English, he dreamed of tourism, especially with the new road. The tourists would need somewhere to stay. His tourist camp had opened the previous year, with *gers* cunningly adapted to offer double beds, lighting, running water and loos, and the double-domed restaurants employing locals to cook Mongolian banquets and entertain with Mongolian music. He arranged sleeper-buses, so that his tourists would

snuggle down in Beijing and awake seven hours later in Xanadu. In the first year of operation, he hosted 1,500 people; in 2004 there were 6,000, a number he hoped would multiply sixfold by the time of the Olympics in 2008. I supposed that his 36,000 visitors would be met by uniformed tour guides, lectured through loud-speakers and shepherded along well-trodden paths to stalls packed with tourist trash. No one would ever again see it as I saw it in those two years, a virgin wilderness.

Except, of course, that it was not virgin at all. It had been raked over and robbed so many times there was virtually nothing left. I asked Benjamin: Where had it all gone, the remnants seen by Bushell and the Japanese? He had part of the answer. In the nearby town of Duolun – Dolon Nur (Seven Lakes) in Mongol – many of the domestic buildings have rather fine brickwork and tiles. Xanadu was mined brick by brick, tile by tile, by local householders.

By 2008 Xanadu had changed again, and not in the way I expected. This time I was determined to under-stand what I was looking at, so I had contacted China's greatest Xanadu expert, Professor Wei Jian of Renmin University in Beijing. We had met a couple of days before departure to plan our trip, with the help of an extremely small and softly spoken English-speaking graduate named Helen. It was obvious Professor Wei was just the man to advise me. Originally a pre-historian, he had started work on Bronze Age and Stone Age sites in Inner Mongolia, but became intrigued by

Xanadu in the early 1990s because no one had done any work there since the Japanese six decades earlier. Now he had been working at Xanadu for fifteen years. With the intensity and charm of a Chinese David Attenborough, he listened keenly as I told him of my previous visits, of my meeting with an inspirational archaeologist . . .

'An archaeologist—' he said, suspicious of someone muscling in on his territory, '—you remember his name?'

'No, I . . .'

'When did you say you were there? Nineteen ninety-six? You know . . .' He paused. 'I think . . . I seem to remember meeting a foreigner . . .'

We stared at each other, then, in unison, light dawned. 'It was you!' Of course it was: twelve years rolled away, and I recognized the athletic frame, the direct gaze, the verve, the operatic voice.

We had driven from Beijing along the usual route, taking the expressway through Badaling to Zhangjiakou, with side-turns and byways that I will tell you all about in due course. We had climbed the zig-zag pass up from Zhangjiakou, struck north-east across the Mongolian plateau along dusty, tree-lined roads, past fields watered by huge overhead sprays and small towns of single-storey houses, made more diversions, and ended up approaching Xanadu in driving rain. It was utterly miserable. Oh, well, I said. We can stay at Benjamin Ren's *ger* camp, and have a banquet.

As we drove along the approach road, and saw the

concrete *gers* of the tourist camp looming through the murk, my spirits lifted. There would be warmth, and good food, and good talks with an old friend, and a comfortable bed. But at the camp gates it became clear that something had gone terribly wrong with Mr Ren's plans. The camp was abandoned, with rank grass between circles of damp concrete where *gers* had once stood. One sodden *ger* remained. I knocked on the door. A decrepit old woman appeared. She was carrying a cat and she looked in bad shape. She, not the cat, had green whites to her eyes. She told us that Mr Ren had gone off to live in Hohhot. There had been no tourists this year or last. The rain came on harder. This was no time to explore. Never mind, said Wei, we will return tomorrow.

We very nearly didn't, because Wei, having worked in the area for many years, was revered so much that, back in Duolun, a feast was held for him by officials and co-workers and former students. Toast followed toast in a raucous mix of Mongolian and Chinese, with much vodka finger-flicked skyward to honour Eternal Heaven. A lady singer arrived who presented me with a strip of blue silk, in the proper fashion, while delivering a Mongolian song, full of baroque ornamentation, of such shattering power that it liquefied my brain. People rose for more toasts like out-of-focus jack-in-a-boxes. The singer told me the words of her song. I have a fuddled memory of a girl, a lover and the grassland being their sweet home for ever. Then there were more toasts, one unfortunately by me, and another song, led

by Wei in Chinese, with additional verses from others in Mongol, about the father being like the grassland and the mother like a river. At this point (or was it later?) alcohol inspired an insight which seemed at the time to be of surpassing brilliance. Usually, Chinese and Mongol keep themselves apart. Here, thanks to Wei, the two overlapped, as they had centuries before – thanks to Kublai – in Xanadu.

Next morning, after a breakfast of milky tea with curds and the remains of a well-muscled sheep, we drove back the 20 kilometres to Xanadu, under a heaven that was mercifully blue, past portents of things to come in this once-empty land: a fine new road, wayside lines of young poplars, an embankment for a railway in the process of construction. So what, I wondered out loud, was the future for Xanadu, which I thought had been developing so well? Wei sighed and shook his head. He had stopped work there a couple of years before; his successors were people less interested in archaeology, more in tourism, without realizing that tourism depended on good archaeology.

We drove down the single-lane approach road, followed the right-angle bends past the abandoned tourist camp and pulled up at what used to be a wire fence, and before that nothing at all. Now there was a grand 4-metre portico, with two copies of the marble pillar for supports and a lintel like something from Stonehenge. While Wei parked in the courtyard, I was drawn by the entrance. It was set in a nice new brick

wall that gave way to a huge stone bas-relief of armies and courtiers and some eminent visitor, all crowding in on a massive Kublai sitting knees akimbo on his throne. An incised plaque provided a brief biography, in Mongol, Chinese and – in anticipation of mass tourism – English. As so often in China, no one had bothered to check the English with someone who actually speaks the language. 'Mongolian dubbed him saint, virtue, marvelous, merit, doing well on both civil and military,' which at least showed Chinese pride in an emperor who was, after all, a Mongol.

Back in the courtyard, someone had been pillaging. The statues had vanished; there was no museum; and where was the marble pillar? 'All gone to storage,' said Wei, which seemed good for the carvings, less good for a site that was supposed to be attracting visitors. Parked in the empty courtyard were four buggies for tourists, but we were the only takers.

We drove down a track across stubbly grass for a kilometre, over a little river that had once been big, for this was all that was left of the Shangdu river, or the Shandian as it became known, after local pronunciation corrupted the original name into the word for 'lightning'. Once this winding and reed-clogged stream bore barges bringing marble and other building materials from the south. Now the only clue to its former glory is the size of the old river bed, which spreads for up to a kilometre on either side.

We came to a mound that had once been the South Gate – the Ming De Men (Gate of Splendour) as it was

in Marco's time – before it fell in. Its centre had been gouged out, the cavity blocked off by fallen bricks that had been rebuilt into a barrier. But the sides were still there, revealing the beginning of an arch. When Bushell saw it in 1872 it had been intact. But in a 1908 photograph its top was only two delicate layers of brick. Some time in the following three decades it fell, having lasted for some 550 years: Harada found no trace of it in 1937. Now it was partially revealed again by Wei. 'This was the main gate in Kublai's time,' he said. 'You can tell from all the bricks that it had a building on top of it. But that was destroyed when the rebels came at the end of the Yuan dynasty. And there was a wooden gate as well. We found some of the framework.' So this explains what Marco saw: a massive wooden gateway blocking the 5.8-metre entrance, topped by a guard-house, with bulwarks either side making an entrance tunnel of 24 metres (I paced it).

From the top of the mound one sees ridges – the low remains of the walls, mostly stripped of their brick facades – running away for several hundred metres, before turning north at right angles to form the square of the Imperial City. Later, Wei took me to a section of wall that he had restored: brickwork about 6 metres high sloping back at a 15-degree angle, so that you could run up it, if you were an athlete in a good pair of track shoes. The top, 2 metres higher than Wei's restoration, would have been flat, paved, easy to patrol. Every 400 metres a U-shaped bastion stuck out, but there were no guard-towers; the wall was

built to assert status, not to withstand an assault.

A track led across long grass to another long mound – more remains of the Imperial City wall – and off to the right a rough path led through the waving grass to the platform on which the palace had once stood. But that was not what Wei wanted to show me first. We stopped at a nondescript bump with a hole dug in it.

'It was here that I found the marble pillar!' he said. 'So I knew this was an important place.'

'Was that just luck?'

'Not luck! Experience! Because it was a mound, I thought there must be something worth digging for.'

And that discovery made him wonder about the name of the palace. It was not only Marco who admired it. The official history of the period refers to a magnificent marbled building called the Pavilion of Great Peace (Da An Ge), where Kublai and his two successors were crowned. Poets had done so as well, inspired by the sight of it. One of them, Zhou Boqi, praised it many times:

> The Imperial Pavilion of Great Peace
> thrusts upward to great heights,
> And gorgeous gate-towers pierce the sky
> endowing Shangdu with magnificence.

And:

> Rafter upon rafter, the storied pavilion
> reaches the azure sky,
> A picture painted in gold
> floating atop seven precious pillars.

Scholars always assumed the Pavilion and the palace were one and the same. Here, though, was proof that marble – carved to a very high standard – was used in another building, whereas no marble has been found at the palace. 'The marble pillar I found has a dragon design, the imperial symbol. For this reason, I think this, not the palace, could have been the Pavilion of Great Peace, where important administrative functions were held.'

Perhaps. Or perhaps there are mysteries still to be solved, for Rashid's account suggests a third possibility, that the marble did not belong to either building: 'On the foundations [of stone, coal, tin and lead] a palace in the Chinese taste was erected, and enclosed by a marble wall.'

A wall which, if it existed, should also have enclosed the Crystal Palace, which stood on the mound to which Wei now led the way. It was round, as you can see from the air, and called 'crystal' first because it had a moat of its own, which reflected the light, and second because it had windows made of glass. Glass? Really? This too inspired poetic tributes from Zhou Boqi:

> Blossoms of ice and wings of snow
> make east and west glisten . . .
> Done by a genius whose hands
> once fashioned the moon,
> This palace of infinite light was originally
> up in the fifth cloudy layer of Heaven.

Where did that leave the palace, the one most people still call the Pavilion of Great Peace? We walked over to it, or rather to the earth platform on which it used to stand. I asked about the holes, the ones I thought had been left by long-vanished roof-beams. No, said Wei, it wasn't like that, and launched into a long explanation, pointing out lines in the earth made by timbers and planks. It made no sense to me until I read Harada's report.

It was he who worked out their origins, along with an explanation of how the platform was built. On the foundations laid down to fill the shallow lake went layers of rammed earth. But earth alone, even when faced with brick, would not have been strong enough to support a palace. Kublai's men knew what to do. Harada wrote:

> By examining caves that had been dug later, presumably as shelters, we were greatly interested in finding that the round holes were pierced through the platform . . . Very likely timbers were used as bones, for re-enforcement in the construction of the platform, and these holes are no other than those created by the timbers which decayed in them.

He was right. The platform had a skeleton of timbers, which had rotted away to leave the tell-tale holes.

(The caves at the bottom, the ones I had assumed had been dug by treasure-seekers, remained a mystery to outsiders until Caroline Alexander paid a brief visit

when researching her book on Coleridge's Xanadu. There had until recently been a modern temple built opposite, where lamas lived, which Impey recorded on his map of the place. The caves, she was told, had been made to store potatoes.)

On top went the palace, explained Wei as we climbed up the 120-metre-long platform, with two wings on either side embracing a courtyard, and access from below by wooden staircases. Yes, wood, because no stones were found nearby, which means the whole palace was made of wood, like a temple, except for its tiled roof. 'We think it had over two hundred and twenty rooms. If I'm right about the Pavilion of Great Peace, then this palace was actually the Pavilion of Harmonious Brightness [Mu Qing Ge / 睦清阁], a place of celebration. For instance we know they had races around the palace, with the winner being awarded a prize by the emperor. And at the full moon there were parties here, because the moon is round, perfect, harmonious, bright like Kublai's dynasty.'

As for what was inside this 'very fine marble palace', Marco says only this: that everything was gilt, and the walls painted with exquisite figures of men, animals, birds, trees and flowers. That's it. Marco was less concerned with art and architecture than with events, and even these are much condensed.

There must have been an arrival, a settlement in lodgings, a flow of messages from the khan, but of all this Marco says nothing, leaping directly to an audience with Kublai and his attendant 'barons'. Perhaps that

was the first time Marco saw the emperor. When he came to dictate the experience, awe of him – 'the most potent man, as regards forces and lands and treasure, that existeth in the world, or ever hath existed from the time of our First Father Adam until this day' – totally overwhelmed his critical faculties. His description of him tells us almost nothing, perhaps because there was nothing much to tell, perhaps because the experience called for a description more in the style of an Arthurian romance than a piece of modern journalism. I think I might have the same problem if asked to paint a word-portrait of the Queen. Kublai, he says, was of good stature, neither tall nor short; carried a 'becoming' amount of flesh, which suggests he may have already been putting on the fat that would mark his gouty old age; was shapely in all his limbs, and white and red in complexion, which sounds more like European than Chinese; eyes black; nose well-formed.

The three knelt, then prostrated themselves. Kublai told them to stand, expressed pleasure at their coming, and asked polite questions. They gave an account of their journey, presumably describing the turmoil that had prevented them bringing the 100 priests requested by Kublai, 'being heard with great and long silence by the lord and all the barons, who wondered much at their great and long fatigues and their great perils'. They presented the pope's letter – their credentials as papal ambassadors – and the oil from the sepulchre in Jerusalem, 'at which he made great rejoicing, and holds it very dear, and ordered it to be kept with great honour

and reverence'. Then, seeing Marco, Kublai asked who he was.

'Sir,' said his father, in the Moule–Pelliot version, 'he is my son and your man.' The last three words are better in medieval French – *et vostre homme* – because the phrase echoes the feudal idea of someone who owes homage. Of course, Niccolò was speaking in Mongol, but the idea of a liegeman was common to both cultures, as was the practice of offering a son as a servant.

'May he be welcome,' replied Kublai. And just when modern readers would love to know the details, Marco shrugs, says, 'Why make a long story?' and summarizes: 'Very great was the joy and the feasting that the great Khan made and all his court at the coming of these messengers, and they were greatly served and honoured.'

6

THE PLEASURE DOME

WEI HURRIED ME ON TOWARDS THE NORTH-EAST CORNER of the Imperial City, to the next enigmatic mound, a huge grassy rectangle. This was once the site of a court-yard, 150 × 225 metres, which contained a temple, named after an esoteric Buddhist sect, the Huayan (Flowery-Severe) school.[1] At the opposite corner had lain another similar courtyard and temple, named after Kublai's dynasty, the Yuan, and a trigram (*qián* / 乾) in the *I Ching* (pinyin: *Yi Jing*), the 2,000-year-old oracular *Book of Changes* that all sects regarded with reverence.[2] As Marco said, 'They have also immense

[1] 華嚴 (traditional) or 华严 (simplified).

[2] Qian Yuan: the name conceals hidden depths that would demand a thesis to explain properly. The *Yi Jing* involves creating and inter-preting six-line patterns (hexagrams), each made of two three-line patterns (trigrams). *Qian* is the first hexagram, made of two identical trigrams, also called *qian*. The whole sign is called 'The Creative', and

Minsters and Abbeys, some of them as big as a small town, with more than two thousand monks . . . in a single abbey.' Here were two, one Buddhist, the other Daoist, with several hundred monks in each. It was the Huayan that had Wei's attention, because, 'here was the big religious debate'.

Sometimes I wonder if there is any point going to places where great events happened. We were standing on a grass mound slightly elevated above more grass. A plaque commemorated the building of the temple, with absolutely nothing to help reconstruct the drama of the occasion.

What happened, 17 years before Marco's arrival, was this:

In 1258, two years after work started on Xanadu, Kublai faced a problem, created by Genghis 30 years previously. He had been impressed by an aged Daoist monk, Changzhun, summoned him from China to Afghanistan, then granted his sect freedom from taxation. Daoists, once the religious juniors of Buddhists, had revelled in their new-found wealth and status by seizing Buddhist temples. Buddhists objected, equally violently, reinforced by an influx of priests from Tibet. The row had to be stopped, because otherwise there would be no stability in north China, and no

represents the power of both Heaven and its chosen leader. One of the attributes includes *yuan*, a word translated variously as 'sublime', 'origin', 'first', 'prime'. So, in Chinese eyes, this temple's name was doubly auspicious, affirming Kublai's claims by referring back to the roots of Chinese culture.

secure base from which to undertake the invasion of the south. In 1258, therefore, Kublai convened a conference of Daoist and Buddhist leaders to force a confrontation and a conclusion. Into the newly built Huayan temple in Xanadu crowded 300 Buddhists and 200 Daoists, held apart by the presence of 200 court officials and Confucian scholars. Kublai was in the chair.

The Daoists argued that Lao Tzu, the Daoist sage, had undergone 81 incarnations, in one of which he was known as the Buddha. Therefore, they contended, Buddhism was actually Daoism. But Kublai's Tibetan adviser, Phags-pa, tore them apart, proving their evidence was fraudulent. Kublai offered the Daoists a chance to work some magic. Naturally they failed. Kublai made his judgement in favour of the Buddhists, to whom 237 temples were restored; peace was made between the rival factions. The debate reinforced Kublai's growing authority. Two years later, he declared himself emperor.

We drove on, through what had been the north gate of the Imperial City's north wall, now looking like a dune on which someone had dumped truckloads of grey bricks, and struck out into the open sea of the hunting ground. In Kublai's time this was a place of fountains, brooks, lawns and groves, in Marco's words, where deer, hares, rabbits and birds wandered and fed freely. These were treated as game, to be hunted with gyrfalcons (*Falco rusticolus*).[3] Normally, these big

[3] Gyr- is the more popular spelling now. It used to be ger-, which seems more correct, because it comes from the German *Geier*, vulture.

sub-Arctic birds, white with black speckles, hunted hares and rodents, but, like eagles, they could also bring down deer by battering them around the head and eyes with their wings.

Marco probably did not know why gyrfalcons were so special to the Mongols. They had always hunted with falcons, of which Mongolia has several species. But the king of hunting birds was the gyrfalcon, which bred mainly in Manchuria and Korea. And the king of kings was a breed that was pure white, and therefore highly auspicious. A long-time symbol of royalty and power, white gyrfalcons were often given in tribute as a sign of submission (the Kyrgyz sent white gyrfalcons to Genghis when they submitted in 1219, along with white geldings and black sables[4]). In *The Secret History*, Genghis's father goes to arrange a marriage between young Genghis and his bride-to-be, Börte, whose father has a dream:

> A white gyrfalcon clasping both sun and moon in its claws flew to me and perched on my hand. I told the people about this dream of mine, saying: 'Before when I looked, I could only see the sun and moon from afar; now this gyrfalcon has brought them to me and has perched on my hand. He has alighted, all white. Just what sort of good thing does this show?'[5]

[4] *The Secret History*, para. 239.
[5] *The Secret History* para. 63.

It shows that glory is coming to the families, for in the dream the gyrfalcon is the *süld*, the vital force or powerful spirit that animates, guards and protects a person (and by extension a lineage) so that the destiny ordained by Eternal Heaven may be fulfilled. Marco may not have known this, because he would not have known of the carefully guarded *Secret History*, but Kublai was raised with these stories, which was one reason why (as Marco says) he had over 200 of these birds, as well as an unspecified number of other smaller species of falcon and hawk.

Kublai also had another pet to hunt with: a cheetah, or 'leopard' as Marco calls it, which had been trained to ride behind him draped over the horse's hindquarters; 'then if he sees any animal that takes his fancy he slips his leopard at it' and feeds it to the gyrfalcons. It must have taken expertise to train both horse and cheetah to do this, but the indefatigable Yule records the same practice among aristocrats in medieval India, Cyprus, France and Italy.

We stopped by a series of faint ridges, about 300 × 110 metres. 'This is the North Yard,' said Wei, 'where they kept rare animals, like elephants and pumas and lions, and many eagles.'

'You mean it was a zoo?'

'Yes, a zoo.'

Kublai loved his elephants, which arrived from Burma in 1279. Four pulled his carriage, and four – presumably the same four – acted as the base for a sort of castle, in which he rode while out hunting and on

campaign. It had not occurred to me, but obviously he would have needed a place for them in Xanadu. This series of slight mounds was the remains of both the zoo and the elephant-stable.

Wei ordered a halt, in what looked like a blank slab of grassland, nibbled by herds and scattered with dried dung. He stood, arms akimbo, as if conjuring up a show on an empty stage.

'It was here, John, that Kublai built his Cane Palace, the one described by Marco Polo. It was a hundred metres all around!'

In the grass I thought I could see, or perhaps my imagination was working overtime, the vague shape of a huge circle. If he was right, this was the base of the creation that has come down to English-speakers through the first two lines of Coleridge's famous poem:

> In Xanadu did Kubla Khan
> A stately pleasure-dome decree

It was part of a dream, of course, an opium-induced vision, running on about measureless caverns, a sunless sea, bright gardens, an incense-bearing tree, deep romantic chasms, a woman wailing for her demon lover, a mighty fountain, caves of ice and so on in surreal images that have nothing to do with Xanadu, which is several days' hard ride from a sea that is no less sunny than any other.

But there is one image that connects with reality, as

Wei's pointing finger showed. And there was a step-by-step link between the two. Coleridge's source was Samuel Purchas, who in 1625 published the re-edited and extended version of a massive three-volume book of travels by his friend Richard Hakluyt. To quote the relevant passage in *Hakluytus Post-humus, or Purchas His Pilgrimes*: 'In Xamdu did Cublai Can build a stately Palace, encompassing sixteen miles of plaine ground with a wall, wherein are fertile Meddowes, pleasant Springs, delightful Streames, and all sorts of beasts of chase and game, and in the middest thereof a sumptuous house of pleasure, which may be removed from place to place.' This was based on Marco's eyewitness account, which had been available in English since 1579.

One thing bothered me when I began to write this. What made Coleridge dream of a *dome*? He mentions the image several times: 'stately pleasure-dome . . . shadow of the dome of pleasure . . . sunny pleasure-dome with caves of ice . . . that sunny dome! Those caves of ice!' Yet Purchas makes no mention of the shape of his 'house of pleasure', and nor does Marco. It is as if Coleridge had a psychic link straight to Xanadu, and could see the faint pattern of his dome on the grass. Was this part of his vision in fact true? The question drove me to examine Marco's account in greater depth.

Kublai's house of pleasure, the pleasure-dome, the Cane Palace, was surely one of the most astonishing – perhaps the most original – creations of its time.

A SPURIOUS SYMBOL OF MARCO'S FAME

This gilded wooden statue, widely said to be of Marco, is as inauthentic as every other portrait of him. It is a copy of one of 500 Buddhist saints in Hualin Temple, Guangzhou (Canton). Impressed by the odd hat and thick moustache, locals claimed it 'must be' Marco, an idea based solely on his status as a famous foreigner. This copy was sent to Venice in 1881, and is still displayed in the Correr Museum as 'Marco Polo'.

The harsh life of herders in the Wakhan corridor has changed little over the centuries.

ACROSS THE ROOF OF THE WORLD

Marco's route into China took him through the high Pamirs of Afghanistan, through the Wakhan corridor that separates today's Tajikistan and Pakistan. He would recognize the landscapes, the wildlife and perhaps the striking looks of the Tajiks, Kazakhs and Uighurs. His first town in China should have been Tashkurgan, though he did not mention it. The long descent past Mustagh Ata and through the Gez defile led to the lowlands of western China.

Ovis poli, Marco Polo sheep.

The fortress of Tashkurgan, silhouetted against the Pamirs, stands watch over lush green pastures.

Above: *Mustagh Ata's cloven crest, rearing up over 7,500 metres, is the beacon marking the descent into western China.*

Below: *In the Gez defile, a walled pasture marks the site of an ancient caravanserai.*

CHINA'S WESTERN WASTES

For 1,500 kilometres, from Kashgar to Dunhuang, western China is mostly desert, ringed by mountains. Meltwater forms rivers that lose themselves in sand and gravel. Most travellers, whether on camel or in cars, skirt the forbidding wastes of the Taklamakan and Kumtag, choosing to follow the ancient routes from river to river, arriving at last at the far western end of the Great Wall.

This is pretty much what Marco would have seen when he reached the Wall's western end: a sand-blasted ruin of earth-and-reed layers.

Further on, the Wall was a ridge-back of eroded earth, if it was there at all, for the Mongols had no need of it. No wonder Marco didn't mention it. After the Yuan (Mongol) dynasty fell in 1368, it was rebuilt many times, until finally abandoned in the seventeenth century.

A camel caravan in the Taklamakan.

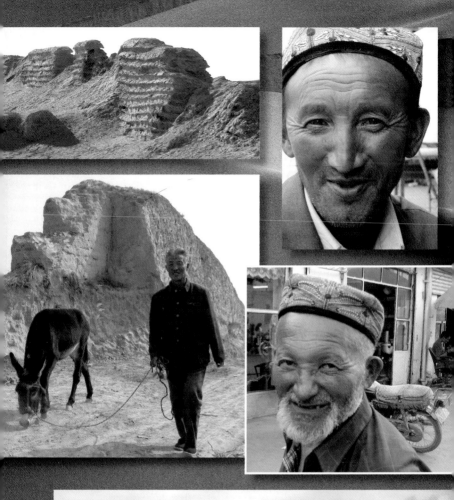

The tombs of the Tangut kings of Xi Xia, stripped of their tile roofs, stand near Yinchuan as monuments to a Buddhist culture that ruled most of western China until destroyed by the Mongols in 1227.

Above: *Xanadu from the north-west, shot in early-morning sun by Wei Jian (right). The palace mound is at this end (north) of the central Palace City. The river at the top (south) is the Shandian.* Below is Xanadu's *rolling landscape: an outer wall, a distant* obo.

The east wall, restored by Wei Jian

IN XANADU

Today, Kublai's 'Upper Capital' is a place of grassy mounds and a few low walls, which make sense only when seen from above (*left*), especially when a low sun picks out the contours. Destroyed by the Ming in 1368, the place was abandoned. Only recently has China begun to recognize its significance, with a grand entrance and a statue of Kublai. Under Wei Jian, archaeologists have identified most buildings and the watercourses designed by the great Yuan engineer Guo Shoujing.

Left: *The new entrance is flanked by copies of the marble pillar found by Wei Jian (see following page), and a majestic statue of Kublai (below left).*

Below right: *Guo Shoujing, top Yuan engineeer: a modern statue in Beijing.*

WHERE MARCO MET KUBLAI

The mound at the north end of the Palace City was once the base of the palace described by Marco. The holes were left by the wooden shafts of a framework used to reinforce the rammed-earth foundations. The stone ring in the foreground is a flag-holder. Nearby, Wei unearthed a marble pillar (*left*), carved with imperial dragons and peonies. Marco mentions marble. Since there is no local source of marble, the pillar is strong evidence that Marco was here.

This, of course, was precisely why Kublai wanted it. Xanadu was part Chinese, part Mongol. This 'house of pleasure' would be created with the same agenda: round like a Mongolian *ger*, but not made of felt; therefore Chinese in its structure. Normally, this would mean a permanent rectangular building: foundations, heavy tiled roof, curlicued eaves, wooden beams, doors, windows. But where then would be the Mongolian elements? No, it had to be round, and, crucially for Mongolians, it had to be temporary; solid as a Chinese building, but moveable as a Mongolian tent.

The Pleasure Dome: Marco's specifications

And again you may know that in the middle place of that park thus surrounded with a wall, where there is a most beautiful grove, the great Kaan has made for his dwelling a great palace or loggia which is all of canes, upon beautiful pillars gilded and varnished, and on top of each pillar is a great dragon all gilded which winds the tail round the pillar and holds up the ceiling with the head and stretches out the arms, that is one to the right hand for the support of the ceiling and the other in the same way to the left; but it is all gilded inside and out and worked and painted with beasts and with birds very cunningly worked. The roof of this palace is also all of canes gilded and varnished so well and so thickly that no water can hurt it, and the paintings can never be washed out . . . You may know truly that those canes . . . are more than three or four palms thick and round and are from ten to fifteen paces long. One cuts them across in half at the knot, from one knot to the other,

and splits them through the middle lengthwise, and then a tile is made; and from each splitting two tiles are made. And of these canes which are so thick and so large are made pillars, beams and partitions . . . so that one can roof a whole house with them . . . each tile of cane is fixed with nails for protection from the winds and they make those canes so well set together and joined that they protect the house from rain and send the water off downward. Moreover the great Kaan had made it so arranged that he might easily have it taken away . . . whenever he wished, for when it is raised and put together more than two hundred very strong ropes of silk held it up in the manner of tents all round about, because owing to the lightness of the canes it would be thrown to the ground by wind. And I tell you that the great Kaan stays there three months of the year, that is June, July and August, sometimes in the marble palace, and sometimes in this one of cane . . . and all the other months of the year he keeps it taken to pieces. (Adapted from Moule and Pelliot, *Marco Polo*)

Again Marco is our guide: it stood for three summer months until Kublai's departure, 'and all the other months of the year he keeps it taken to pieces. And he has so planned it that he can make it and take it to pieces very quickly.' No wonder it was original.

As far as I can discover, no one had thought of making a large building entirely of cane, by which Marco meant bamboo, a word that did not yet exist in any European language. In Kublai's China, a bamboo structure had only recently become a possibility, because

bamboo grows in the tropics, which in China means the south. Kublai did not complete the subjugation of the south until 1279; but he did control one southern province – Yunnan, which is rich in bamboo. Kublai himself had led the conquest in 1253. Of course, in theory it would have been possible to import bamboo from Song, but it is unlikely the idea would have occurred to Kublai's advisers had the Mongols not been masters of Yunnan. They had to start from scratch.

This was to be a sophisticated piece of Chinese architecture, though no doubt the décor was Mongol, with many animal skins on the floor. It was held up by gilt and lacquered columns, each of which had a dragon-shaped carving wrapped around it, with the head and fore-claws supporting the rafter above. Lavishly decorated, but ingeniously simple in structure, to keep it light and collapsible. There could be no foundations, so it was secured against gales by 200 silken cords, a Mongolian touch. Marco also says the roof was held together by nails, to hold the semicircular bamboo 'tiles' on in high winds. Possibly, I thought, he meant wooden pegs (a technique used for example in the eleventh-century Wooden Pagoda, in Yingxian, 70 kilometres south of Datong in Shanxi province).

It was taking shape in my mind's eye, with one hesitation. Listen to Marco: 'The roof of this palace is also all of canes gilded and varnished so well and so thickly that no water can hurt it.' The bamboo was split into half-tubes up to 15 metres long and about

0.3 metres across ('about three palms'). To seal a roof with these half-tubes, they would have to be placed in overlapping rows, like semi-circular roof-tiles, with one row facing up, the next facing down, and so on. I could see this working for a traditional flat or sloping roof, but not for a circular one, because if you put the rows in a circle, running from top to bottom, they would surely spread out between the peak and the rim. The Cane Palace (I concluded, rather too quickly) must, after all, have been square or rectangular, not circular. It could not have been a dome at all. Coleridge was wrong, and I was on the brink of a major archaeological and literary breakthrough.

But how did that fit with the vague circular shape pointed out by Wei? Or with Kublai's determination to balance Chinese and Mongol characteristics?

I turned back to the question: Can you make a *round* roof out of *straight* bamboo?

Yes, you can. A couple of calls to bamboo importers told me why. Not only is bamboo a superb material – lightweight, many times stronger than oak, easy to cut, long-lasting – it is not in fact straight as a drainpipe: it has a natural taper. Well, of course it does! How could I have been so stupid? That's what plants and trees do as they get higher. Placed on the ground, bamboo stems fall *naturally* into a circle. The same is true when all the roof-poles are cut in half to make overlapping tiles. With just a single, uniform item – a 15-metre bamboo pole – you have the elements of a roof, and a perfect upgrade of a Mongolian *ger*, which uses straight poles

to support its felt roof. Once in position, the bamboo half-stems would make a fine roof ideally suited to shield those inside from the rain and sun.

It began to make sense, practically, politically and historically. A Mongolian tent-shape, with tent-like movability, and Chinese architecture, using elements that had just been made available by the conquest of the south: bamboo from semi-tropical Yunnan, lacquer, colours, Chinese designers and artists.

But how would it work in practice? I looked around for help. It was not hard to find. My son Tom is an architect. A friend of his works for a London-based company of engineers called Expedition[6]. Their website fizzed with energy and imagination. They specialized in challenging projects, they believed in controlled risk for high reward, they were experimental, leading-edge, interactive. And they had more than fizz: they had a great track record of building bridges, skyscrapers, airports and river engineering projects. They had built a base like a spaceship on ice for the British Antarctic Survey, a city-sized 'water engine' in China, an aerial walkway above a forest. And to cap it all, said the website, 'sometimes we do television programmes (for fun)': a seventeenth-century submarine made of wood, a Roman catapult. Would the two of them build me a virtual stately pleasure dome, using Marco's specifications and Wei's onsite briefing? Yes, they would.

We were in the position of Kublai's architects, with a

[6] See www.perioliman.com and www.expedition-engineering.com.

brief but no precedents. Everything had to be worked out from Marco's basic specs: a roof of 15-metre lengths of split bamboo, a third of a metre at the base, all supported by pillars. That gave us the size: about 33 metres across, including a roof hole. That's over 700 square metres in area, enough to hold 1,000 people. The concept was fine. All we had to do was work out the practicalities. Easier said than done. As with all engineering and architectural projects, problems produced solutions which raised more problems. To condense several conversations, phone-calls and email exchanges between Tom and Expedition's Ben Godber, the thinking developed something like this.

OK: so the split bamboos are like enormously long roof-tiles, overlapping each other. If each is 0.3 metre across at the base, that means we have 314 bamboo 'tiles' split in half lengthwise, with another 314 overlapping them. The taper takes them down to about 10 centimetres at the top, which leaves a hole about a metre across, as in a Mongolian *ger*. How do we support them?

They can rest on lintels top and bottom.

What sort of lintels?

Well, the whole thing would stand on pillars –

Wait a minute. Are you sure? Why not walls?

Because Chinese houses never had supporting walls, only a framework of beams filled in if necessary. Besides, Marco says pillars. Besides, this was a summer palace. You need to have the breeze blowing through it.

OK, so pillars. One set of pillars round the outside, each

joined with a lintel to the next, making a great circle; and the second right at the top, about a metre across, like the smoke-hole of a Mongolian *ger*. The roof-tiles can rest on the lintels.

Hang on. Bamboo is super strong, but bamboo split lengthwise is not strong enough to support its own weight over 15 metres. We've checked. If you tried it, the tiles would buckle in the middle.

So we put another set of pillars inside halfway along the tiles.

But that would clutter the interior. I think Kublai would want open space inside.

That means the roof-tiles need to be supported by rafters, which would also be of bamboo, complete trunks of it.

Touching each other? That would make the roof really heavy.

Well . . . to save weight, they could be separated by gaps, which would have to be covered with battens, on which the tiles would rest.

Still a heavy roof. Bamboo is 800 kilos per cubic metre, but we're dealing with tapering, hollow bamboo . . . [much tapping] We have 628 half-bamboo tiles, at something like 45 kilos each and, say, 50 heavy-duty rafters, at 213 kilos each, plus battens . . . My God . . . that's 24 tonnes.

What sort of a load does that place on the pillars?

Well, how many pillars do we have?

I guess, if it's 30 metres across and about 100 metres around, you would want about 50 pillars, just for the

look of it. Each panel would have the proportions of a door, like in a Chinese temple, say a couple of metres wide and 3 high. High enough for grandeur, not so high they dwarf Kublai.

A 3-metre pillar can take many tonnes, so no problem there. The problem is going to be the wind. This thing is shaped like an aerofoil. In a gale, it will try to take off. The lifting force on that surface is phenomenal. A lot more than 24 tonnes. Maybe double that.

That's why Marco talks about 200 silken cords. They hold it down.

But how do you attach the cords? Did they have tent pegs?

No. In Mongolia they tie their cords to rocks and car-tyres. Can you tell me the size of the rocks they would need to stop it taking off in a gale?

Well, they should amount to 20 tonnes, so 100 kilos per rock should do it. Or less if you bury them, which would look nicer.

Do the cords also hold the individual tiles down? What's this about nails?

I don't like the idea of nails. Nails through bamboo ... that can't be right. It would split. The rain would get in. You couldn't take it apart.

Could you use ropes?

To hold the tiles? Bit make-shift. How about wooden pegs? You'd need a way to make them secure and water-tight and easily removable.

So the questions and solutions mount. In a gale, you get downward pressure on the leading edge, upward

pressure on the trailing edge, and the roof distorts. Is there a danger of it slumping sideways? Do we need supports running diagonally to stop it twisting? (Yes, we do, to avoid the rather dramatic consequences of what Ben called a 'death spiral', which is what happens to circular roofs if not properly strutted.) The central pillars are pretty big: will they need lifting gear to get the top support ring in place? No lifting gear – this is not heavy-duty engineering. A simple bamboo scaffold would get a guy up there for as long as it takes. If there's rain, won't the pillars tend to sink in? Yes, so they need stone footings. But all this needs to be dismantled, lifted, carried away and stored, so what size footings? Come to think of it, what happens to the rain? Did they have drains? No, of course not: the water just sinks into the ground. Are the lintels curved, or can they be straight? Straight, we think, because they are bamboo, in which case they have to be joined at an angle, an exact angle. Do the pillars have to be bamboo, in which case they are round, or can they be, for instance, oak timbers, squared off? No, because the weight is enormous – oak that size (300mm × 300mm), which it has to be to support that weight, weighs 325 kilos per metre. And the lintels – if they're oak, we have to factor in 14 tonnes of oak. Don't you think we had better make it all of bamboo? Yeah, maybe. In that case, how are the roof-beams attached to the lintels? (And remember that the roof is round, but the lintels are straight, so do the beams vary in length?) And what about transport? Several hundred 15-metre poles would be tricky

to carry, and wouldn't the thin end be liable to split?

As the answers build up, Ben and Tom derive figures which give us the scale of the operation, how the elements fit together, a time-and-motion breakdown of construction, and a rough schedule.

We have been obsessed with structure. But there was more to this pleasure dome than its structure. It was lacquered, and painted, both highly technical and demanding processes.

Take the lacquer, a remarkable substance which was vital to seal almost any material to make a foundation-layer for paint. Hard and lustrous, lacquer had been known for 3,000 years as a protection against acid, water and mould – 'the most ancient industrial plastic known to man', in the words of Joseph Needham. Though it's common enough even in the West, not many non-specialists know where it comes from. Lacquer is the thick, light-grey sap of the lacquer tree (or varnish tree, as it is sometimes known),[7] obtained in egg-cup amounts – 10 grams per tree on average – by cutting through the outer bark and bleeding the sap into a cup, rather like gathering rubber, or maple syrup. Trees have to grow for six years before they are ripe, and they can be tapped only during four months, June–September (carefully, because the sap is toxic and causes a nasty

[7] Botanical note: *Toxicodendron vernicifluum*, as it is now, after years of dispute about classification. The lacquer tree is related to other Toxicodendrons, e.g. poison ivy and poison sumac. Strictly speaking, lacquer goes under paint, varnish over it.

HOW TO MAKE A PLEASURE-DOME
(*see* the design in the plate section)

This is an initial proposal of what it would take to build the Cane Palace. It includes only the major items (as suggested by Marco's description), the qualities of bamboo and availability of materials, labour, and technical know-how in Kublai's empire.

1 The basics

Year 1:

– Design dome, list specifications (manpower, materials, costs etc.).

Year 2, spring and summer:

– Organize the cutting of about 500 mature bamboo trees in Yunnan. Cut them down to 15 metres, with the thick end measuring about 0.3 metres across, tapering to about one-third of that at the thin end (100 mm). These stems will become the roof-tiles and rafters. Of the rest, cut 50 lengths for lintels (2 metres each), 4 for central pillars (9 metres each) and another 50 for pillars (3 metres each).
– acquire 70 oxen with 35 handlers, and four wagons. Strap the long trunks to the oxen, 8 for

every two-ox team. Load the shorter stems on to the wagons.

– order the collection of enough lacquer to seal all the bamboo (this alone is a huge operation, demanding the sap of hundreds of lacquer-trees).
– order paint.

– order a kilometer of silk rope, enough to be cut into up to 200 5-metre lengths.
– order 200 50-kilo stone blocks to anchor ropes.
– commission stone-workers to make about 60 circular stone bases for the pillars.
– supervise the transportation of the bamboo: a 2,000–kilometre, six-month journey to Xanadu. Arrive in September. Arrange storage.

2 On site

Year 2, summer:

– cut at least 314 of the 15-metre stems in half lengthwise to make 628 'tiles' (allowing for extras in case of damage).
– commission artists to do the lacquering and painting, and metal-workers to make the 50 dragons that will decorate the tops of the pillars.

3 Construction

Year 3: Late May – work starts when messengers announce the emperor's departure from Dadu (Beijing).

Check list:

10 foremen
50 construction workers
oxen, ox-wagons and handlers to transport the
 Palace from storage
50 bamboo pillars, 3 metres each
4 bamboo pillars, 6 metres each

50 x 15-metre beams
628 15-metre 'tiles'
battens
200 silk ropes
200 stone rope-anchors
54 stone pillar bases, circular
54 metal dragons for pillar-tops

Schedule:

Day 1:
Transport all of the above to site.
Build scaffold to erect four central pillars and top lintel(s).
Place 50 short pillars in a circle. Add dragon decorations. Secure pillars with lintels. Connect

top and bottom lintels with beams.
Dig pits for rope-anchors.

Day 2:
Add battens over beams.
Place the 314 half-tiles side by side at the correct angle on the battens. Add top halves, over-lapping bottom halves. Insert pegs to secure tiles.
Attach guy-ropes to lintels and stone anchors. Bury anchors.

4 Deconstruction

Early September – procedure to be followed every year, after emperor's departure.

As above, in reverse. Palace returned to storage, including all stones (for next year the emperor may want the Palace in a different position).

rash if touched and a violent reaction if inhaled). The varnish, which turns black on exposure to humidity and warmth, has to be stirred, beaten and sieved to make it pure and even. If many coats are needed, each has to 'dry' before the next is applied. The quotes are there because the sap doesn't exactly dry, but reacts chemically with the water in damp air to harden into something like enamel. It can be applied to almost any-thing: it seals wood, bamboo, even cloth, and was used for centuries to make wooden dinner-services that resisted the heat of cooking as effectively as metal. One

hundred coats applied over many months create a surface thick enough to carve.

Then there are the colours. The Chinese adored their colours, mainly because they were hard to come by, hard to make, expensive, and therefore symbols of luxury. Of the main colours used – red, white, green, black, brown, blue, purple, gold – each has a story. Whatever the original material, it had to be ground to exceptional fineness. The red, for instance, was made with cinnabar, a rare mineral of red crystals which, when processed, produces mercury. Gold leaf was made from a mineral called orpiment, sometimes known as 'Chinese yellow', which is produced by volcanic action and is chemically related to arsenic. China is not known for vulcanism, but one source of orpiment is in Yunnan, in mountains south of Dali. Despite being highly toxic – as alchemists discovered when they incorporated it in their attempts to make gold – it was used for many centuries, until replaced by cadmium in the nineteenth century.

So: once the pleasure dome was built, imagine teams of artisans lacquering the bamboo and artists designing and carving the dragons that swirled up the pillars, then painting them in green, red, blue and gold.

We set off again over the ocean of grass, which was more than a metaphor, because Xanadu had a problem not mentioned by Marco. It was to do with the flow of water. There were moats to be filled, and the Shandian river was downhill to the south. So the water for the moat was drawn from annual pulses through a valley to

the north-west and captured in a lake, from which it could be released as required. Impey had recorded the lake, but he had not guessed why it was there. The problem was that every now and then more water flowed through the valley than could be contained in the lake and moats, with the result that the whole place was subject to occasional flooding. Moats would fill with silt, and have to be redug. Perhaps the Cane Palace itself once threatened to float away. Xanadu's walls could one day be undermined by water.

The solution, obviously, was to build in controls, and Kublai had just the man for the job: Guo Shoujing (1231–1316), the most famous Yuan engineer, who deserves to be far better known to the outside world than he is. It was he who was largely responsible for water management in the new capital of Dadu, and towards the end of Kublai's reign he arrived to save Xanadu.

We parked in the lee of a hill. 'This mountain is called Lung Gang [Dragon Mound],' said Wei. 'Look: the flood could come any time. The mountains are only three kilometres away, very dangerous in wet weather. So this is where Guo decided to build a dam.'

I had read about Guo, knew he was influential in designing the flow of water through Beijing – I'll explain how later – but had no idea he had also been in Xanadu.

'Well, not many people know. You are the first foreigner to see this!' Wei pointed this way and that. 'The dam went for eight hundred metres from here,

the base of Dragon Mound, to that rise over there.'

He got busy with a tape measure at a spot where he had unearthed the dam's foundation. 'You see this wall. It is . . . hold this, please . . . forty-eight centimetres across . . . and this bit fifty-seven centimetres. Perhaps this was part of a supporting wall for a bank of earth. Or part of a sluice system to control the flow. There is much more we need to know. You see the *obo* on top of Dragon Mound? I think there was a guard up there to give a warning of storms in the mountains, then those responsible for the dam could take action.'

For Kublai and his entourage, summer ended on 28 August, with a ceremony. Remember the herd of white horses that Marco glimpsed on arrival? He says there were 'more than 10,000 of them, and all pure white without a speck'. If black symbolized everything ordinary, poor, low-class and inauspicious, white stood for the opposites: rank, wealth, nobility, good luck. Nothing for a Mongol could be more auspicious than a white horse, unless it is a *tumen* (10,000) of them – not that there really were 10,000, because in both Mongol and Chinese 10,000 was a synonym for 'a huge number'. The herd ranged over the surrounding pastures, being given a respectful berth by ordinary Mongols.

The milk of the mares, says Marco, was solely for the royal family (and for the Oirat tribe, which had been granted this privilege by Genghis after an important battle that Marco does not identify). For consumption,

the milk was turned into the Mongols' staple drink – *koumiss*, as it is in Turkic languages (spellings vary), or *airag* in Mongol. The preparation of this mildly alcoholic brew has been unchanged since time immemorial. You can see the same procedure in the countryside today. Mares are tied in a line; foals suckle to get the milk flowing; men remove the foals and continue milking; the milk is poured into a huge sack; and some old *airag* is added to start fermentation. Then comes the real labour, well described by a monk, William of Rubrouck (from the village of Rubrouck in north-east France, 21 kilometres south of Dunkirk), who was in Mongolia 20 years before Marco arrived in China:

They set about churning it with a club which is made for this purpose, as thick at the lower end as a man's head and hollowed out [i.e. an enormous paddle-like spoon]. As they stir rapidly, it begins to bubble like new wine and to turn sour and ferment, and they keep churning it until they extract the butter. Next they taste it, and when it is moderately pungent they drink it. While one is drinking it, it stings the tongue like poor wine [vinegar, in another translation], but after one has finished drinking it leaves on the tongue a taste of milk of almonds. It produces a very agreeable sensation inside and even intoxicates those with no strong head; it also markedly brings on urination.[8]

[8] Jackson, *The Mission of Friar William of Rubruck*.

This is your basic *airag*. A similar drink can be made from cow's or camel's milk, though it then acquires a different name. Also it can be distilled into a sort of brandy, which in my experience is so smooth and delicious and potent that it could have become Genghis's secret weapon for world dominance. *Airag*, in brief, underpins Mongolian culture. By reputation, it cures almost everything, solves problems, binds families together, seals bonds of friendship, and is in a word the Mongolian equivalent of nectar, the drink of the gods. So when the gods are to be thanked, milk is offered to Heaven. This may be done, now as always, almost casually, with the flick of the third finger, or reverentially on special occasions with a libation.

White milk from white mares – what could be more auspicious or more pleasing to Heaven? For that reason, as Marco reports,

> the milk of all those mares is taken and sprinkled on the ground . . . so that the Earth and the Air and the False Gods shall have their share of it, and the spirits likewise that inhabit the Air and the Earth. And thus those beings will protect and bless the Kaan and his children and his wives and his folk and his gear, and his cattle and his horses, his corn and all that is his. After this is done, the Emperor is off and away,

beginning the annual haul from Xanadu to Beijing.

7

FROM XANADU TO BEIJING

'OFF AND AWAY.' EASILY SAID, BUT NOT SO EASILY DONE.
Travel of any kind with the emperor was an immense
and cumbersome undertaking, with carriages by the
score, an entourage of hundreds, their horses and
the elephants. A procession on this scale could travel
only about 20 kilometres a day. Nor could it take the
direct route due south, 260 kilometres as the crow flies,
because it had to bypass steep mountains and descend
1,200 metres from the Mongolian plateau to the plain.
This meant taking a dog's-leg that made the journey half
as long again, heading south-west and turning south-
east halfway, zig-zagging down from the highlands, past
Xuanhua, where Marco had first crossed the imperial
tracks, over the final crinkly range of mountains at
Badaling, where tourists by the zillion now come to
admire the Great Wall, then on through the narrow

Juyong pass and over the plain to Dadu, today's Beijing. It took almost three weeks. And these were not happy campers, throwing up tents randomly. Every overnight stop was at a town specifically built for the purpose – and there were at least 20 of these way-stations, each one a smaller version of Xanadu, each one needing permanent residents whose task was to stand by for the two big days every year when the emperor made his stately progress to Xanadu, and then, three months later, went back again.

That was one route, the imperial route, in general terms. There were others. At the entrance to Xanadu there is a nice new plaque purporting to show them all: the main one, two short cuts that run north–south (which might actually be alternates, one going, one returning), and an eastern road that approaches Beijing through another pass, Gubeikou, about 100 kilometres to the north-east, where the Chao river cuts a valley through which the railway and new expressway now run. I had a printed copy of the same plan. The lines seem convincing, with many place-names and neat circles for towns. But they are problematical. Why four routes? How do those lines and circles and names relate to mountains and rivers and today's towns? Where exactly were the way-stations?

These are questions that not many people have asked, and answers are hard to come by. Marco, who must have taken one or more of these routes many times, is no help. To him, the journey was so routine and so irrelevant to his purpose in writing the book that he

makes no mention of it at all. Six weeks of travel there and back every year for many years, and he leaves it a complete blank. I would guess it was because the trek held no charm or interest for him, adding nothing to the fabulous wealth and ritual displays on which he focused. But think about it: several hundred kilometres of routes, punctuated by mini-Xanadus and other pony-express posts, permanently staffed by builders, cooks, housekeepers, grooms and soldiers, all awaiting their bi-annual moment of glory. It was worth trying to find out something to fill the blank.

This was, in part, what Wei had been trying to provide by looking for 'ground-truth', as archaeologists say: the evidence lying in the earth.

One day's march along the north bank of the Shandian river, over the gently rolling Golden Lotus grasslands – 20 kilometres, as you may discover on Google Earth[1] – brought Kublai, his retinue and the three Polos to their first overnight stop. Today, a track leads across the river to the unprepossessing low-rises and broad streets of Zhenglan Qi, with its smoking factory chimney, slim as a cigarette. On that 28 August, nearly 750 years ago, there would have been tents, herds, grazing horses, and the imposing little town of Huanzhou, square like Xanadu, but with walls just over half as long, and with eight buttresses – 'We call them horse faces,' said Wei – per side.

[1] Xanadu's references are 42.21.37/116.11.06 (the palace mound); Huanzhou's are 115.58/42.15.

We parked on the track, climbed over barbed wire, and strolled across mounds to more mounds. There was nothing inside this hollow square but grassy billows and a scattering of stones. But a brief survey revealed a pattern, the shape of a discreet little citadel of 300 metres per side tucked into the top right-hand corner. It had served well, because it also had a moat, hardly more than a regular dip now, built with a right angle to hug the citadel's wall. Here there had been a bridge – Wei was standing on a small rise – and there a stone portal.

'What would Marco have seen?'

'The main gate was over there, to the south.' Wei pointed in the direction of the distant line of buildings and the smokestack. 'Walls five or six metres high. An arch, with big wooden gates. *Gers* for the common people. Lots of rammed-earth buildings.' Their outlines were invisible on the spot, but you can see their soft outlines if you zoom in on Google Earth.

'But this was more than a camp site,' I said. 'Perhaps there were people here all the time?'

'Yes, all the time! It was a proper little city.'

With a history of its own, as Wei went on to explain, because this was the inspiration for Xanadu: this was the reason Kublai's people, and perhaps Genghis himself, came here in the first place. Neither Kublai nor his grandfather was the first to see the potential of the Golden Lotus grasslands. Almost 100 years before, when north China was ruled by the Mongols' predecessors the Jürchens, the fifth Jin emperor,[2] known as

[2] Wanyan Yong (Wulu) reigned as Jin Shizong 1161–89.

Wulu, led a revolution to regain the old martial spirit of his people, which he thought had been sapped by an addiction to Chinese luxuries. Like the Mongols, he had a taste for a good hunt, and for this he needed a base on the grasslands. Huanzhou was his Xanadu.

There were four of us: Wei, little Helen, me and a lanky Mongol called Tu-mu-le (Tömör – Iron in Mongolian). Once Wei's pupil, now his friend, Tu-mu-le's lugubrious face reminded me of an Easter Island statue. It was June, but a bitter wind blew, so we pulled our coats tight and huddled round Wei to hear the story, while Helen translated. 'So Wulu made this his summer vacation place. There was nothing here before he came. He named the area Golden Lotus after this beautiful little golden flower. In Chinese it's *lián*, which also means—' Helen searched for the right word '—"connection" or "union", so it sounds also like Golden Union. Very symbolic, very suitable for an emperor.'

So Kublai had been looking to a previous dynasty for a model for his own summer palace – except, of course, that as founder of a new dynasty he had to squash memories of his predecessor by taking over his creation and then building something grander nearby. As revelations go, this would not set the world aflame, but it added a nuance to Xanadu's origins and Kublai's character. By the time Marco arrived, these unwelcome details would have been lost to memory.

Wei nodded. 'It is not in any history book. One day, I will write it.'

We made our way into Zhenglan Qi for lunch. Over

Mongolian dumplings, brick tea and a steady flow of heady Mongolian vodka-like *arkhi*, Tu-mu-le revealed an affection for Marco, who was as alive as Kublai for the locals – both of them still more alive for Tu-mu-le, perhaps, given his archaeological training. Somehow that interest fitted together with a rather touching life story, the two being linked by the theme of affection. His wife, a teacher, had died of a heart attack in her own classroom. They had had no children. Then, still single, he had adopted two, one Chinese, one Mongol, living out an ideal that involved keeping both cultures in balance. Yes, Mongolians are warm-hearted people, he agreed, that was what attracted Marco to them, that was why Kublai had taken to him and given him a position and trusted him enough to send him off around the empire.

Next stop was Li Ling Tai (Platform), named after a general of the Han dynasty (202 BC – 220AD). It lay off the main road up an 8-kilometre track, though rather less of a track than it had been, because it was paved with hardcore to carry trucks to a mine of some sort, past one of those signs that are meant to inspire workforces: 'Wish for a flourishing future.' Huge circular sprays encouraged reluctant grassland to produce crops, and a diffuse spider's web of power cables and telegraph lines spoke of development.

We were approaching a line of some sort, a wall – could it be a section of the Great Wall? If you like. There are so many walls, ex-walls and boundary mounds in this old frontier area that no one has yet

sorted out what bits to call the Great Wall. Technically, Tu-mu-le said, this was the Jin Frontier Wall, which became redundant when the Mongols rode over it in 1211 in their first assault on north China. This second stopover was in the middle of farmland, with a lumpy line of hills – Camel Mountains, as Tu-mu-le called them – hemming us in to the north. The road ran straight through the city, as if it wasn't there. We climbed another barbed-wire fence, and wandered over gentle billows that were more like grey desert than grassland, so barren I wondered if the mounds were nothing more than random rises. But Wei picked up some pottery and a coin with a square hole in it. He pointed out stones that had once been the foundations of walls. And the mounds made a pattern: a 600-metre square, with the same 'horse-face' buttresses every 50 metres, and an inner sanctum 300 metres square in the south-west corner.

This was becoming repetitious. If we stopped at every way-station, I would die of cold and boredom. But there was one more place Wei wanted to see, and so did the ghost of Marco hovering over my shoulder, because we were almost at the first place that seized his attention when he was approaching Xanadu.

Having travelled north from the military base of Xuanhua for three days, he came to a place he called Chagan Nor, as it is in one of several spellings. This was the way-station Mongols knew as Tsagaan Nuur, White Lake, and Marco, revealing a previously unsuspected talent as bird-watcher, was much struck by its bird life,

which included swans, partridges, pheasants and 'other game birds' – particularly cranes, of which he noted five species – 'so that the Emperor takes all the more delight in staying there, in order to go a-hawking'. Literary scholars and historians do not usually double as bird experts, so no one saw much significance in his words, until Stephen Haw turned his attention to them. Remarkably, considering Marco was working from memory over 20 years after the event, his descriptions are good enough to allow Haw to identify all the species.[3] 'This is a striking fact,' writes Haw, 'for only a good and observant observer of birds would be likely to give such useful and accurate information.' Marco's inspiration was surely Kublai himself, who knew all about cranes because he liked to hunt them with hawks.

Where and what was this White Lake? The name has caused endless confusion, and still does. Mongolians name all sorts of features by colour, and there are many blue, black and white lakes. There's one not far to the west, which the Chinese transliterate in various ways and re-transliterate as Qagan or Chahan Nur or Nao'er. Not that it really matters, because it's not Marco's 'Chagan Nor'. His is a smaller lake further east, right

[3] For bird-watchers, the species are: the Demoiselle Crane (*Grus virgo*), grey and black with long plumes on the wings; the Japanese or Red-crowned Crane (*Grus japonensis*), very large (1.5 metres), with a head of black, white and red; the Common Crane (*Grus grus*), which breeds right across northern Eurasia; the Hooded Crane (*Grus monacha*), with bare red skin and black quills on its head, which breeds in Manchuria; and the large, grey, White-napped or White-necked Crane (*Grus vipio*).

en route, just north of today's Guyuan, and the place named after it was a couple of kilometres away. In a ferocious wind, with the sky veiled by fine dust which turned the sun to a silver disc, we followed a fine new road, neatly lined with poplars. We parked among scattered trees, in the midst of huge fields of rich, red soil. There was a ridge of earth alongside the road which turned a few hundred metres away to make a square. This, said Wei, was the Little Red City (Xiao Hong Cheng / 小紅城),[4] named for its soil, and it had once contained the palace known as White Lake. It had all gone, of course, mined over the centuries for building materials or ploughed back into the soil of which it had been made. This was not like the nested cities closer to Xanadu, more a summer camp, with a mound 15 metres square where the palace had once stood. We paced it, wind-battered and frozen, glad to get away for a brief view of the lake through a dip that had once been a grand entry to the lakeside. But the water was too far away to see any birds.

It was here the road divided: the easy western route for the emperor and his wagons, the direct route due south for messengers on their sturdy little post-horses. The way led down through Dushikou, a pass in the abandoned Great Wall, to the town of Tumu, 40 kilometres

[4] . . . though my local map says it is not 'red' but a different *hong*, 宏, meaning 'spacious'. Little Spacious City? Sounds like a misprint on the map.

west of Badaling. Now there's a nice road, of course. But until recently it was a tough journey. Lawrence Impey went this way when he visited Xanadu in 1924 (though neither he nor anyone else seems to know anything of the parallel route marked on the map at the entrance to Xanadu).

Up the valleys and through the passes winds the road, clearly defined in some places, obliterated in others, but always traceable by its succession of watchtowers. Countless thousands of footsteps have worn away the stones composing the original track, until in places where it crosses some range of hills by a defile the very rock is hollowed out for a couple of feet or more, so that the path of the pilgrim of yesteryear is become a veritable pitfall for the feet of the unwary traveler today. All the way up, from the Nankow pass above Peking to the last miles of marshland that bring one into the ruins of Shantu [Xanadu], one finds the watchtowers that guarded the trail for the great Khanate . . . these towers are landmarks for miles around.

You would not expect Kublai himself to struggle on foot or horseback through a defile a couple of feet wide. He and his carriages went the long way round, though his exact route remains doubtful. It got confused partly because a later road between Beijing and Mongolia followed a similar path – the one that led, and still leads, across the Gobi from Zhangjiakou, the town that used to be known as Kalgan, from the Mongolian for

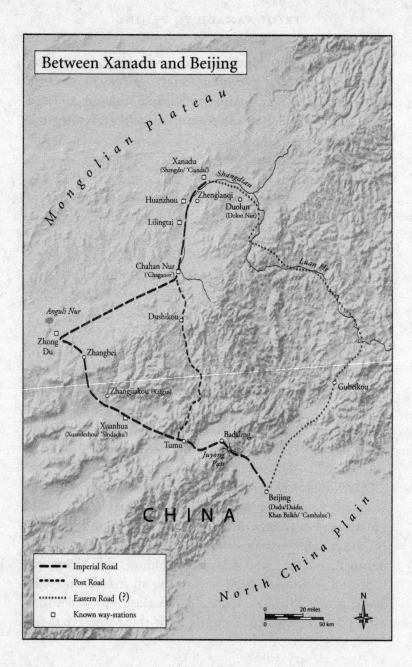

Between Xanadu and Beijing

Mongolian Plateau

Xanadu
(Shangdu/ 'Ciandu')

Shangdian

Huanzhou Zhenglanqi

Duolun
(Dolon Nur)

Lilingtai

Chahan Nur
('Chaganor')

Luan He

Anguli Nur

Dushikou

Zhong
Du

Zhangbei

Zhangjiakou (Kalgan)

Gubeikou

Xuanhua
(Xuandezhou/ 'Sindachu')

Tumu

Badaling

Juyong
Pass

CHINA

Beijing
(Dadu/Daidu,
Khan Balkh/ 'Cambaluc')

North China Plain

— — — Imperial Road

- - - - - - Post Road

• • • • • • • Eastern Road (?)

□ Known way-stations

0 20 miles

0 50 km

N

the 'gateway' into Mongolia. Confusion followed on confusion – so please forgive what's coming – because the third Mongol emperor, Khaishan (who ruled 1307–11), decided to build his own palace-city, a place travellers knew as Tsagaan (or Chagan) – yes, White again – Balgasun, *balgas* being an old Turkic–Mongol word for 'town'. It was not far from a lake named Anguli (安固里). To Chinese, the town was a straight translation of the Mongol, the White City. But the 'White' convinced some nineteenth- and twentieth-century travellers that this must be the place described by Marco, and that the nearby lake must therefore be Marco's White Lake, when in fact there was that other White Lake, also not Marco's, about 50 kilometres further west, the real White Lake (Marco's) being the one I mentioned earlier, to the east.

In an attempt to make sense of this, I was happy to seek some 'ground-truth'. Wei knew the way around back-roads and fields to the White City, which turned out to be in rather better shape than Xanadu, probably because it wasn't ravaged when the Mongols were thrown out. The walls, several metres high, but ragged as torn cardboard after centuries of rain and wind, converge on the remains of a great gateway to a triple palace-within-city-within-city structure. Wei sketched the plan with a stone on the dusty earth. It was like Xanadu, but bigger. Why, I wondered, did Khaishan need this place, when he had inherited numerous way-stations and Xanadu itself?

'He loved luxury!' said Wei. 'He wanted to show

himself greater than Kublai Khan! He gave it a new name, Zhong Du [Central Capital]. But it was never finished. He only reigned for four years, and his heir, his brother, never wanted it. So it was never used.'

Interesting, but useless for me, seeking Marco. Marco could not have been here. I was off-track – though not by much, because Kublai did have a way-station near here, according to the Yuan annals.[5] It was called Khara-balgasun, Black City, which seems to have vanished off the face of the earth, despite having several other names and being an important local town before, during and after the Mongol period.[6] I wonder . . . a Black City and a White City so close together, both on the main road between China and Mongolia, both on the corner where emperors turned off right to Xanadu – could they possibly have been one and the same? Only more ground-truth would tell, and who knows how long *that* would take.

There was only one more thing I wanted to do before moving on: see Lake Anguli, to get a feel for the wealth of bird life Marco had described. I imagined cranes by the thousand in residence and/or – I really had no idea about the habits of cranes – migrating between Manchuria and the tropics of south-east Asia. It shouldn't be hard. Anguli was on every map; I had seen it from space glistening like a jewel on Google Earth,

[5] See Bretschneider, *Archaeological and Historical Researches*, fn. 108.
[6] The other names included Fu-chou (Fuzhou), Lung-hing Lu and Hing-ho Lu (a *lu* being a large administrative unit).

and – zooming in – as a shield measuring 9×5 kilo-metres. And Wei was keen, because he hadn't been to the lake for eight years.

Half an hour later, we were almost there, in the midst of vast grasslands. A herd of horses grazed near a dozen concrete *gers*, which a sign proclaimed to be 'Anguli Holiday Camp'. There was no one around. It looked more like a punishment centre. We drove up a slight rise to give ourselves a view over the lake, which was surely nearby.

There was absolutely nothing there.

We stared, amazed, unable to take it in. Nothing but skimpy grass to the hazy horizon. Maybe we were in the wrong place. Wei stopped a man on a bike to ask. Yes, he said, that was Anguli, had been for centuries, except it wasn't any more. Global warming had sucked it dry. 'Eight years ago, we had water. Then three or four years ago, it dried up and vanished.' No wonder the holiday camp looked a bit forlorn. Well, maybe there was a hint of something white glistening in what used to be the lake's centre, but nothing like the 45-square-kilometre shield I had seen on Google Earth. The reason, as I dis-covered back home, is that Google Earth is only as up-to-date as the source – in this case, one of the cheaper commercial satellite companies – which means the images are up to three years old, and maybe more in obscure areas like this. It will take a few years yet for Anguli to vanish on-line as it has vanished on the ground.

* * *

Anyway, wherever Kublai spent his tenth night en route, he now headed south-east, over the last of the grass-lands, and four days later, having spent more nights in as yet undiscovered way-stations, came to the edge of the Mongolian plateau, from which there was – and is, on clear days – that stupendous view southward over hills and valleys speckled with shadows to the faint mountains that guard Beijing. His entourage and its wagons ground downward, west of the empty spot where Kalgan, today's Zhangjiakou, would arise, to the lowlands, and to Xuanhua, the local capital where Marco first crossed the imperial track.

No one from Kublai's time would recognize today's Xuanhua, big, and busy with roads and traffic. Its historic monuments – city wall, gate tower, drum tower, bell tower, dragon screen – all date from much later, except for something that Wei was keen to hunt down. A phone call summoned a local expert, Mr Liu, a solid middle-aged official on a scooter, who cheerfully led the way down back-streets to a vineyard, with vines strung out on bamboo poles (Xuanhua is famous for its grapes). There, dividing two vineyards, against a back-drop of drab apartment blocks, was a bit of a wall, 3 or 4 metres high, of grey rammed earth. Another bit nearby was crowded almost out of sight at the back of a huddle of farm buildings.

This was very important, said Mr Liu, because it was all that was left of a medieval monastery, the Zhao Yuan temple. The Daoist monk Changzhun (Ch'ang-

ch'un in his Wade–Giles spelling), summoned by
Genghis Khan, stayed here in February 1221 on his way
to meet Genghis in Afghanistan. It was a rich place
then, and big enough to dominate this whole area,
200–300 metres per side. When news came of the
Master's approach, the local governor had hastened 'to
repair the main buildings, fill it with holy images and
redecorate all the adjoining cells and outbuildings'.
Perhaps the temple was Kublai's way-station. If anyone
wants to do any archaeology, they'd better hurry: there
are only a few metres of it left. You see, Mr Liu went on,
Xuanhua was famous as a natural frontier-town, away
from mountains, well supplied with its own food, and
wonderfully positioned for trade. It was only later that
Kalgan/Zhangjiakou took over from it, which is why in
Marco's day the old road up ran somewhere to the west
on its still-to-be-discovered way up on to the grasslands.

And so the royal entourage had pressed on for
another 90 kilometres, four or five days' journey, spend-
ing nights in more undiscovered palaces, to the last line
of hills before Beijing, the gentle climb to Badaling and
the final drop through the Juyong pass. From there it
was a mere three more days across open ground to
Kublai's new capital.

So much for the imperial route between the two
capitals, with its short cut for messengers. What of the
third one, the eastern route marked with equal certainty
on the map at the entrance to Xanadu, of which I had a
copy? It apparently ran from Xanadu down the valley

of the Shandian river, which becomes the Luan, and then approached Beijing along the main road through the Great Wall at Gubeikou. But it only marked four places, which may or may not have been way-stations. This seemed odd, given that the other two routes had about 40. Wei, who had not as yet done any archaeology this way, was adamant the emperor had used the two equally, going north by the eastern route in the spring 'to avoid the winds'. It was time for some ground-truth.

To start with, the signs were good. After passing Xanadu, the Shandian river curves east, then south around a steep hill, joining with a tributary from the north. Nearby was a smallholding, where Wei was delighted to find minute remnants of his lost world: a sliver of wall, a marble block that had been built into a silage pit, the faint line of a town wall almost covered by drifting sand. This had once been Dong Liang Ting, the East Cool Pavilion, last stop perhaps in the emperor's progress northward, if he really came along the eastern route. A few kilometres south was Duolun / 多伦, which bore many reminders of its Mongol roots. Its name comes from Dolon Nur, Mongol for Seven Lakes, all of which have now vanished, like Anguli, and half its 200,000 people are Mongolian. Southward, new roads, a new railway and a new coal-fired chemical plant made my new map as out of date as last year's laptop. It will, for example, take a while for maps to show a sinuous new lake, 15 kilometres long, created from the Luan (as the Shandian had now become) by a

dam built in 2000. When the Yuan dynasty fell in 1368 the rebels, known as Red Turbans, camped at the dam site. No doubt, before 2000, Wei could have dug up some revealing items. Now it's all under immeasurable amounts of concrete and water.

Of the journey south on the eastern road, what shall I tell you (to paraphrase Marco)? Very little to do with him, or Kublai. The lake, which already supplies impressive fish to Duolun, is in immense and empty hill-country, which, if Duolun goes on growing at current rates, will no doubt soon have its first golf course. Further on, soft hills and the occasional village, where ducks and cattle share the road with carts and the few cars, gave way to an immense embankment and a new tunnel through a mountain, a major link between Hebei and Inner Mongolia for settlers and trucks.

'Wei, this pass is new. There's no other way through. Do you really believe that there was an old route along the river?'

He was silent.

I pointed at my map. 'Look at this big gap with only one place name between the Great Wall and where we started.'

'Yes. Yi Xing Zhou. It's not a place. It's another pass.'

'No palace?'

'No palace.'

Occasionally the road dipped down to the Luan's river bank, but the valley was narrow, and once, before the coming of the road, it must have been subject to floods. Same thing when we crossed over to the next

valley and wove our way down the Chao towards the Great Wall at Gubeikou. No emperor in his right mind would go either over the mountains or along the valley floors.

'And surely, if there were way-stations down here, someone would know,' I said. 'They would be marked on the map.'

I was beginning to wonder if the map was merely wishful thinking. The western route for the emperor and the middle route for messengers: those we knew about from independent sources, confirmed by Wei's research. But this one had no ground-truth, in fact the opposite. There are ways northward, sort of, from Gubeikou, but the main ones lead north-west along the Chao river or almost east to the later imperial summer palace of Jehol, today's Chengde. To go north to the Luan would mean crossing some very challenging heights. Yes, there are several possible ways over the mountains, but why bother? Why take a tougher and longer route? It didn't make sense. And if there had been a regular route, surely Marco would have mentioned it, and perhaps a name or two?

Where had the idea of an eastern road come from? The Persian historian Rashid al-Din, writing during the Mongol period, says, 'The third road takes the direction of the pass of Siking [which is unidentified], and after traversing this you find only prairies and plains abounding in game until you reach the city of Kaimingfu [Xanadu], where the summer palace is.' But Rashid never went to China, so naturally there's not much to go

on: a pass that may not exist, no mention of mountains, and rather too much emphasis on the plains, which are really not much in evidence until you get to Xanadu. Emil Bretschneider, a nineteenth-century botanist, physician at the Russian legation, and assiduous historian of Beijing who knew the area intimately, is adamant, but vague because he never explored the route: 'This road, according to the ancient itineraries, was used generally by the officers in the suite of the emperors, and for conveying the baggage to the emperor.' His source was a manuscript pamphlet 'compiled by a learned Chinese of our days, from [unnamed] works written in Mongol times'.[7] It all sounds very iffy. Was there really an eastern route at all? If so, where did it run?

Well, the man to answer these questions was right there, and now as sceptical as me. 'As a result of this trip,' Wei said, as we slipped on to the motorway leading back to Beijing, 'I will plan an investigation of the eastern route.'

[7] The pamphlet was entitled *Yuan shang du yi cheng kao* /元上都 驛 程考 (Yuan Shangdu Relay-Station Journey Research), quoted in Bretschneider, *Archaeological and Historical Researches*.

8

KUBLAI'S NEW 'GREAT CAPITAL'

BEIJING WAS NOT DESTINED FOR GREATNESS. FOR 3,000 years it aspired at best to regional prominence. Then, by chance, it had greatness thrust upon it, as Marco describes in some detail. What he does not describe is how the city came to be a potential capital for Kublai in the first place.

When China first became China in the third century BC, its heartland was way to the west, and so were its many successive capitals. They revealed a tendency that ran through the next 1,500 years: as capital succeeded capital, each one was further east. Only in the early tenth century did Beijing emerge from the shadows, thanks to the Khitans, who swept in from Manchuria to seize all of China's north-east and Mongolia from the Song. Not many people nowadays know about the Khitans, but they were once famous enough for

foreigners to use their name for China: Kitai (Russian), Khiatad (Mongol) and Cathay, which remained in use in English and other European languages until recent times, and is still used commercially by corporations, shops, restaurants and a major airline. A century later another group of 'barbarians', the Jürchen from Manchuria, made Beijing their 'Central Capital' (Zhongdu). The south, what remained of Song, was left alone. So when Genghis assaulted north China in 1211–15, it was Beijing that was the key to conquest: a square of 3.5 kilometres per side which stood just south-west of today's Tiananmen Square. Genghis ruined the place, and it remained ruined for decades. In 1260, when Xanadu was rising as Kublai's base, Beijing's original heart was still broken, with shattered walls and burned-out palaces.[1]

With all north China as his new fief, Kublai had a decision to make. He might have ignored old Beijing and ruled from Xanadu, a Mongol capital with Chinese characteristics. But if he did that he would declare himself forever an outsider. Seeing the benefits of governing

[1] Beijing has had many names. Traditionally, it was Yanjing (Southern Capital), then Zhongdu (Central Capital, 1153–c.1215), then Yanjing again (c.1215–72) and finally Dadu (modern Chinese, Great Capital) or Daidu (thirteenth-century pronunciation, and Mongol spelling), or popularly Khan-baliq (Mongol–Turkic), Marco's 'Cambaluc'. The Ming (1368–1644) named the city Beiping, then later – finally – Beijing (Northern Capital). Note the two words for 'capital' or 'big city'. In the past, *Du* could be a stand-alone word (the modern equivalent is *Shoudu* / Leading Big City); *Jing* can be used only in combinations, as in 'The emperor chose Bei*jing* as his *Du*.'

from a Chinese base, he might have chosen to revive an ancient seat of government, like Kaifeng or Xian. But Beijing had one major attraction: it was close to Xanadu and to the Mongolian grasslands. In 1264, only eight years after starting Xanadu, Kublai decided to make Beijing his main base. This would complete a progression away from the Mongolian steppes into China. He would abandon Karakorum and commute between his two bases, spending summers in Xanadu and winters in Beijing, which was his way of straddling his two worlds. It would remain his capital when the conquest of the south was completed in 1279. That's why Beijing is China's capital today.

But how best to handle this dilapidated piece of real estate? Incoming dynasties have often made their mark by total demolition and reconstruction (as the Ming would do to Mongol Beijing). Perhaps there was a year of indecision, for in 1261 the walls of the old city were mended, as if Kublai was on the verge of building on the past. But these ancient alleyways would be seething with resentment, and to rebuild on the ruins would be to accept the agenda of a defeated dynasty. Best start afresh.

Just north and east of the Jin (Jürchen) capital was a perfect site, where runoff from the western hills fed Beihai (the North Sea), which for 30 years before the Mongols arrived had been a playground for the wealthy. The 35-hectare lake had been made as the local expression of an ancient legend about three fairy mountains where the immortals lived on the miraculous

Potion of Immortality. In the second century BC, Emperor Wu Di of the Han had had a lake dug by his palace in his capital, with three islets representing the fairy mountains. Later emperors did the same in their respective capitals – including the Song in Beijing in the late tenth century, excavating an area made swampy by a little river to make Beihai and giving it the traditional three islands. It was this carefully landscaped beauty spot that the Jin emperor chose for a summer palace in the twelfth century, the Palace of a Myriad Tranquillities; he also built a second retreat on top of today's Jade Island, the city's highest point (now crowned by the seventeenth-century White Dagoba, Beijing's equivalent of the Eiffel Tower). The imperial buildings had been ransacked when Genghis's troops took Beijing in 1215, but the lake was still at the heart of the abandoned and overgrown park. It was natural that Kublai should choose it as the centrepiece of his new city.

With Xanadu being in part Mongol – remember the hunting park and surrounding grasslands – the new capital would be thoroughly Chinese. In the autumn of 1263 the emperor arrived from his summer capital to reclaim an area that was half-wilderness after 50 years of neglect: the lake silted and overgrown, summer-houses decaying round its edges, and here and there smallholdings where farmers had colonized the once-royal parkland. Saplings and bushes were cleared, and an imperial camp sprang up: a royal area of grand *gers*, lesser establishments for princes and officials, hundreds

more for contingents of guards, grooms, wagoners, armourers, metal-workers, carpenters and other workers by the thousand, including, of course, architects.

Kublai's first step was to commission an Ancestral Temple. In honouring his ancestors, Kublai could prove himself both a good Mongol and a good Confucian. The temple's eight chambers were local versions of the Eight White Tents that were already established as travelling shrines to Genghis back in Mongolia and centuries later would reach their final resting place, Edsen Khoroo, the Lord's Enclosure, south of Dongsheng, Inner Mongolia. (In the 1950s they were replaced by a new shrine, the temple known as the Mausoleum of Genghis Khan.) Kublai's original eight-chambered Great Temple commemorated his great-grandparents, Genghis's parents; Genghis himself; and those of his sons and grandsons who had ruled as Kublai's predecessors. Genghis also acquired a Chinese title, Taizu (Greatest Ancestor or, as we would say, Founding Father) – the same one given posthumously to the founders of several other dynasties. It was Kublai therefore who gave Genghis his Chinese credentials, and thus founded the widespread belief among Chinese today that Genghis was 'really' Chinese; which, in the eyes of many, makes all Mongols and Mongolia itself Chinese.

Overall authority for the design of the new city was borne by Liu Bingzhong, the architect of Xanadu. But among his team of architects was one of particular

significance, named something like Ikhtiyar al-Din.[2] Being a Central Asian Muslim, Ikhtiyar is not mentioned in the official Chinese sources; that we know of him at all is due to a Chinese scholar, Chen Yuan, who in the 1930s came across a copy of an inscription dedicated to Ikhtiyar's son, Mohammad-shah. Ikhtiyar must have proved his worth in Persia after the Mongol conquest a generation before, for he was summoned to head a department in the Ministry of Works, and had become an expert in town planning. Now an elderly man, he was selected to mastermind Kublai's grand new scheme. In autumn 1266, the inscription says, the court ordered the planning of the new capital's walls and palaces,

> passes and gates, audience halls, roads, and residential quarters, informal reception rooms and detached courts, administration offices, shrines, guard houses, storerooms for clothes, food and utensils, quarters for officers on duty in the imperial household, and so on up to pools, ponds, gardens, parks and places for dalliance, high storeyed structures and beamed pavilions and verandahs with flying eaves ... In the 12th month [28 December 1266–12 January 1267] a decree was issued ordering [three Chinese officials] and Ikhtiyar al-Din to take on together the duties of the Board of Works and carry out the programme of constructing the palaces

[2] Or Igder al-Din, both being rough retransliterations from the Chinese version of his name, Ye-hei-die-er-ding / 也黑迭兒丁.

and city walls . . . All met with imperial approval. The services of Ikhtiyar al-Din were highly appreciated, but he was beginning to feel the weight of his advancing years.

Yet in the official Yuan history, Ikhtiyar's name is omitted, the only individuals mentioned being his three – junior, but Chinese – colleagues. Ikhtiyar was simply written out of history, until Chen Yuan deciphered the inscription.

Liu Bingzhong and Ikhtiyar planned a city that would have the traditional form of previous capitals (like Xanadu): a nested pattern of palace within inner city within outer city. The design recalled the ground plans, and the grandeur, of several previous capitals – most notably Xian, once the world's greatest city. This was the mantle of power and glory to which Kublai now laid claim.

In August 1267 work began on the ramparts, which would stretch over the hills and along the three winding rivers. As the several thousand labourers set about their task, the 382 smallholders who had moved into the area were thrown out, with the equivalent of compulsory purchase orders – they all received compensation in 1271. How was all the building material to be brought in? Ox-wagons would not do. The answer was provided by one of Kublai's geniuses, the astronomer, designer and now water-engineer Guo Shoujing, who opened up one river (the Jinkou) and rerouted another (the Lugou) to bring in lumber from the mountains to the west.

After a year, rammed-earth walls 10 metres thick at the bottom rose for 10 metres, tapering to a 3-metre walkway at the top. They made a rectangle of just over 5.5 × 6.5 kilometres, 28 kilometres all the way round, punctuated by eleven gates.[3] Inside, a second wall rose to conceal the Imperial City, and inside that a third wall, within which in due course would lie the palace, enclosed by its own walls.

From March 1271 more armies of workers – 28,000 of them – began to build the Imperial City's infrastructure, setting out a network of right-angled roads, Manhattan-style, each block the property of a top family, complete with its grand house. A year later it became Dadu, or rather Daidu, which was how Chinese pronounced it then and what the Mongols called it. Informally, it was also Khan-baliq – Marco's Cambaluc – the Khan's City, because that was what Turkic and Mongol peoples traditionally called their leaders' HQs. At the heart, off-centre, just to the east of Beihai, was the palace: unfinished, but ready enough in 1274 for Kublai to hold his first audience in the main hall.

All of this explains why Beihai Park is today at the heart of the city. Beijingers and tourists owe Kublai some gratitude. It was he who first built a bridge across to Jade Island (replaced late in his reign by today's marble Eternal Peace Bridge), landscaped its slopes with rare trees and winding staircases, and bestowed poetic names on temples and pavilions – Golden Dew, Jade

[3] Marco says there were twelve, but he got it wrong.

Rainbow, Inviting Happiness, Everlasting Harmony. Naturally, as incoming monarch, Kublai replaced the old palace on the top of Jade Island with a new one – its footprint is today's Circular City – having increased the height of the hill with soil excavated from the lake-bed. This, presumably, was where he held court while the city proper was under construction nearby.[4]

The hilltop palace is now long gone, but is recalled by a surprising object standing in its place in the Circular City. In one of the palace's seven halls was a second, miniature palace, and in this was a bed, inlaid with gold and jade, from which Kublai liked to hold court. Beside the bed was an immense jade urn, weighing 3.5 tonnes, intricately carved with dragons cavorting in waves. From this Kublai would dispense wine, 3,000 litres of it. Lost for over 400 years, it was rediscovered in the eighteenth century and placed again at the top of the hill, sheltered by its own little pavilion and on a new jade stand. Today, tourists buy little red charms to hang from the surrounding fence: Good Luck All Life! A Prayer for the Whole Family's Happiness!

There's not much else left of Kublai's Beijing, the one Marco knew: just one impressive building, created by Kublai while the city was being built, at a time when he needed all the spiritual help he could get in the conquest of the south and in seizing control of his immense new empire. He commissioned a temple, the Baita Si, the White Pagoda. Its site was west of Dadu, in a place of

[4] See Kates, 'A New Date for the Origins of the Forbidden City'.

power. There had been reports of fireballs bursting from the low-lying soil here, perhaps flares caused by marsh gas. Kublai ordered an excavation, and by happy chance his workers found ruins, and coins, and a stone tablet engraved with dragons: surely a sign that a dragon-palace had once stood there, making it an ideal site for a royal temple. It was Kublai himself who marked out the area, by means of an ancient Mongol practice. He fired arrows to the four points of the compass, each 200-metre shot defining the distance to a wall, creating a compound of 400 × 400 metres. Time and the encroaching city have reduced the area, but the pagoda itself, like a great upside-down ice-cream cone, remains much as it was in Kublai's day.

The temple was Buddhist through and through. For 20 years Kublai had thrown in his lot with Buddhism, for two main reasons. The first was that he needed to assert a claim to Tibet, which had been under Mongol control since the 1240s. The second was that he needed to assert his claim to universal rule, and this was exactly the claim made by Buddhists for their 'universal emperor', or Chakravartin Raja. This was something not on offer from Confucianism, Daoism, Nestorian Christianity or shamanism. To this end he had taken on a Tibetan spiritual adviser, known as Phags-pa (Noble Guru), and to buttress his claim – and aid in his military advances in the south – the White Pagoda would be a shrine to Buddhism's most fearsome god, Mahakala, the 'great black one'. His image is still worshipped by monks in the White Pagoda: black face, three staring

eyes, a ferocious snarl, a head-dress of skulls set in yellow hair. To build the complex, Kublai naturally chose a Buddhist: a 27-year-old Nepalese architect and painter named Arniko (or Arnige, as he is in Chinese), whose elegant statue stands beside his creation.

As the chequerboard of streets and new buildings began to turn a work-site into a capital, Kublai had another decision to make. He needed to announce the start of a new dynasty, for which he needed a name. Clearly, a Mongol name would not go down well with his Chinese subjects. It was his adviser Liu Bingzhong who came up with the solution. It is the first word in a phrase in the great book of divination, the *I Ching* (*Yi Jing*): *yuan*. The dictionary definition of *yuan* is first, chief, principal, fundamental. But there is much more to it. This, in summary, is what Stephen Karcher has to say about *yuan* in his *Total I Ching: Myths for Change*: Yuan is the ultimate source, the *primum mobile*, the movement behind the absolute origin of the universe. It is the power of spring, and of the east. As well as implying primacy, it also suggests the concepts of 'eldest' and 'the source of thought and growth'. It signifies the good man and a connection with fundamental truths. It is linked to ideas of fundamental rituals, greatness and founding acts. No name could have better appealed to Chinese sensibilities (which is why, incidentally, it is also the name of today's Chinese unit of currency).

Meanwhile, great events were under way to the south. Kublai had started the invasion of Song, and had hit a

major obstacle, about which Marco had a good deal to say, blowing up an enduring storm of controversy as a result.

The key to conquest was the mighty Yangtze, beyond whose lower reaches lay the capital, Hangzhou. The Yangtze flows west–east, while Kublai's armies advanced from the north. But a major tributary, the Han, swung southward, making a river-road straight down to the lower Yangtze – and Hangzhou. There was just one problem. The Han had its own key, in the form of the town of Xiangyang.[5] Today, Xiangyang and its sister-city across the river, Fancheng, form the super-city of Xiangfan. In Kublai's day, Xiangyang was a moated fortress-city and a major trade crossroads of 200,000 people, linked to Fancheng by a pontoon bridge of boats moored between posts driven into the river bed. Xiangyang would have to be eliminated by any army heading south by river. This was common knowledge, so Xiangyang had been busy rebuilding its defences. It had 6 kilometres of solid stone walls, some 6–7 metres high, set in a rough square just over a kilometre across; three of the six gates gave directly on to the river, which was a high road for supplies and communication half a kilometre wide when it was in flood, and far too deep to wade; in winter, when the water was low, it became a maze of channels and sandbars. The moat, fed from the river, was 90 metres across. All of

[5] Xiangyang has been through all sorts of different versions and spellings – Saianfu in Marco Polo, Sayan-fu in Rashid, Hsiang-yang in more recent, but pre-pinyin times.

this meant that attackers could not get close enough either to assault the walls with ladders and towers or undermine them.

This presented the Mongol general, the brilliant 32-year-old Aju, with a knotty problem. After a siege that dragged on for five years, Aju advised Kublai that he needed more and better artillery, powerful enough to smash down Xiangyang's walls. The Mongols already had artillery of many kinds – mangonels, trebuchets, arrow-firing ballistas – having acquired the technology and specialist troops after the siege of Beijing in the year of Kublai's birth. But current artillery simply didn't have the range or the power, and no one in Mongolia or China had the expertise to build bigger, more powerful siege engines.

Kublai, hearing of the problem, also saw the solution. He needed the empire's best siege-engine designers, who happened to be in Persia, 6,000 kilometres away, two-thirds of the way across the empire. The siege of Baghdad by his brother Hulegu in 1258 had ended when huge catapults, known as counterweight trebuchets, breached its walls. That's what Aju needed now, in Xiangyang.

In these trebuchets the power was supplied by a counterweight, a box filled with ballast, usually of rocks or earth. The weight could be many tonnes, the throwing arm over 10 metres, the missile itself 100 kilos or more (modern trebuchets sling cars and pianos). In the Islamic world these machines had developed in the twelfth century, spreading to Europe soon after the

crusading armies came across them in about 1200. By the end of the fifteenth century they were gone, blown away by gunpowder. But at the time of the siege of Xiangyang, they were in their prime.

Nothing could have shown better the advantages of having an empire all run by one family, bound together by a network of transcontinental communications. Off went Kublai's letter by pony express. Five weeks later his message was in Tabriz, northern Persia, HQ of his nephew Abaqa, Hulegu's son and Il-khan since the death of his father in 1265. Abaqa had on hand several siege-engine designers who had built the counterweight trebuchets used in many sieges: Baghdad, Aleppo, Damascus, Syria's crusader castles. He could spare two of them: Ismail and his assistant Ala al-Din.[6] In late 1271 the pair arrived with their families at Xanadu, and were given an official residence for the winter. The following spring, after building a catapult to demonstrate the principles to the emperor, the two men – plus, apparently, Ismail's son, whom he was training to follow in his footsteps – found themselves in the battle zone, staring at Xiangyang's solid walls, the moat, the broad river and Fancheng, Xianyang's sibling city across the river.

Ismail's task was to sling a 100-kilo ball of rock at Xiangyang's walls, from a position at least 100 metres

[6] Rashid gives completely different names: Taleb and three sons, which sounds like another family altogether. I have not seen a resolution to this, and follow the Chinese sources, the *Yuan Shi*.

away on the other side of the moat. So this had to be a machine too large to be manoeuvrable. That meant he had to position himself and the crew yet further away, out of the range of arrows and bombs from the walls. That increased the range required to some 200 metres, which demanded an even bigger machine, something that would weigh 40 tonnes and tower almost 20 metres high.[7]

That summer, Ismail and Ala al-Din set their teams to work, felling suitable trees in nearby forests and hewing rocks for missiles. Then, having smashed the pontoon bridge across the river, the Mongols turned on Xiangyang's sister city, Fancheng. Ismail's catapult 'breached the walls . . . [and since] the reinforcements from Xiangyang no longer reached the fortress, it was captured'. Its inhabitants – some 3,000 soldiers and an estimated 7,000 others – had their throats cut like cattle, the bodies being piled up in a mound to make sure that the massacre was visible from Xiangyang. Then Ismail was told to turn his siege engine on Xiangyang itself. Ismail, a master of his art, now knew his machine's abilities very precisely. The missile, we are told, weighed 150 catties, which is just short of 100 kilos. The result was astonishing. In the words of a Chinese biography of the Mongol general Ariq-Khaya, 'The first shot hit the watch-tower. The noise shook the whole city like a clap of thunder, and everything inside the city was in utter confusion.'

[7] I tell this story in greater depth in *Kublai Khan*, ch. 8.

What now? An assault, ending with another pile of bodies, arousing understandable revulsion among the Mongols' potential subjects downriver? Ariq-Khaya went in person to the foot of the wall, called for the city's leader, and put to him the benefits of surrender. On 17 March 1273 the city was opened to its conquerors.

It is hard to overstate the significance of this victory, for it opened the way to the conquest of the south and the reunification of China under Kublai. Rightly, it is one of the most famous sieges in Chinese history, so famous that Marco Polo heard its story and loved to tell it. The trouble was that by the time he came to dictate his adventures he had apparently told the story so many times that he had written major roles for himself, his father and his uncle. His account of the siege of 'Saianfu' is, if you wish to be generous, garbled. To many scholars, it sounds like a flagrant bit of self-promotion. Let's be frank: it's a lie.

This is how Marco and his ghost, Rustichello, recorded the affair in the Yule–Cordier edition:

Now you must know that this city held out against the Great Kaan for three years after the rest of Manzi had surrendered [not true: Manzi – i.e. Song – fell in 1279, six years after the siege]. The Great Kaan's troops made incessant attempts to take it, but they could not succeed ... And I tell you they never would have taken it, but for a circumstance that I am going to relate.

You must know that when the Great Kaan's host had

lain three years before the city without being able to take it, they were greatly chafed thereat. Then Messer Nicolo Polo and Messer Maffeo and Messer Marco said: 'We could find you a way of forcing the city to surrender speedily;' whereupon those of the army replied, that they should be right glad to know how that should be. All this took place in the presence of the Great Kaan . . . Then spoke up the two brothers and Messer Marco, and said: 'Great Prince we have with us among our followers men who are able to construct mangonels which will cast such great stones that the garrison will never be able to stand them, but will surrender incontinently, as soon as the mangonels or trebuchets have shot into the town.'

The Kaan bade them with all his heart have such mangonels made as speedily as possible. Now Messer Nicolo and his brother and his son immediately caused timber to be brought, as much as they desired, and fit for the work in hand. And they had two men among their followers, a German and a Nestorian Christian, who were masters of that business, and these they directed to construct two or three mangonels capable of casting stones of 300 pounds weight. Accordingly they made three fine mangonels, each of which cast stones of 300 pounds weight or more. And when they were complete and ready for use, the Emperor and the others were greatly pleased to see them, and caused several stones to be shot in their presence; whereat they marvelled greatly and greatly praised their work. And the Kaan ordered that his engines should be

carried to his army which was the leaguer of Saianfu.

And when the engines were got to the camp they were forthwith set up, to the great admiration of the Tartars. What shall I tell you? When the engines were set up and put in gear, a stone was shot from each of them into the town. These took effect among the buildings, crashing and smashing through everything with huge din and commotion. And when the townspeople witnessed this new and strange visitation they were so astonished and dismayed that they wist not what to do or say. They took counsel together, but no counsel could be suggested how to escape from these engines. They declared they were all dead men if they yielded not, so they determined to surrender ... and all this came about through the exertions of Messer Nicolo, and Messer Maffeo, and Messer Marco; and it was no small matter.

It is a good story, but full of holes. There is no detail about the trebuchets and no mention of Fancheng; only vague references to 'followers' who never appear again and unconvincing generalizations about Xiangyang. And the clincher: young Marco, aged just 21, did not reach Kublai Khan's court until 1274 or 1275, at least one and perhaps two years after the great siege was over. There is absolutely no way he or his father and uncle could have had anything to do with devising a catapult, and really no excuse for Marco writing the Polos in and Ismail and Ala al-Din out. The whole thing is an exercise in self-aggrandizing invention.

Well, both he and Rustichello were story-tellers. But there is a difference between hype and deception. All one can say is that it was not the first time, or the last, that Marco's truth was overridden by his ghost.

So, in mid-September 1275, only a year after Kublai's first audience in his new capital, Marco approaches 'Cambaluc' in the company of the emperor, or at least not far from him. Behind is the last of the sharp-edged hills that guard the 50 kilometres of open ground separating mountains from capital. An unpaved road, temporarily cleared of a myriad ox-carts by guards, is cleaned and smoothed by armies of labourers; peasants are cutting and stacking corn; villages of single-storey mud-brick houses dot the countryside; in the distance, buildings, walls and towers emerge from a haze of smoke. Then the suburbs: a sea of the same houses, most with pocket-handkerchief plots of land for vegetables, crops and fruit trees, but scattered among them grander residences and inns for foreigners – mainly merchants, 'of whom', says Marco, 'there are always great numbers who have come to bring presents to the Emperor, or to sell articles at court'. Houses crowd each of the eleven gates, spreading outwards for a kilometre or two. These suburbs, 'so great that they contain more people than the city itself', pulse with life and death in the raw. The haze is made by the smoke of funeral pyres, for burial inside the city is banned and the dead must be carried well outside the walls for cremation. And because no prostitution is allowed

inside the walls, 20,000 'public women' (I wonder how Marco had an idea of their numbers?) who cater to the foreigners must ply their trade out here in the suburbs.

Closer to, the 10-metre wall looms from the smoky air; indeed, although made of earth, it glows, because it is whitewashed (as was customary for great earthwork fortifications, like the early Great Wall). Sloping back a few degrees to the battlemented walkway along the top, it extends out of sight, its far ends vanishing back into the haze. The imperial procession skirts the wall, following it south for 6.5 kilometres before turning right towards the middle of the south wall, to the great gate reserved for the emperor's use. Inside, a walled entry leads to the first of the inner cities, the Imperial City. Another wall, another gate, and they are into the sanctum of the rich and powerful with their great mansions and gardens and armies of servants. From here the way leads over a moat, crossed by a three-arched marble bridge divided into three passageways, the central one being reserved for the emperor. Then onward towards three gates, the central one – 50 metres across, flanked by towers, and with five doorways – being the emperor's entry to his innermost sanctuary.

The palace itself, now nearing completion, is the jewel-box created to contain the supreme embodiment of omnipotence, Heaven's own choice to rule the greatest political entity since the Fall of Rome, against which the Arab and Russian empires would have paled. It is a single storey, raised a metre or so above the ground by a marble terrace, reached by marble

staircases at each corner. Its lustrous, varnished wood-work and its roof of red, yellow, green and blue tiles make it glitter in the sun 'like crystal'. Its walls, adorned with sculptures of dragons, animals, 'knights and idols', are 'all covered with gold and silver'. It covers a huge area, with an audience hall 'so vast, so rich and so beautiful that no man on earth could design anything superior to it'. This hall, named Great Brilliance (Da Ming / 大明), could easily dine 6,000 people, and . . .

Wait a minute. Sit-down banquets for 6,000? Was that possible? I called the people who do banquets for Hilton Hotels. They said that for a banquet that size, if it was 'in the round', by which they meant using round tables seating 10 people each, you would need (obviously) 600 tables and – there was the sound of figures being tapped into a computer – a room of 72,193 square feet (6,627.4 square metres), about 1 square metre per person. Considering the palace grounds formed a rectangle measuring 500×600 metres,[8] a room measuring 81 metres per side would not have been a problem. In fact, the Da Ming Hall measured 54×32 metres (1,728 square metres),[9] which would have been big enough to seat only about 1,500 people. But, as we shall see, Marco mentions tables only for the royals. The commoners sit on carpets. These were rather crowded banquets, but even so I suspect that Marco was exaggerating again.

[8] Marco says it was 4 miles around. In fact, it was about 4 *li* (2 kilometres, 1.25 miles).
[9] Bretschneider, *Archaeological and Historical Researches*, p. 27.

In addition to its audience chamber/dining room, the palace had uncounted halls, chambers, treasure rooms, offices, apartments for wives and concubines and family members, and suites galore for the emperor himself, all either just built or still in the process of construction. Kublai had his opponents and insecurities; but approaching the throne would dispel any thoughts of dissent or weakness. Anyone following this path – let alone Marco, his father and his uncle, all three of them having the experience for the first time – would, as intended, have been thoroughly awed by the royal attributes of might, majesty, power, mystery and wealth untold.

Outside are other glories. To the north of the Forbidden City, as later emperors called their private quarters, was another closed-off area, the emperor's garden, today's Jingshan Park. In the lake, the artificial island-mound on which the Circular City sits is famous for its evergreen trees, 'for I assure you that wherever a beautiful tree may exist, and the Emperor gets news of it, he sends for it and has it transported bodily with all its roots and the earth attached to them' and planted on the Green Mount, as Marco calls Jade Island.[10] Parklands are grazed by deer, gazelles 'and all manner of other beautiful creatures', and criss-crossed by raised

[10] Jingshan Park includes another artificial mound, Coal Hill, also created from excavated earth, and now famous for the view from the top. It has been widely assumed that Marco's Green Mount was Coal Hill. In fact, Coal Hill was made in Ming times in the late 1500s, its name deriving from stocks of coal piled at its foot in case of siege.

walkways cambered so that the rain runs off before it can soak the feet of officials and courtiers. The lake itself is well stocked with fish, which are prevented from swimming up or down river by metal gratings.

In the south, the Mongols surged on down the Yangtze towards Hangzhou and final victory. The Song prime minister scuttled for safety. On 26 January 1276 the empress dowager sent a note to the Mongol general Bayan in his HQ 20 kilometres north of the city acknowledging Kublai's overlordship. A week later, another memorandum stated the willingness of the five-year-old emperor Zhao Xian to give up his title to Kublai and hand over all his territories. Bayan – known as 'Hundred Eyes', as Marco says, for reasons made clear below – made a triumphal entry into the city, with his commanders and contingents in full array. And finally, on 21 February, came the final, formal ceremony of submission, when the young emperor himself led his officials into Bayan's presence and bowed in obeisance towards the north, where Kublai resided.

Marco, who drastically simplifies the story of the conquest, has his own view of these events. To him, the southern Chinese were effete lovers of luxury who deserved their fate:

> The people of [this] land were anything rather than warriors; all their delight was in women, and nought but women; and so it was above all with the King him-self, for he took thought of nothing else but women

[though which king he is referring to is unclear, since the country was in the hands of the empress dowager and a five-year-old emperor]. In all his dominion there were no horses; nor were the people ever inured to battle . . . the country never would have been lost, had the people but been soldiers. But that is just what they were not; so lost it was.

This is a bit harsh, considering that the Song had lost tens of thousands, held off the Mongols for twenty years and withstood a siege for five. Marco also misunderstands Bayan's nickname: 'Bayan Chincsan, which is much as to say "Bayan Hundred Eyes" . . . And you must know that the King of Manzi had found in his horoscope that he never should lose his Kingdom except through a man that had an hundred eyes.' Well, no. 'Chingsang' or *chengxiang* / 承相 meant 'junior grand councillor'; and to the Chinese Bayan sounds very much like *bai yan*, which means 'hundred eyes', hence his nickname. Clearly, Marco's smattering of Chinese wasn't much use.

Bayan was as good as his word, and Kublai's: a peaceful handover, a strict ban on unauthorized troops entering the city, the safety of the royal family guaranteed, the royal mausoleum protected, no attempt made to upset the currency or even the style of dress. Mongol-Chinese officers made inventories of the troops, civilians, cash and food supplies before removing the treasures for transport northward. Militias were disbanded, regulars incorporated into Bayan's armies.

An edict from Kublai told everyone to continue their lives as normal: officials would not be punished; famous sites would be protected; widows, orphans and the poor would be assisted from public funds.

On 26 February the first of two great entourages left Hangzhou for Beijing – 300 officials, 3,000 wagons of booty, the seals of office, the surrender itself. A month later, Bayan, his task completed, left Hangzhou – indeed, all of southern China – in the hands of subordinates, and headed north to Xanadu with the second entourage, the royal family: the boy ex-emperor, his mother, the princesses, the relatives and the concubines (perhaps including someone of particular significance to Marco, as a later chapter will reveal).

These were interesting times. In 1277 Kublai decided the moment had arrived to add Burma to his list of conquests, in a campaign described by Marco with his usual mixture of fact and hyperbole, leaving open whether he was actually present or not.

The Burmese, with 200 war-elephants, had advanced over the border along the steep-sided, forested valleys that lead to what is now the town of Baoshan. Blocking their path were 12,000 men of the Mongol Chinese army, their backs against a forest slope. Few of the Mongols, and none of their mounts, had seen elephants before, and when the horses were spurred to advance, they refused. So the commander, Nasir al-Din, ordered his men to leave their horses, approach on foot, and use their bows. A single arrow isn't much use

against an elephant, but hundreds are a different matter.

> Understand that when the elephants felt the smart of
> those arrows that pelted them like rain, they turned tail
> and fled, and nothing on earth would have induced
> them to turn and face the Tartars. So off they sped with
> such a noise and uproar that you would have trowed
> the world was coming to an end. And then too they
> plunged into the wood and rushed this way and that,
> dashing their castles against the trees, bursting their
> harness and smashing and destroying everything that
> was on them

– and everything in their path, including the unfortunate
Burmese infantry.

Now the cavalry came into its own, as Polo relates
with the zest and much of the phraseology of a medieval
epic poet. Blows are dealt and taken with sword and
mace, arms and legs hewn off, and many a wounded
man is trapped among the dead by the sheer weight of
numbers. As the Burmese fled, the Mongols went after
them, using captive enemy mahouts to capture
elephants. 'The elephant is an animal that hath more
wit than any other; but in this way at last they were
caught, more than 200 of them. And it was from this
time forth that the Great Kaan began to keep numbers
of elephants.'

Whether Nasir al-Din actually caught 200 elephants
is a moot point, because when he arrived back at
Xanadu in July 1279 he had just twelve in tow, having

walked them over 2,000 kilometres cross-country. He had achieved a kind of victory, sending the Burmese king fleeing down the Irrawaddy. But faced with an alien land and its unhealthy climate, as disease spread among his troops Nasir al-Din had no appetite for thoroughgoing conquest and, having tallied up the households in the area and set up some postal stations, he set off home. The subjugation of Burma was left for another day.

When all China fell to Kublai in 1279, Dadu/Beijing became the capital of the whole united nation, and so it has remained. The heart of today's Beijing, the Forbidden City, was built right over Kublai's creation, its entrance facing south, like the door of any Mongolian tent. The 800 palaces and halls, the 9,000 rooms, the entrance from Tiananmen Square – all these are where they are because Kublai chose to place his palace there. Beihai Park's shape, with its central island, recalls Kublai's vision. Today's innermost road-systems run along Dadu's walls. That's about all that remains of Kublai's Dadu: ghostly outlines beneath the shapes of the modern city.

One hot summer's day, I tried to bring the ghost to life by following the tracks of Emil Bretschneider. In his day, around 1875, Mongol ramparts reared up from a countryside crossed by paths and cart-tracks. Forty years later, when the historian Lin Yutang wandered over it, he found it still 'completely rural in aspect, with farmsteads and duck-ponds'. It

sounded as if the Mongols had just recently departed.

But by the time I retraced their steps all charm had long since vanished. Four kilometres north-west of Beihai Park, a tree-covered ridge divides a dual carriageway. It was the remains of Kublai's earthen ramparts. You reach it by dodging cars. Paths of grey brick flanked by ranks of tired grass-clumps led to the top, for a fine view of high-rises, carriageways, traffic and soupy air, and no hint of the past. A modern temple was unused, except for a man with a close-shaven head playing a single-stringed fiddle on his knee. Traffic whizzed where once guards marched and courtiers strolled. A block north, a canal was once the moat marking the northern limit of Kublai's new estate. I followed it, and came upon Yuan Dadu Park, after Kublai's dynasty and the name of Mongol Beijing. Garish little pleasure-boats awaited day-trippers. A young man dozed on a bench. Paving stones fringed the ex-ramparts, now bearing nothing but slender trees and pathways. A pillar displayed a bas-relief of Genghis attended by a cloud-borne orchestra and his heirs. This was not real history: it was made in 1987, along with the park. But here at least something had survived from the thirteenth century – two stone tortoises bearing rectangular pillars, those symbols of power favoured by the Chinese and adopted by the Mongols. Behind them, Kublai's palatial grounds overflowed with apartment blocks.

If you want to get a feel for Kublai's Beijing, best avoid the streets and search for something to set your imagination free – like Marco's words.

9

THE DISPLAY OF POWER, THE POWER OF DISPLAY

ONE SECRET OF POWER IS TO MAKE A DISPLAY OF IT. Modern democracies are half-hearted about this, but autocrats have always known that power and display reinforce each other. From ancient Persia to pre-Revolutionary France to Nazi Germany, absolutism was made palpable with symbols, rituals and ceremonies. Roman emperors became gods at their funerals, Nepalese kings proved themselves embodiments of the universal god Vishnu by acts of generosity, in Bali the king showed his power by acting in pageants, Hitler had himself turned into an epic hero by the theatricality of the Nuremberg rallies. As one historian, David Cannadine, points out, kings have ruled as much by divine *rites* as by divine *right*. Rites vary, but almost always they assert some or all of the following: the stability of the state; its power over the individual; the importance of the power structure;

the legitimacy of the ruler; and the ruler's superhuman qualities.

Kublai, smart enough to see the benefits of ritual but with no experience in their form, had teams of Chinese advisers to guide him, drawing on precedents like an immense three-volume corpus of imperial rituals recorded half a millennium before during the Tang dynasty (618–906), when China was unified, rich and stable.[1]

A summary shows what Kublai and his advisers believed was necessary. The 150 rituals, the symbolic essence of government, combined cosmology, ethics and Confucianism, with admixtures of Buddhism and Daoism. Here were rules for sacrifices to gods of Heaven and Earth, of the five directions, of the harvest, sun, moon, stars, sacred peaks, seas and great rivers; to ancestors; to Confucius. There were rites for recurrent and non-recurrent rituals, for the sovereign and for those taking the place of the sovereign, for receiving and entertaining envoys, for the proclamation of victories, for the marriage of dignitaries, for royal congratulations, for investitures, for coming-of-age ceremonies, for the dispatch of memoranda by provincial officials, for procedures to be conducted after bad harvests, illness and mourning – and variations of all of these, and more, at every rank from the emperor down to those of the ninth grade. Propitious rituals demanded abstinence at

[1] David McMullen, 'Bureaucrats and Cosmology: The Ritual Code of T'ang China', in Cannadine and Price, *Rituals of Royalty*.

two levels, relaxed or intensive, spread over seven, five or three days, depending on whether the ritual was major, medium or minor. Rules specified the tents, the musical instruments, the position of participants, the words of prayers. The rituals had their own huge and complex bureaucracy, with four departments – looking after sacrifices, imperial banquets, the imperial family and ceremonies for foreigners – and a Board of Rites within the Department of Affairs of State. These demanded hundreds of specialists in ritual; but all the 17,000 scholar-officials of all the other departments were expected to know the rituals associated with their own areas of expertise.

All of this immense, expensive and cumbersome apparatus was considered absolutely vital to the workings of the state, because it provided a context for human actions and linked these to the cosmos. It maintained the social hierarchy and restrained unruly appetites. It affirmed the benevolence of the cosmic order, and the emperor's role in mediating between Earth and Heaven. It was, as it were, a vast social gyroscope that kept society stable (which is one reason why dynasties so often kept going even when moribund, until an end that seemed to come suddenly). Later dynasties followed the Tang lead, producing their own ritual codes. If Kublai wanted to be taken seriously as a Chinese ruler, this was what he had to take on board.

So Kublai displayed and regimented for all he was worth, which was more than any monarch on earth at the time. If you rule one-third of inhabited Asia and

have family ruling the rest; if at the same time your original claim to power is a little shaky; and if you are ageing, overweight, short of breath and wincing on gouty feet; you would naturally wish to put on as much of a show as you possibly could. By the time of Marco's arrival, Kublai commanded more wealth than any monarch in history, and, by Eternal Heaven, he knew how to use it to display and reinforce his power.

Much of this was based on Chinese precedents. Kublai, always eager to weld Mongol and Chinese cultures, set up an imperial academy where the sons of the Mongolian élite were instructed in Chinese protocol, ritual and behaviour. His favourite son's tutor had a Chinese title, Exalted Tutor of the Crown Prince. So it was with ritual: to balance Mongol and Chinese traits, he instituted Mongol feasts with Chinese means of inspiring awe – ritual and display that raised him from man to monarch, from monarch to demi-god, on each of the three main state occasions: the khan's birthday at the end of September, New Year's Day and the annual spring hunt. Each ceremony also had its own pattern, though all had similarities.

New Year's Day, for example, was a festival designed to emphasize both his Chinese and Mongol credentials in a celebration of gargantuan proportions. Marco describes it. From all over the empire come gifts, many in the good-luck number of nine, or even 81, for ninefold luck. Horses, elephants and camels are paraded, laden with gifts – Marco mentions 100,000 horses and 5,000 elephants, but these are surely ritualized

numbers. Thousands dressed all in white (for luck) – sons, nephews, senior officials, local rulers, experts in every speciality, all in due order according to rank – overflow from the Hall of Great Brilliance into surrounding areas. A 'great prelate' of some kind calls out 'Bow and adore!' and the whole assembly touches forehead to floor, four times, in a mass kowtow. A song follows, then a prayer from the minister (in the Moule–Pelliot version): 'God save and keep our Lord long with joy and gladness!'

The god, of course, was Heaven, the Mongol Tengri, the Chinese Tian, though in what language all this was taking place Marco does not record. Chinese probably, given that the whole ritual was directed towards the thousands of Chinese officials. For select foreigners like the Polos, interpreters would have been on hand.

And the congregation responds: 'God do so!'

'God increase and multiply his Empire from good to better, and preserve all the people subject to him in tranquil peace and goodwill, and in all his lands may all things prosperous continue!'

'God do so!'

Then each minister goes to the altar and swings a censer over a tablet inscribed with Kublai's name. Officials from every corner give their presents of gold, silver and jewellery.

Then 'the tables are set, and all take their places at them with perfect order' – at least, the royals do. In the north of the hall, Kublai sits at the high table, facing south with a view of the whole assembly. He is on a

platform raised a couple of metres above the floor, with Chabui, his principal wife, on his left. The princes and their wives are immediately below, on a lower platform, their heads on a level with the emperor's feet, but a metre clear of the commoners, who crowd the floors on carpets. To one side is a huge buffet table, decorated with animal carvings. The centrepiece is a golden wine-bowl the size of a barrel with four dispensers, from which servants draw wine into golden jugs. Down the hall range ranks of small tables, several hundred of them, flanked by carpets on which sit the guards and their officers. To one side of the dais is an orchestra, its leader giving his musicians the nod to play every time the emperor drinks.

Marco mentions an odd element in this scene, something that recalls Kublai's nomad roots. Anyone travelling in Mongolia today would understand. When entering a *ger* you must take care to step right over the threshold, the bottom bit of the door-frame, without touching it. No one knows the origins of this super-stition, but there's no denying its force. If you kick the threshold by mistake, it is a bad omen; on purpose, a deliberate insult. At each door stand two immense guards, armed with staves, who watch for infringe-ments. Back in Mongolia, a serf might be killed for stepping on a prince's threshold. Not so at Kublai's state banquet. But it's still no joke. The guards have orders to humiliate those who transgress, stripping them of their finery or giving them some nominal blows with a stave. To be spared you have to be an ignorant foreigner, in

which case a senior official will pounce upon you to explain courtly ways.

Once all are seated the banquet begins, with those at tables being served by butlers. The Lord graciously receives a cup. Even in this the khan uses ritual to assert his status, for these butlers are actually senior officials, 'great Barons', as Marco calls them; and they 'have the mouth and nose muffled with fine napkins of silk and gold, so that no breath or odour from their persons should taint the dish or the goblet presented to the Lord'. The orchestra proclaims the significance of the moment. The cup-bearers and the food-bearers kneel. The Lord drinks. He deigns to accept food. The musicians strike up again, the servants kneel. These observances punctuate the feast, until the end, when the dishes are removed, the tables are cleared away and it's time for entertainment, a cabaret provided by actors, jugglers, acrobats and conjurors.

The many ways to display power include making your mark on the world around you: with armies, land and palaces; treasure and art; fawning retainers and body-guards. The more bodyguards you have, the more precious your body, the greater your significance. Sometimes, this may really be a matter of security. The First Emperor, the man who first unified China in 221 BC, having survived several assassination attempts, took to travelling in an enclosed carriage into which no one could see, in a throng of other carriages, one (perhaps more) of which was a look-alike decoy (there's

a half-size model of it in the Terracotta Army Museum in Lintong, outside Xian). Kublai had 12,000 personal bodyguards, not so much because he needed them for security as because that was how he asserted himself, thereby making a powerful impression on Marco, who may well have had another, highly personal reason for taking a close interest in them.

The troop was known as the *keshig*, a word that is perhaps connected with the Mongol for 'favoured' or 'blessed' or, more likely, with the Turkish for 'to watch'. These men were either 'favoured' or 'watchmen'; in fact, they were both. Anyway, they were more than just bodyguards. Genghis picked up the idea from his neighbours, the Keraits, whom he defeated in 1203, setting up a *keshig* first of 80, then of 1,000, which acted as both a crack military formation and a personal guard. When he became khan in 1206 the *keshig* ballooned to 10,000 and became his general staff, through which he exercised power, the heart of government and the source of new, young leaders. At one level, the *keshigten* looked after the royal household as cooks, doorkeepers, grooms, servants and cart-supervisors; at another, they were clerks and administrators. The institution also had another major purpose: it ensured dictatorial control. Each lower-level commander was expected to provide two relatives to serve in the *keshig*, each with five to ten retainers, so that in effect the bulk of the group were hostages, guaranteeing the loyalty of their older relations. But they were also of higher rank than their non-*keshig* equivalents. High status and the

fact that the ranks were hereditary induced a fierce loyalty, and the *keshig* became a seedbed for talent, producing several of Genghis's greatest generals. Four companies served three-day shifts each, so that Genghis was protected and served round the clock. Loyalty was to the khan personally, so when he died, his heir formed his own *keshig*. This was, in the words of Igor de Rachewiltz, Mongolist and translator of *The Secret History*, 'the most important institution of all and the one which insured, together with the strict enforcement of the Mongol "Law" (*jasaq*), the enduring success of the conqueror's armies'. Top *keshig* member, senior minister, great general: these roles were on many occasions performed by the same man, 'quiver-bearer' or ' door-keeper' one year, conqueror or high official the next.

That was the tradition that most later khans across the empire followed, in China, Persia, southern Russia and Central Asia. Kublai was in one sense a traditionalist: his senior *keshig* member, known only by his title Ulug Noyan ('Grand Official'), was the grandson of one of Genghis's greatest companions, Bo'orchu, who had helped him retrieve stolen horses when the two of them were teenagers. But Kublai also, as usual, adapted. He established a new group of non-Mongol troops to take on the *keshig*'s military duties, and gave his *keshigten* a purely political role as administrators, particularly lawyers, with a smattering of Chinese as 'hostages' guaranteeing the good behaviour of their sponsors, and perhaps – as we shall see – a few other foreigners as well.

Many of these 'guards' did important and useful jobs. And 12,000 bureaucrats was not an excessive number to administer such an empire. But, as Marco reveals, the 'quesitan', as he calls them in one of several spellings, were not just bureaucrats; Kublai kept them not 'for fear that he may have of any man, but he does it for grandeur, excellence and magnificence'. They were jewels in Kublai's crown, and were made to glitter, though possibly not quite to the extent stated in Marco's text. Each was granted 'thirteen changes of raiment, which are all different from one another' in terms of colour, all 'garnished with gems and pearls and other precious things'. Plus a golden girdle for each guard, and a pair of leather boots 'curiously wrought with silver thread'.

Thirteen different suits, supposedly for a feast every lunar month for a year – that means, in all, 156,000 jewelled costumes! Could this have been true? The figures are repeated several times, and underlined with the grand total of costumes. But there is something fishy here. There were thirteen lunar months in the year in only seven years out of every nineteen (roughly, for the system was not exact), when an 'intercalary' month was added; the other twelve years had twelve months each. It seems odd for Marco to insist on thirteen, particularly as there is reason to think he knew his subject well. On the other hand, there were *three* great annual festivals in Kublai's court (New Year, Kublai's birthday and autumn, all of which Marco mentions). It's possible that Marco said 'three' (*tres*) and that his ghost, Rustichello,

wrote 'thirteen' (*treize*), then embellished the text to strengthen the point.

One piece of theatre adopted by many rulers down the ages is the ceremonial hunt. It was, for instance, one of the most significant events in Charlemagne's Frankish empire after he was crowned emperor in the year 800. It was the natural conclusion to an assembly in which major political crises were resolved, for 'the hunt was an exercise in, and a demonstration of, the virtues of collaboration'.[2]

So it had always been with the Mongols; and the greater they became, the greater the hunt. For big game, hunts took place in autumn, when animals were fat from the late summer glut. Horsemen gathered by the thousand and spread out in an immense line extending over perhaps 100 kilometres – left wing, centre, right wing, as if in battle formation, with arrows and food supplies to last them many days, perhaps weeks. The line gradually formed itself into a circle, with one mounted archer every few metres. Juvaini, the great Persian historian who worked for the Mongol empire some 30 years after Genghis's death, gives a powerful account of the great *av*, or hunt (called a battue in western languages, from the French for 'beaten') and its significance for military organization and discipline:

[2] Janet Nelson, 'The Lord's Anointed and the People's Choice: Carolingian Royal Ritual', in Cannadine and Price, *Rituals of Royalty*.

For a month, or two, or three they form a hunting ring and drive the game slowly and gradually before them, taking care lest any escape from the ring. And if, un-expectedly, any game should break through, a minute inquiry is made into the cause and reason, and the commanders of thousands, hundreds and tens are clubbed therefor, and often even put to death ... For two or three months, by day and by night, they drive the game in this manner, like a flock of sheep, and dispatch messages to the khan to inform him of the condition of the quarry, its scarcity or plenty, whither it has come and from whence it has been started. Finally when the ring has been contracted to two or three parasangs [about 10–15 kilometres], they bind ropes together and cast felts over them; while the troops come to a halt all around the ring, standing shoulder to shoulder. The ring is now filled with the cries and commotion of every manner of game and the roaring and tumult of every kind of ferocious beast.

Then the killing starts, initiated by the khan and his retinue, followed by the princes, officers and finally the troops, until only 'wounded and emaciated stragglers' are left. At this point, old men humbly beg the khan for the lives of the survivors, so that their numbers can recover from the cull. The hunt ends with a head-count and distribution of the spoils for food and furs. 'Now war,' says Juvaini, 'with its killing, counting of the slain and sparing of the survivors, is after the same fashion, and indeed analogous in every detail.'

This was part of Kublai's background. And indeed his new Beijing was the centre of hunting on an industrial scale, the countryside out to 500 kilometres – 40 days' journey, as Marco says – in every direction being dedicated to the business of supplying the court, controlled by a 14,000-strong army of huntsmen.

But it is not the battue that Marco describes, because it did not fit into Kublai's schedule. Big-game hunting was an autumnal activity, and Kublai was back in Beijing by then. It was hardly feasible to mount battues in the village-covered plains east of Beijing. So the great spring hunt, lasting three months (March–May) is all about hunting with birds of prey.

It is 1 March. Winter is over, spring approaching, despite bitter winds. Ten thousand falconers prepare their birds, says Marco, but remember that the number is a Chinese *wan* or a Mongolian *tumen*, both synonyms for 'lots'. Add 500 gyrfalcons, and unnumbered peregrines, sakers, hawks, goshawks – and some eagles, which hunt hare, foxes, deer, wild goats, boar, even wolves, tearing their prey with claws and beak while battering them into stupefaction with their wings. There are 2,000 dog handlers. The palaces and much of Dadu empties into wagons by the hundred, and on to horses by the thousand. For Kublai himself, four elephants are harnessed together, carrying an enormous howdah, a room made of wood, lined on the inside with gold leaf and dressed outside with lion-skins. A dozen senior aides ride beside him in attendance. In order not to clog the gateways and

the roads, the vehicles leave in bunches of a hundred.

Marco says they headed south, towards the sea. That can't be right: the closest coast is 160 kilometres south-east, and if they were after good hawking they would have swung east to the plains that fringe the mountains where the Great Wall now runs, towards the Wall's end at Shanhaiguan. There is no stone Wall yet, of course, only (perhaps) the remnants of the old earth wall, and no danger from the nomads, because the land is all Kublai's. The emperor makes stately progress on his elephants, say 30 kilometres a day, arriving every evening at a camp site that is a tent-city. Along the way, birds of many species scatter and soar from their new nests, and there is sport for all. Many thousands, in groups of 100 or 200, roam the steppe, while the emperor is attended by '10,000' beaters, in pairs, each with a whistle and a hood to catch birds after a strike. All the imperial hawks are labelled,

> And sometimes as they may be going along, and the Emperor from his chamber is holding discourse with his Barons, one of the latter shall exclaim: 'Sire! Look out for Cranes!' Then the Emperor instantly has the top of his chamber thrown open, and having marked the cranes he casts one of his gyrfalcons, whichever he please; and often the quarry is struck within his view.

Sometimes there is big game as well as birds, and the dogs are let loose – huge mastiff-like creatures trained by their handlers, known as 'wolf-men' (Marco gets the

Mongol word right). 'And as the Lord rides a-fowling over the plains, you will see these big hounds coming tearing up, one pack after a bear, another pack after a stag, or some other beast.'

After a week of this majestic progress, Kublai's elephants bear him into the camp that will be the court's HQ for the next three months. It is a traditional spot, perhaps in the borderlands of Manchuria, no one knows where exactly,[3] chosen for broad expanses and wealth of game. Falconers and hawkers, with their hooded birds on their wrists and bird-whistles at the ready, scatter over the billowy ground. His three tents are ready – a huge one which can hold a whole court of 1,000 people, sleeping quarters and a smaller audience chamber. Marco does not tell us what shape the tents are, but they each have three poles, which probably support the centre of traditional round tents to remind Kublai of his grassland origins.

What impresses Marco is the decoration. The tents are weatherproofed with tiger skins[4] – Siberian tigers not at this stage being endangered – and lined with ermine and sable, the most valuable of Siberian furs. Consider: a tent that could hold 1,000 people has a circumference of about 125 metres. To cover its walls would take 16,000 pelts, each today costing $50–100

[3] Marco calls it Cachar Modun, which is his version of the Mongol for 'the place of trees'.
[4] This may have been a tradition. Saghang Sechen's seventeenth-century history of the Mongols records that the ruler of Korea sent Genghis tents covered with 'panther' skins.

each. The equivalent of $1 million, just to line the main tent. That's without the tiger-skin waterproofing. Spread out all around are the tents of the royal family – Kublai's senior wife Chabui, the three subsidiary wives, and the princes; also for the girls from the Ongirat (the Mongolian clan that traditionally supplied Genghis's family with mates) brought in for the harem, the senior ministers, the attendants, the '10,000' falconers, the grooms, cooks, dog-handlers, household staff and secretaries, all with their families, and all of course protected by contingents of soldiers. This is a tent-city, devoted to blood sport. Every day hawks and falcons bring down cranes, swans, ducks, geese, hare and deer, which the soft-mouthed dogs mark and fetch. Hare, stag, buck, roe – these are designated as royal game, which ordinary people are banned from hunting at this time to ensure a good supply on the plains of north-east China.

Meanwhile, the business of the court continues, with conferences and audiences and messengers coming and going and ambassadors from abroad. And at the centre of this vast array is the emperor, overweight, gout-ridden, but still eager to reconnect with his roots by riding out over the plain. A portrait of him by the court artist Liu Guandao shows him perched heavily in the saddle, wrapped in an ermine fur coat against the cold, with Chabui at his side. He has two attendants. It is a scene of deliberate pseudo-casualness, like a Cartier-Bresson snapshot, for all four have had their attention caught by something off camera, someone perhaps

calling, in Marco's words: 'Sire! Look out for cranes!'
But there is no bird on the royal wrist, and a whippet
awaits an order.

So it continues for two and a half months, until, in
mid-May, the immense operation reverses itself, bring-
ing emperor and entourage back to the capital, where,
as the summer begins to build, preparations start again
for the haul northward to Xanadu.

10

A ROUGH GUIDE
TO MANZI

TO MEDIEVAL EUROPE, ONE OF THE REMARKABLE THINGS about Marco's book was that it did more than bring Kublai and his court to life. It brought a whole unknown country to life. There had been news of the Mongols, because they had made themselves known in Europe. But no one had a clue about China, and Marco was the ideal reporter, roaming widely, curious, always gathering information.

Once back in Italy, he might as well have been returning from another planet; so he was keen to lay out his qualifications, to prevent people thinking he was an armchair traveller talking about some legendary place he had merely imagined. This meant he had to accentuate the positive; in a word, boast. In two editions, he has a 'very distinguished mind'. He was discreet, he was prudent (so he says), with good sense,

knowing how to conduct himself well. He also had a flair for languages: 'Now it came to pass that Marco sped wondrously in learning the customs of the Tartars, as well as their language, their manner of writing, and their practice of war; in fact he came in a brief space to know several languages, and four sundry written characters'.

Scholars have wondered what these languages and scripts might have been. We have enough evidence that he learned Mongol, as his father and uncle had done, because he could apparently talk to Kublai without an interpreter. He could have picked up Persian and Uighur, both on his journey and working with officials at court. He also had a smattering of Chinese, for many of the city names are a pretty good approximation of the Chinese, and he remarks at one point that in southern China 'they employ one speech and one kind of writing only, but yet there are local differences in dialect'. Spoken Chinese is one thing, written quite another. Since Kublai himself did not know the language, Marco had little incentive to show any interest in the script.

Boastful, yes; but with good reason. Kublai, frustrated by the inadequacy of reports from his usual officials, decided to use Marco as his eyes and ears in the remoter parts of his realm. For seventeen years he was a sort of reporter-at-large, informer, even perhaps a spy, possibly being asked to pay special attention to foreign merchants. As a result, he was 'continually coming and going, hither and thither, on the missions

that were entrusted to him by the Lord', returning with eyewitness reports – in Mongol, presumably – that delighted Kublai. He fulfilled his role with spectacular success, guaranteeing himself a special status that aroused some envy among Kublai's retainers.

It is possible that his career culminated in a very high office indeed, governor of a provincial capital. This was Yangzhou, a great city on the Grand Canal just north of its junction with the Yangtze, a couple of hundred kilometres from Shanghai. It had fallen to the Mongols in 1275, the very year Marco arrived in China, or the year after. As one edition says, 'And Messer Marco Polo himself, of whom this book speaks, did govern this city for three full years, by the order of the Great Kaan.'

What a bandwagon of academic disputes this claim has set rolling, because among the governors of Yangzhou there is no record of a Polo or Poluo or Boluo, as it might be in pinyin, in any combination of the 20 different *bos*, 9 *pos* and 12 *luos* (there was a *lo* in the old Wade–Giles transliteration, which becomes *luo* in pinyin).[1] Many have leaped on board to claim that Marco was lying, that he was never there, that this was evidence the whole book was a scam.

But a closer look urges restraint, and also opens the way to an intriguing piece of speculation. The claim that he was a governor is missing in four editions

[1] Actually, there was a 'Polo', a transliteration into Chinese of a famous Mongol named Bolad, Kublai's ambassador to Persia, where he became grand councillor.

(including the Z manuscript, the more personal Latin one in Toledo), and in others it appears in a different form. Perhaps he *seigneura* (ruled) in Yangzhou, in some unspecified way? Or simply *sejourna* (stayed) there? Or was he, as one edition claims, merely a temporary replacement for the permanent governor? The variations are many, the truth well hidden.

Though unlikely, it is not totally impossible that he was a governor. Many non-Chinese – Muslims, Uighurs, Khitans – held high office (like the appalling Ahmad, whose story is told in a later chapter), and Marco mentions another case of a city being granted to an outsider, a Nestorian Christian named Sarghis (Sergeius), who for three years governed Zhenjiang, a small provincial capital on the lower Yangtze only 20 kilometres south of Yangzhou.

What, then, are we to make of his absence from any record?

Stephen Haw suggests some answers. If he was a replacement, he would not merit a mention. Anyway, the name of Polo would not appear in the records because, as a Mongol-speaker employed at a high level by the khan, he would have been given another name, a Mongol name. This leads on to an intriguing suggestion: that, as someone much favoured by the khan, he was granted membership of the bodyguard, the *keshig* of 12,000 officers who formed the inner circle of Kublai's administration. As such, he would have been available for any job Kublai chose to give him. Haw cites examples of *keshig* members who were

sent off on business elsewhere. One, a Chinese named He Sheng, became vice-regent of Xanadu; another was promoted to general and later became an overseer of local officials in subject kingdoms.

Is there evidence for this? Sort of, circumstantial evidence: Marco's attitude to Kublai, the difficulties this posed, and how he solved them.

First, the extreme loyalty he felt towards Kublai. His admiration was nothing less than hero-worship. Kublai was the richest and most powerful ruler the world had ever seen, 'the most potent man, as regard forces and lands and treasure, that existeth in the world, or ever hath existed from the time of our First Father Adam until this day', and just in case we miss the point, he repeats himself (unaware of Kublai's death four years before the time of writing): Kublai is 'the greatest Lord that is now in the world, or ever hath been'. He became khan because of his 'ability and valour and great worth'. Of course, he had seized and held all China by force. But that paled against the benefits he brought to his people. To crush a rebel named Nayan, he prepared to fight in the certainty that his cause was just, 'confident in his own conduct and prowess'. He is endowed with almost god-like virtues. Recall the great feast day in the palace hall in Dadu, when a dignitary proclaims that everyone should 'Bow down and worship!' And at once 'the company bow down until their foreheads touch the earth in adoration towards the Emperor as if he were a god'.

This is all tenuous evidence of his being a member of

the *keshig*, not strong, but at least positive. There is also negative evidence, in that Marco's failure to say he was a *keshig* member could have been deliberate. Let's assume he was in the *keshig*; let's also assume he wants to keep it quiet. Why would he do that?

In brief, because he (and his ghost Rustichello) had his readers and their attitudes in mind. When he dictated his story he was back in the Christian West, intending to appeal to Christians. He was a leading citizen of a leading Christian city, the rise of which was, as everyone knew, due to God's blessing. Yet here he was so dedicated to a non-Christian leader that he was his adoring servant. How could Kublai's perfection be squared with the fact that he was not a Christian? And Marco's own actions be justified?

The answer, I think, was twofold:

First, Marco had to disguise the fact that he had actually worshipped a pagan emperor as if he were God – an emperor who, remember, was intimately related to those who had threatened all of Christendom. He could talk about the *keshig*; but he could not mention being a part of it, and thus one of the worshippers.

Second, he makes Kublai a closet Christian, with saintly virtues. The emperor performs great works of charity, looking after the poor – 30,000 of them every year – and setting up granaries for times of famine. He and the local Nestorian Christians get on fine. At Easter, which Kublai knows to be special, he summons the Christians, sends for a bible, honours it with incense and kisses, and orders his followers to do the same. And

because he is a model of tolerance, he also honours Jews, Muslims and Buddhists, but makes Christianity first among equals. 'The Great Kaan let it be seen well enough that he held the Christian faith to be the truest and best – for, as he says, it commands nothing that is not perfectly good and holy.' Again, this is for European consumption, because in fact, years before Marco's arrival, Kublai had encouraged Buddhism as first among equals, building the White Pagoda to house the powerful spirit Mahakala to aid him in his conquest of the south. Naturally enough, Buddhists – idolaters all – get short shrift in Marco's book.

It should be said that Marco did not have a hard task in presenting his employer's virtues. As well as driving ahead with his grandfather's agenda of world conquest, Kublai was a consummate manager. He was, after all, building an empire that would last for ever. China being the key, China had to be stable and prosperous. He presided not over a grim dictatorship, but over a revival of much that had vanished during decades of warfare. True, he established a strict pecking order, with Mongols at the top, followed by Muslims who knew about trade and administration, then the northern Chinese, then the southerners. A Central Secretariat controlled six ministries, and a Bureau of Military Affairs acted as a secret service, controlling the controllers. But since only one in a million were in the top two grades, most of his subjects – 100 million of them – were untouched by Mongol rule. He could not afford discontent. So there were indeed aid programmes

to stimulate agriculture and offer relief in harsh times. Trade, once seen as parasitic, was encouraged, as were the arts: Yuan ceramics were exported by the shipload. Law was, of course, horrendous by modern standards: beatings were delivered with eleven degrees of harshness, up to 107 blows with a heavy stick, of which, as Marco notes, many died. But in fact Kublai's code was noted for its leniency, with only 135 capital offences (including a slow and painful death by up to 120 cuts for treason) as opposed to 293 under the preceding Song dynasty. In fact, executions were quite rare – an average of 72 per year when Marco was there. In 1287, when Kublai heard that 190 people faced the death sentence, he ordered reprieves. 'Prisoners are not a mere flock of sheep. How can they be suddenly executed? It is proper that they be instead enslaved and assigned to pan gold with a sieve.' He even built a cooling-off period into his own judgements. An injunction quoted in the official history says: 'If We are angry against one who is judged guilty and command you to execute him, do not kill him immediately, but wait for one or two days and then report to Us again for the final decision.' It is extraordinary that a man whose background, rise and rule cost the lives of millions did in the end go some way towards deserving Marco's adulation.

Marco anticipated his readers' reaction: Why then, if Kublai was almost Christian, wouldn't he take the final step, and convert? Good question. It was asked by Marco's father and uncle on their first visit, and answered at length in Ramusio's edition, the one that

perhaps reflects Marco's personal opinions most closely. The reason was that the Christians were not good enough at magic. The 'idolaters' could conjure up glasses full of wine, control storms and predict the future. If the khan converted, what excuse could he give his barons? How could he prevent the idolaters assassinating him? It was at this point that he asked the Polos to fetch 100 priests from Europe, so that they could refute the idolaters. 'And if the Pope . . . had sent men fit to preach our religion, the Grand Kaan would have turned Christian; for it is an undoubted fact that he greatly desired to do so.' In brief, it wasn't Kublai's fault; it was the pope's.

Whoever devised this argument, whether Marco or Rustichello, they were venturing into dangerous waters. In Marco's absence, Venice had accepted the first representative of the Inquisition. Venice insisted that any heresy would be dealt with locally, but who would wish to put the ruling to the test? Here was Marco in effect saying that a pagan was as good as a Christian king, and that Rome was to blame for failing to take advantage of the glorious opportunity presented by the Polos. Moreover, he, a Christian, had been part of an organization that worshipped a pagan. If, as some scholars think, Marco cut out the dubious material (reintroduced by Ramusio two centuries later), this could have been the reason. Best not court trouble.

All of this discussion about Christianity started because of the suggestion that Marco was a member of the *keshig*. In conclusion, yes, he could have been;

and, if he was, he had a good reason to hide the fact.

(There was to have been a further bit of evidence, which with regret I have to relegate to these bracketed paragraphs. After Marco's death, an inventory was made of his possessions. One item, which I'll get to in the next chapter, is of special significance. There might have been another, mentioned by the Italian scholar Leonardo Olschki in *Marco Polo's Asia*. From the inventory, he says, we learn that almost 30 years after his return home Marco still owned numerous items that he had collected on his travels, including 'the silver belt of a Tartar knight which he probably wore as a sign of his rank'. These words have since been quoted by others, who see in the belt an indication of Marco's status and of his membership of the *keshig*. As Stephen Haw says, 'The conclusion to be drawn is surely that Marco was very probably one of the *keshigten*.'

Naturally, I wanted to check the original source, if only to find out the Venetian for 'Tartar knight'. It wasn't too hard. The inventory is transcribed as an appendix in the Moule–Pelliot 1938 edition of Marco's book. The inventory is in fourteenth-century Venetian Italian and Latin, and the 200-plus items are all listed in abbreviated form.

To my surprise, I could find no mention of the belt of a 'Tartar knight'. Two items are described as *tartaresci*, and seven belts are listed,[2] all *darçento* (of silver), but none of them is either Tartar or ascribed to a knight, let

[2] Five instances of '*çentura*' and one of '*çenture doe*' (two).

alone both. Then I checked Olschki's Italian. There, he speaks of *la centura d'argento dei cavalieri tartari* ('the silver belt of Tartar knights', plural), which is slightly odd, but anyway weaker than one belt; would a *keshig* member really need seven belts as a sign of rank? Anyway, Marco said that the *keshigten* wore golden belts, not silver ones.

What happened? It seems likely that Olschki, writing in Italian in the 1950s, jumped to his conclusion, and his colleague and translator, John A. Scott, did not check the original source; nor did anyone else, then or since. As a result, Olschki's insecure conclusion has been repeated several times by others. John Larner, for instance, in his excellent *Marco Polo and the Discovery of the World*, cites the inventory in Moule–Pelliot as his source, but must have relied on Olschki without checking for himself. I can't ask him why, because he died in 2008.)

So there was Marco, close to the greatest leader in history, perhaps an officer in his inner circle, and trusted to go on research trips across the empire. No one was better qualified or better placed to describe it, especially the teeming south, the empire formerly known as Song, which he calls Mangi or Manzi, from the disparaging name given to it by northerners, 'uncouth sons' (*mán* / 蛮 *zǐ* / 子).

He does not record the dates of his journeys, but the place-names he mentions, almost 70 of them, suggest that he made at least four, perhaps five or more. The

first, probably between 1276 and 1280, took him to Yunnan, in which Kublai had a special interest, because he had conquered it 20 years previously and because he was interested in its neighbours, Burma and Vietnam. Having impressed Kublai with his first report, Marco returned to Yunnan twice, the second time going on into Burma and making a report on Bengal, probably from hearsay rather than experience. He also journeyed down the Grand Canal to the old capital of the Song empire, Hangzhou, which he apparently visited several times. Certainly, if you look at the places he mentions, 26 of them mark this section of his route, many of them directly on the Grand Canal. The last time was a one-way trip – more of an escape, really – in which he and his father and uncle went on beyond Hangzhou to Zaiton (today's Quanzhou), from where they sailed for Persia. A mere ten places are mentioned on this final leg of his travels.

If he visited all these places in the course of five land journeys, he covered some 14,000 kilometres as the crow flies. Double it for twists and turns. Assume 30 kilometres a day. Double the time spent travelling to allow for bad weather, rest days and research. That works out at two and a half years of being continuously on the move – in effect, five years, assuming that he would not have been travelling in the winter, at least not in the north. It's perfectly possible, since he was in Kublai's service for seventeen years. Perhaps there was more. He describes in impersonal detail an expedition to Sri Lanka ('Seilan'/Ceylon) with the unlikely purpose

of obtaining some hair and teeth of Adam, 'our first parent'. If he made this journey as well, he would have been away another year or two. That leaves ten free years, plus the winter months in which he wasn't travelling, during which he could have been with Kublai, going to Xanadu for the summer, feasting in Beijing, undertaking smaller local journeys and hawking on the north-eastern plains. For a young man thrilled with the endless novelty, proud of his position, well supplied with money, transport and servants, free to use his *paizi* to go anywhere he wanted, this must have amounted to an extended peak experience.

The first landmark on leaving Dadu was as famous then as it is today. As Marco says, you come to a large river over which 'there is a very fine stone bridge, so fine indeed, that it has very few equals'. This is the Lugou Bridge, over what is now the Yongding river.[3] It is doubly famous today as a tourist attraction and as the site of the incident that opened the war with Japan in 1937, to which there are several memorials nearby. In the thirteenth century the river it spanned was the Sanggan, part of the complex of rivers that were constantly being modified to ensure regular waterborne supplies to Kublai's new capital. It was notoriously erratic, sometimes empty, sometimes in flood, sometimes bearing silt or ice, hence the bridge's sharp,

[3] Marco calls the bridge Pulisanghan (or other similar spellings), which by a linguistic coincidence seems to be Persian for both 'Stone Bridge' and the Sanggan bridge, proof that Persian was commonly spoken by visitors to Dadu.

bow-like bastions; only in the eighteenth century, when it was banked, dammed and tamed, was it renamed the Yongding – 'Forever Calm'.

In Marco's day, the bridge had been famous since its completion almost a century before simply because it was such a magnificent object: 300 paces long, 8 wide, with 24 arches (he says), and many watermills taking advantage of the swift current; but what really marked it out was that its sides were made of balustrades of grey marble 'to prevent people from falling into the water', supported by columns on each of which was a carved lion, or two, or three. It is the same today, having been rebuilt and restored. Considering he was working from memory, Marco's description is pretty good, which is why foreigners named it after him. There are only eleven arches, and the bridge is of granite, not marble; but he got the lions right, though being Chinese lions most of them look more like toads to me. Luckily he didn't try to guess their number. There weren't so many in Yuan times; most were added later, with one or more on each of the 280 columns (about: I may have missed a couple). No one agrees on the number of lions because there are lions upon lions, lions in the manes of other lions, lions underfoot, baby lions mixed with adults, and all of them unique. I gave up at 300. Others have put the full pride at between 482 and 496.

Lugou Bridge – Marco Polo Bridge – deserves its fame for another reason: the shape of its graceful arches. Most bridge-builders, whether in the east or Europe, chose the easy option of semicircular arches, which

work perfectly well, but may be unnecessarily high. In the seventh century, however, an engineer named Li Chun realized that, instead of half a circle, it was better to use only a smaller part or *segment*. The arch would be lower, stronger, lighter and cheaper. It worked beautifully – his Great Stone Bridge, built around 600, still stands today not only as China's oldest, but also as a classic example of a segmentary bridge, reaching for 37 metres over the Xiao river, Hebei province, a monument to a stroke of genius that pre-dated similar bridges in Europe by 700 years. The Marco Polo Bridge is one of nine other ancient segmentary bridges in this part of China, though today its arches usually span nothing but grass, because the river's water is diverted except in times of flood.

The bridge is well restored, except for one thing Marco would find rather odd. When he saw it, the traffic of carts would have already worn ruts in the paving stones. Ruts were worn in many bottlenecks, typically in entry gates like the Cloud Terrace arch that guards the Juyong pass leading to Beijing through the Great Wall. Though the rutted paving stones are under glass now, and sprouting a nice crop of weeds, it's clear what these cart-tracks should look like – a railway line in negative, indented instead of raised. But on the Marco Polo Bridge the rutted paving stones have been replaced any old how, so that the ruts don't join up. They make as little sense as a book with its pages scattered.

Across the bridge, a different world beckoned.

* * *

There was something about Kublai's China that baffled Marco: paper money.

The technology of papermaking was ancient, though new to Marco. According to legend, it had been invented in AD 105 by the imperial counsellor Zailun, who in the words of a fifth-century historian 'conceived the idea of making paper from the bark of trees, hemp waste, old rags and fish nets'. Near his home was a pool, where he learned to mash his materials into a slurry with a mortar, setting it to dry on fish-net webbing. This paper was as soft and absorbent as toilet paper, but it was fine for calligraphers using brushes. Five hundred years later, Buddhist monks carried the secret to Korea and Japan, and in the eighth century Chinese prisoners captured in Samarkand brought the art to the Islamic world. From there it reached Spain, then under Arab control, in the twelfth century. It might have been known to a select few in Venice when Marco was a boy, but it was not much use to scribes because it was too soft and absorbent for their quills.

The second element needed for paper money – printing – had also been around for hundreds of years, probably since the fifth century, certainly from the eighth. Soft, fibrous paper was fine for taking rubbings. China, Japan and Korea all printed books, using blocks of wood or stone on which whole pages were carved in reverse. They even had the idea of using moveable type, an invention attributed to a certain Bisheng in the eleventh century. Individual letters were hand-made in

clay, wood or metal, set in a frame and used to make block-prints. This was not a revolution: it could not be mechanized, because the Chinese writing system has many thousands of characters, which meant that printing remained hand-work. But it is fascinating to see how close the East came to Gutenberg's invention of printing with moveable type in the fifteenth century.

The Chinese had had paper money, 'flying money' as they called it, because of its lightness, for 300 years before Marco saw it. In the eleventh century there were sixteen businesses minting paper money, which had a built-in safety device: it was only valid for three years. Even so, it proved problematical. First, vast amounts were printed, which debased the currency and caused inflation. Second, it was easy to forge, a drawback countered by ever more sophisticated designs (as in any economy based on paper money) and by executing the forgers.

Marco knew little of paper or block-printing. So the technology amazed him. How odd to mash the bark of mulberry trees to produce paper; to cut the sheets into various sizes; to put a stamp on each; and then – most astonishing of all – to get everyone to treat this scrap of stuff as if it were pure gold or silver. 'And the Kaan causes every year to be made such a vast quantity of this money, which costs him nothing, that it must equal in amount all the treasure in the world.' And it worked pretty well, because the paper money was in fact backed by silver. Four pillars of the economy – unity, stability, confidence and growth – all combined in a way of

which many a modern finance minister would be proud. 'You might say he hath the Secret of Alchemy in perfection, and you would be right!' And yet nothing similar emerged in Europe until the Swedes issued the first paper currency in the late seventeenth century, 600 years after its appearance in China.

Even today, it is something of a puzzle. Why should bits of paper be treated as valuable? The promise on a ten-pound note seems totally tautological: if you, the bearer, asked the Paymaster General to pay you the sum of ten pounds, you would receive nothing but another ten pounds. Once upon a time, of course, the promise meant the equivalent in gold, considered valuable because it is rare and hard to get and does not corrode. Why did that make it valuable? In western cultures, it was a self-evident truth. Not so in others, like the Inca empire before the arrival of the gold-obsessed Spaniards. The fact is that no currency, no metal, no object has inherent value: value is conferred by culture. It is, at heart, a matter of faith. As Niall Ferguson says in *The Ascent of Money*, 'Money is not metal. It is trust inscribed.' Nowadays, you simply have to have faith that your ten pounds, dollars, yuan, whatever, is a minute slice of the country's wealth. If there's more wealth, the government can print more paper money. If there isn't, and it still prints more – or, like Spain in South America in the sixteenth century, steals more gold – the system rebels, faith is lost, the currency declines, and you need more bits of paper (or gold) to buy the same amount of goods. That's inflation, which is what

happened later, after Kublai's death. But when Marco was there, it was, to him, pure magic.

From now on, Marco offers only the occasional flash of colour. On the way south-west to Yunnan, Tibet and beyond, one name follows another with hardly a hint of landscape, or the difficulty of travel, city following city in no particular order, with stock phrases repeated ad nauseam: lots of silk, fine vineyards, great for trade and industry, fine palaces, rich in forests, numerous villages, gold dust here, cinnamon there. Every city is one of idolaters, to the point that even he seems bored by the cliché – 'I may as well remind you again that all the people of Cathay are Idolaters.' At first glance, it seems he could have fabricated this list of places, because it is virtually impossible for a non-expert to guess what the names refer to. But an expert can do more than guess. Stephen Haw has tracked almost every reference from the thirteenth century to the present, and shown that almost every one was a real place, despite changes in name, status, even position.

Along the way lies the ancient capital of Xian, ruled by one of Kublai's younger sons, Manggala, who died in 1280, thus strongly suggesting that Marco was there before that date. Further on were Chengdu, now known worldwide because of the great earthquake of 2008, and Dali, beautifully set between lake and mountains. Yunnan's seductive mix of peoples and ecologies at last provides him with something worth saying, though it is as usual a mixture of fact and fiction. He implies he saw

giant snakes – ten paces long and thick as a barrel – 'so fierce looking and so hideously ugly that every man and beast must stand in fear and trembling of them'. They are caught, he says, by hunters who find the furrows left by the immense tails, and bury blades on which the foolish animals, returning along the same track, inadvertently spear themselves. A likely tale: how does a huge snake manage to move fast enough to impale itself? Why does it not see the blade? If the blade is buried so deep as to be invisible, how come it runs into it? Marco is accurate about what he sees, but this he didn't, at least not in the flesh, because this 'snake' had front legs. Possibly he heard tales about – or saw the skins of – salt-water crocodiles from the coasts and rivers of Burma and Vietnam, which at 6 metres are indeed among the world's most fearsome predators; but they don't occur in Yunnan, and never did. We shouldn't judge him. In a world that took far more exotic monsters seriously, a snake with two legs was no more unlikely than an animal with five legs, one of which it uses as an arm, which was a medieval European description of an elephant.

His stay in Yunnan, together with a brief excursion into Tibet, still 'sorely ravaged' from the Mongol war of conquest, introduced him to a subject close to his heart, as we shall see in the next chapter: women. There was more to intrigue him. Near the Burmese border, a place of wooded mountains, the men, who wear a plate of gold over their front teeth and tattoo their arms and legs, retire to bed for 40 days after their wives give

birth, while the women go back to work. As Yule notes, this strange custom occurred in many traditional cultures. No one knows why for sure. Known both by its French name *couvade* and as 'sympathetic pregnancy', it may be a way to minimize sexual differences in pregnancy and birthing, or regain status, or allow the father to claim a role in the child's life. In any event, Marco once again reveals his essential truthfulness. No one could make up such things.

So into Burma, which Marco seems to have entered on a later trip, perhaps in 1287–8, after the country had fallen, at least notionally, to the Mongols. In 1283 an attempt to gain the king's submission with a force of 10,000 from Sichuan had been frustrated when he fled to the hills. In late 1287, fresh from defeat in Vietnam, Kublai turned back to Burma, this time with some success, because the king had just been assassinated by his son. This was a realm in disintegration, in no state to resist the 7,000-strong Mongol Chinese army that marched down the Irrawaddy to Pagan. Here they stripped the city's monasteries of their gold and silver – though not according to Marco, who tells a story of two great towers of gold and silver which, because they had been built by the king to honour a royal ancestor, Kublai kindly ordered to be left untouched. But the prize was hardly worth the effort. No more able to cope with the climate than Nasir al-Din's army ten years earlier, the troops returned home, leaving Burma to further bouts of civil war and regicide.

Marco makes two cursory glances beyond Kublai's

realm. From the Burmese coast he seems to have stared across the Bay of Bengal to report on what lay the other side, which, as far as he heard, was nothing much. Idolaters, eunuchs, spices and slaves: that was about it for Bengal, dismissed almost as casually as the 'mostly harmless' Earth in *The Hitch-Hiker's Guide to the Galaxy*: 'There is nothing more to mention about this country, so we will quit it.' This, apparently, was not the visit to Sri Lanka and India he mentions later on. Vietnam likewise did not detain him: idolaters (of course), a king with 300 wives, most people tattooed, end of story.

It is time to speak of one of the wonders of the medieval world, the Grand Canal, because Marco was in China when it was being restored and extended. He travelled on it at least twice, the second time with his father and uncle when they finally made for home.

The canal, started in the fifth century BC to serve a previous capital, was being extended by Kublai to serve his new capital just at the time Marco was in China. When it was finished the year after he left, it became the world's longest artificial waterway (1,800 kilometres), and has remained so, with minor variations. As Joseph Needham says in the section on hydraulics of his *Science and Civilisation in China*, this is 'comparable with a broad canal extending from New York to Florida'. It worked well for over 1,000 years.

Old Beijing was not desperate for water transport, but the new one was, with its rich villas, booming

population and insatiable demand for food, the bulk of which had to come from the fertile south. 'It was said that, if there was a good crop in the area round Suzhou and Huzhou [near the mouth of the Yangtze] then the whole empire had enough to eat.'[4] Carts clogging the muddy roads and jamming the eleven gates could never do the job. The city needed another solution. But north China does not have many navigable rivers, and the few that exist run west–east, not south–north. Many of the old canals had decayed during previous centuries, when China had been divided between north and south, partly because the shallow and silty Yellow River had clogged itself and changed course in the early twelfth century, swamping dykes and canals, as it has done several times since. Anyway, the old canal system tended westward towards previous capitals. But to build a new canal system would be expensive and slow. So Kublai's first idea was to supply his new capital by sea, bringing grain up the Hai and several other small rivers that snaked to the coast from the Beijing area. Not a bad idea, because when the Mongols conquered the south in 1279 they inherited that vast navy that he used to invade Japan. But Bohai Bay is both stormy and littered with shoals – in 1286 it claimed a quarter of the ships sailing from the south – and the rivers approaching Beijing/Dadu were liable to flood, or dry out, or silt up.

So Kublai decided to resuscitate the old canal system

[4] Haw, *Marco Polo's China*, p. 75.

and also build afresh. The southern sections were passable – the 550 kilometres from the southern terminus, Hangzhou, to the Yangtze and then beyond to the old frontier between north and south. But northward from there the canals had been out of use for centuries, and rivers between Beijing and the sea would have to be linked up. Work began in 1283, eight years after Marco's arrival, quickly bringing the canal to within 350 kilometres of Beijing. Five years later a final dig, creating a narrow waterway that could take only four-man boats, linked the canal to Beijing's rivers. It was finished in 1293, to universal admiration. 'Here was a great work of engineering indeed, all the more remarkable when one remembers that in its course it had to connect with two of the greatest rivers in the world and one of the most changeable.'[5]

Only in 1288, therefore, could Marco have explored the whole length of the Grand Canal, which he clearly did, because he says of the town of Guazhou on the Yangtze, almost 900 kilometres from Beijing:

At this place are collected great quantities of corn and rice to be transported to the great city of Cambaluc [Khanbaliq/Dadu/Beijing]; for the grain for the court all comes from this part of the country. You must understand that the Emperor hath caused a water-communication to be made from this city to Cambaluc, in the shape of a wide

[5] Needham, *Science and Civilisation in China*, vol. 4, part 3, section 28, 'Civil Engineering Hydraulics: Grand Canal'.

and deep channel dug between stream and stream, between lake and lake, forming as it were a great river on which large vessels can ply.

As an eyewitness's detail, he adds that there is also a road on top of an embankment, made from the mud dug from the canal. Since he also mentions silk being brought into Dadu by the cartload, rather than the boatload, we know that he was in Beijing after 1288, when the final link in the main canal was made, but before 1293, when the last connection to Dadu's lake was opened.

It's hard to find any trace of Kublai's city in Beijing's palls of concrete, smog and expressways, yet in one important sense his city defines today's. The lakes, the rivers and the waterways are still there. Without them there could have been no Dadu, no modern Beijing. In a sense, therefore, the man who made Kublai's dream of a new capital come true was not its architect but the man who regulated its rivers and designed its canals, a genius largely unsung outside China: Guo Shoujing, whom we first met building dams to save Xanadu from flooding.

Marco would surely have known of him, because in the very year of his departure from China, 1292, the new canal with 20 locks was being dug to bring vessels to the eastern wall of Dadu's Imperial City, and then into the lake at the city's heart, the Ji Shui Tan. Guo is now honoured in Beijing several times over.

The Ji Shui Tan, which Guo split into three serpentine sections, is now a pleasure-ground where people pedal-boat, stroll, play mah-jong, drink beer and fish without a thought for whom they should thank. But today's officials know. He's there, twice, at the northern end of the lake. A statue of him stands, right hand outstretched in a sort of blessing, left hand holding a scroll, viewing his creation from beneath an overarching willow in a little backwater, with a walkway all around him so that visitors can admire him from every angle. Behind him, on the bank, is a tree-covered hill, with paths spangled with garden-lights in the shape of lions. They were still building it when I wandered up to find the spot where he supposedly had his office. There is a building up there, a neat, restored temple. In its courtyard, there he was again, in a smart new statue, a fine-looking bearded sage carrying his scroll, the symbol of his talent.

If in imagination, because it's a long walk, you follow the lake southward, into Beihai Park, past the Forbidden City, down a drain – for the river dips underground for a few kilometres – and turn left, eastward, you will pick up the Tonghui river, running parallel to the Beijing–Tongzhou Expressway. On Beijing's eastern edge the river spreads out into a lake several hundred metres wide created by a dam. To one side is a glade of trees on an island, where the noise of the city is a murmur and you can hear the birds. It is separated from the bank by a sluice of huge rectangular stones. This was Guo's work, and in a park being developed as a 'history and culture area' there he stands again, in

newly carved stone dated August 2007. Today's Chinese artists are good at these iconic statues: larger than life (but not forbiddingly massive), flowing robe, loose sleeves, beard, left arm raised, thumb and forefinger parted as if measuring a gap by eye, gaze fixed on a future bright with promise.

A few kilometres further east, beneath a sun made dim by hazy air, an old friend, Cheng, an expert in medieval cities, led me along a packed street clogged with bicycle rickshaws, where – even here – there were signs in English: California Beef, King Noodle Bar, New York Affect Wedding (perhaps it meant 'effect'). In a park, an ancient man pedalled a tricycle with his ancient wife on a backwards-facing seat behind him and a young man practised an *arhu* fiddle, with a long neck and a tiny sound-box that rested on his thigh. Ahead loomed a cylinder of thirteen storeys, every one with an extended curlicue roof: the Burning Light Tower, an earlier version of which – this is the much-restored heritage version – had guided barges at the junction of the Tonghui and the Grand Canal, a good 200 metres across. In Marco's day, as a set of metal bas-reliefs on the balustrade showed, the waterway here teemed with laden junks. Today, it is turgid, slimy and empty.

Now look south, to the southern end of the canal, to the city Marco calls 'beyond dispute the finest and the noblest in the world'. It was certainly the most populous, with an estimated 1.5 million inhabitants. As for its charms, he knew what he was talking about: he

'was in this city many times and determined with great diligence to notice and understand all the conditions of the place'. It was the capital of the Song, who often called it Xingzai, which Marco transcribes as Quinsai or Kinsay. Today, it is Hangzhou.

It was never intended as a capital, but had become one after the unified Song empire was cut in half by the Jin in 1125. To start with the southern Song rulers thought they would be going back to Beijing at any moment; hence the city's unofficial name, Xingzai Suo / 行在所, [the Emperor's] Temporary Resting-Place,[6] or more accurately 'a place [for the imperial court] to stop while travelling'. The name stuck, for 150 years, though in everyday speech they dropped the *suo* (place). Marco says it means 'City of Heaven'. So much for his knowledge of Chinese. Under its official name Linan the city had boomed, with over a century of royal investment before the Mongol attack in 1275–6. Its location alone destined it for greatness: near the mouth of the Yangtze, halfway down the coast, open for trade with Japan, Indo-China, India and the Arab world. Marco was probably right: it could well have been the world's finest city. But he went on to quote statistics many of which were dubious, exaggerated or just plain wrong. He says he based his facts on a memo delivered by the Song

[6] This brief statement papers over much uncertainty. Moule takes eight pages to come to this conclusion with a clinching quote, an order dated 11 December 1277: 'The Song must in future be called the late Song and the Xingzai must be called Hangzhou.' Thanks to Stephen Haw for the translations.

KUBLAI'S PLEASURE DOME: AN ARCHITECT'S VISION

If Marco's description of the 'Cane Palace' is taken seriously, it suggests something like this sketch, with standardized elements (pillars, beams, lintels, battens, pillar bases) that are easy to assemble and take apart. The design addresses major issues – how to support a roof weighing some 37 tonnes? How best to counteract the lift and torque imposed by gales? How to design the 'nails' that hold the tiles down? But this is just a start: countless details need attention, like what the dragons were made of (metal, perhaps?) and how they supported the 'ceiling'.

MARCO'S WORDS MADE REAL

Based on Marco's specifications, this is how the Cane Palace may have looked, with 15-metre bamboo 'tiles' supported by bamboo pillars and held down by some 200 silken cords. It was a unique building, with a unique agenda: a Mongolian tent, easily dismantled, yet solid, built in the Chinese style, with Chinese techniques, using a material – bamboo – that had only recently been made accessible to Kublai by his conquests of semi-tropical Yunnan.

This, or something like it, was the source of the 'stately pleasure dome' made famous by Coleridge. Many questions remain. How are the cords anchored (we chose rocks, and half-buried them)? What about the central hole – was it sealed in some way, perhaps with a canvas flap? Did Kublai have a grand entrance (we have left space for one between the cords)? These questions, and many more, were solved by Kublai's architects. We hope one day to replicate their work.

FROM XANADU TO OLD BEIJING

Kublai's stately progress from Xanadu down to Dadu (Beijing) involved retainers, wagons, horses and probably elephants. The column moved only about 20 kilometres a day, and each evening the emperor arrived at a camp site that was a small town, permanently staffed. Some three days out was the place Marco called 'Chagan Nor' – Tsagaan Nur, White Lake. Wei, Helen and Tu-mu-le showed me several of the 20 or so way-stations, but many have not yet been identified. Nearing journey's end, Kublai's procession wound through Badaling and Juyong, where the Great Wall now runs, before entering Dadu, with its palaces and huddled suburbs, its gardens, lakes and canals.

Right: *Today, 'Chagan Nor' is just a few enigmatic ridges across farmland.*

Below: *Zhong Du, built by Kublai's heir, Khaishan, marked the place where the road to Xanadu met the one across the Gobi to Mongolia.*

The pass at Badaling.

Above:
Tu-mu-le

Right:
Wei

Below:
Helen

A riverside scene in Kublai's Dadu, as portrayed in a diorama in the City Museum.

KUBLAI'S 'GREAT CAPITAL'

Xanadu was Kublai's summer retreat, Dadu, today's Beijing, his power centre. Here he set out on weeks-long hunting expeditions, planned campaigns, established a new religious base, and built a court of fabulous wealth. Though merchants of many nationalities knew China's ports, few penetrated to its heart, and no one described it until Marco. It was his account that made 'Cathay' so famous in Europe that almost two centuries later Columbus sailed westwards in search of a direct route, avoiding the hazards described by Marco.

Below: *The Lugou Bridge, with its lions, was described by Marco, which is why English-speakers also call it the Marco Polo Bridge.*

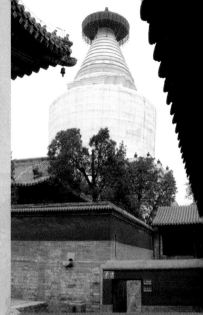

Left: *Kublai at 65, fat and ageing, in a portrait by the court painter Liu Guandao, done five years after Marco's arrival.*

Right: *The White Pagoda, built on Kublai's order in 1271, is the only building in Beijing to survive from Yuan times.*

Below: *Cathay ('Chataio') on the 1459 map by the Venetian Fra Mauro. It is confusing because north is at the bottom and it is very rough. But it owes much to Marco. In the middle is 'Chanbalek' (Khanbalikh or Beijing), with the Marco Polo Bridge top right. 'Sandu' (Shangdu/Xanadu) is at the bottom. The cities, though European in style, are clearly very rich.*

The fleet heading west
through the Indonesian
archipelago in a nineteenth-
century drawing. Possibly,
the volcano in the back-
ground is Krakatoa,
between Sumatra and Java.

HOMEWARD BOUND

The fleet bearing Marco, his father and uncle was
also escorting a Mongolian princess to Persia; hence
its size (above). The two-year journey was an epic
during which Marco picked up many facts and
fictions, which he often mixed. Among his
possessions was a *bogta*, an upper-class woman's
headdress, which he preserved through the
demanding voyage and overland journey from
Persia to Venice. This delicate object must have had
a special significance. Perhaps it was a keepsake
from a wife or concubine in China.

Right: *The legendary roc or rukh was
possibly suggested by the soon-to-be-
extinct elephant bird of Madagascar.*

Left: *Kublai's senior
queen, Chabui,
wearing a bogta.*

Right: *The Andaman
islanders probably
looked the same in
Marco's time as in
this nineteenth-
century view. He
never saw them,
dismissing them on
hearsay as cannibals.*

empress to the city's conqueror, 'Hundred Eyes' Bayan, in which she describes the city's glories in order to move him to spare it. Would she have exaggerated? I doubt it. But she was presumably writing in Chinese, and experts agree that Marco had only rudimentary spoken Chinese at best (witness his translation of 'Quinsai / Kinsay'), and certainly could not read it. He claims to have seen the document, and proposes to tell 'the truth as it was set down in that document. For truth it was, as the said Messer Marco Polo at a later date was able to witness with his own eyes.' He certainly seems to have absorbed a lot of information, because he devotes more words to Hangzhou – its canals, streets, bridges, river, ware-houses, lake, temples, palaces, watch-towers, markets, baths and crematorium – than to Xanadu and Beijing combined. But since he could not read the original, fic-tion crept into fact. Perhaps he saw a bad translation into Mongol, or had an imaginative interpreter. Or is it possible that there was no letter, that Marco never wrote much of the description at all? In earlier editions, it is much shorter, a mere two pages. He may, of course, have added and subtracted again in the original version(s), but perhaps the details were added later by someone else as information became available – additions which themselves were subject to corruption.

Hangzhou, he (or the anonymous editor) says, had 12,000 bridges, most of which were high enough for ships to pass under yet low enough for carts and horses to pass over. There were twelve guilds, each with 12,000 houses containing twelve people, or more.

That's too much of an obsession with twelves to be true, certainly too many bridges. His figure has sparked a quite unnecessary amount of fuss. Actually, there were an unremarkable 347. To say there were 12,000 is so ridiculous that it is obviously an error, either in the original or in a copy. Moule suggests how it could have happened. Suppose someone is translating the passage from French into Latin. If you can imagine the quote in French, the translator sees something like:

> What can I tell you? There are twelve
> *portes* [gates] and again more than 300 great
> *ponts* [bridges] . . .

Our translator's eye confuses *portes* and *ponts*, and misses a line, so that his new text reads 'There are xii [twelve] bridges . . .' Only twelve, thinks this scribe, or maybe the one who comes next. That's not worth saying. Must be a mistake, otherwise why mention it at all. I know, I'll add an *m* (1,000 in Latin numerals). There: 'xiim', and 12 becomes 12,000. Such a small change to produce a marvel.

Marco says there were 160 *tumens* (Mongol ten thousands) of fires, which is not only an odd way to measure housing, but also makes 1.6 million houses, 90 per cent of which would belong to craftsmen. At a stroke, he triples, quadruples, quintuples the city's true population. He also exaggerates the size of the lake and the size of the city and the width of the main street.

He's better with eyewitness material, telling us that

the city is criss-crossed by canals; that the streets are paved; that there were 'great towers of stone', possibly the huge warehouses, which were moated to protect them from storms, fire and thieves; that the Mongol officials keep a close watch on the inhabitants by ordering them to post their household details on their doors, this being the best way to control the city's revenues. Some revenues! As he knew, because (according to one edition) it was to inspect the province's tax returns that he was sent there by Kublai. Millions in whatever currency you like from salt alone; add in the spice tax and sales tax (3.3 per cent each), the silk tax (10 per cent) and all the other taxes, and in very round figures he comes up with a total in the equivalent of gold of 180,000 ounces or 5 tonnes: in modern terms, about £122 million per year – from one of nine provinces into which all China was divided. One whole sector housed foreign, mainly Muslim, merchants. Those were the rich areas. He avoided mentioning the slums, narrow houses of three, four or five storeys, so crammed together that barrows couldn't fit between them, and all goods were carried in and out by hand.

There was much to delight residents and visitors, if they stuck to well-off areas. The great Western Lake, for instance, with its islands and villas and double-deck pleasure-boats, which were punted about in the shallow waters:

Truly a trip on this lake is a much more charming recreation than can be enjoyed on land. For on one side

lies the city in its entire length, so that the spectators in the barges, from the distance at which they stand, take in the whole prospect in its full beauty and grandeur, with its numberless palaces, temples, monasteries and gardens, full of lofty trees, sloping to the shore. And the lake is never without a number of such boats, laden with pleasure parties; for it is the great delight of the citizens here, after they have disposed of the day's business, to pass the afternoon in enjoyment with the ladies of their families, or perhaps with others less reputable.

Chinese accounts back him up with descriptions of punts used for fishing and selling fruit, and large boats for rich families to have picnics: 'The utensils and things needed are all provided, and one has only to come out in the morning and go on board and drink and go home in the evening without any other exertion than that of spending money.' It's as if he is selling holidays to Europeans, praising the palace of the former emperor, with its 20 halls, gold-leaf paintings, gardens, orchards and immense surrounding walls, where the ruler lived in a style brought to life for Marco 'by a very rich merchant of Kinsay when I was in that city'; the great houses of the foreign businessmen; the crowds; the rich in their stretch-carriages, 'long covered vehicles, fitted with curtains and cushions, and affording room for six persons'; the ten markets packed with fruit, game (roe-buck, deer, hares, rabbits, partridges, pheasants, quails, fowls, chicken, ducks, geese) and fish (in such amounts

you would think it 'impossible that such a number could ever be sold'). And to cap it all, the people possess every virtue: peaceable, honest, truthful, neighbourly, respectful of women, hospitable.

Quinsay did not *mean* 'the City of Heaven', but clearly, for Marco, that's what it was: the most glorious city of the world's most glorious empire, in which he had spent seventeen glorious years.[7]

[7] In the long term Hangzhou, which looked set fair for lasting grandeur, would not fulfil the promise Marco saw in it. After the Ming drove out the Mongols in 1368, expansion continued until the mid-fifteenth century, when economic collapse crushed interest in trade and exploration, and Hangzhou ceased to be a world-class city. For this complex and long-lasting revolution, see Abu-Lughod, *Before European Hegemony*.

11

MARCO AND THE WOMEN

HE HAD SPENT ALMOST HALF HIS LIFE IN CHINA. HE SPOKE reasonable Mongol, he was under the protection of the emperor, he had status, his Italian (or rather Venetian) must have become rusty, he had nothing much to draw him back to Europe; he was in his late thirties, he could surely have decided for himself where to live, independent of his father and uncle, if he had wished. So why leave?

The answer, I think, is that he had two good reasons to leave: an uncertain future, and a broken heart.

Let's start by saying he liked women. Remember the 'very beautiful' women of Kashmir and those on the Afghan border, 'beautiful beyond measure'? There was a good deal more than beauty on offer on his journeys to Yunnan and the south-west. In Tibet, old women ply

strangers with girls, because sexual experience is valued by future husbands:

> People travelling that way, when they reach a village or hamlet or other inhabited place, shall find perhaps 20 or 30 girls at their disposal. And if the travellers lodge with those people they shall have as many young women as they could wish coming to court them. You must know too that the traveller is expected to give the girl who has been with him a ring or some other trifle, something in fact that she can show as a lover's token . . . for every girl is expected to obtain at least 20 such tokens in the way I have described before she can get married. And those who have the most tokens, and so can show they have been most run after, are in the highest esteem, and most sought in marriage . . . I have related to you this marriage custom as a good story to tell, and to show what a fine country that is for young fellows to go in.

It is very much the same in Sichuan, where men offer their wives, daughters or sisters. The stranger

> abides in the caitiff's house, be it three days or be it four, enjoying himself with the fellow's wife or daughter or sister, or whatsoever woman of the family best likes him; and as long as he abides there he leaves his hat or some other token hanging at the door, to let the master of the house know that he is still there.

As he says, a fine country for young fellows. Hangzhou, for instance, was notorious for its prostitutes, especially in the post-conquest world when the old capital was crammed with ex-soldiers and refugees. Courtesans thronged the streets

> in such a number that I dare not say what it is. They are found not only in the vicinity of the market places, but all over the city. They exhibit themselves splendidly attired and abundantly perfumed, in finely garnished houses, with trains of waiting-women. These women are extremely accomplished in all the arts of allurement, and readily adapt their conversations to all sorts of persons, insomuch that strangers who have once tasted their attractions seem to get bewitched, and are so taken with their blandishments and their fascinating ways that they never can get these out of their heads. Hence it comes to pass that when they return home they say they have been to Kinsay or the City of Heaven, and their only desire is to get back thither as soon as possible.

Doesn't it sound as if he is carefully disguising his own experience with a veil of objectivity? If so, it wasn't just about sex. He was a lover of women, in whatever form. The wives of Hangzhou master craftsmen were 'dainty and angelical creatures'. And an intriguing passage, reproduced in only one edition of the book, suggests that he had a deep interest, perhaps a personal one, in upper-class Chinese women. He warmed to them precisely because they were *not* like the Mongol and

Tibetan girls or those plying their trade on the streets of Hangzhou.

The passage (in the Moule–Pelliot edition) sounds like a detailed piece of social anthropology, which reads as if it is based on the rule-book of a particularly grim convent. 'The girls of the province of Cathay are beyond others pure and keep the virtue of modesty. They do not skip and dance, they do not frolic, they do not fly into a passion, they do not stick at the windows looking at the faces of passers nor showing their own faces to them,' they don't spread scandal, they don't go to parties, they go to temples accompanied by their mothers, they keep their eyes demurely cast down beneath their pretty bonnets, they never speak foolish words, they keep to their rooms, and they speak only when spoken to. It sounds very unappealing. What foreigner would wish to break into this enclosed world? And if he wished to, how could it be done?

Marco wished to, and somehow did, apparently learning a good deal about the private lives of Chinese girls. They were expected to be virgins at marriage, which was not true of Mongol girls, for 'the Tartars do not care about this sort of convention'. First, future husband and father agree on terms. Then there is a test of virginity, which involves a procedure that was both odd and, as far as I can discover, unique. It was conducted by 'certain matrons specially deputed for this duty who will first examine the girl's virginity with a pigeon's egg'. *With a pigeon's egg*: what are we to make of this astonishing detail? My guess is that pigeon's eggs

were readily available and of the right size (which involves some interesting assumptions about Chinese masculinity). An egg having been procured, it was used to see whether entry was easy or impossible. If easy, imagine the consternation: the girl proven a non-virgin with an egg inside her. But entry would prove impossible, definitively, only if the egg broke. Perhaps that was the point. Imagine the tension, the embarrassment, the mess; and then the doubt. With a high level of anxiety in the girl and her mother, if present, there would surely have been considerable pressure, emotionally and physically, for the egg to crack.

So understandably, even if the pigeon's-egg test was virgin-positive, the answer was not considered 100 per cent reliable, 'since a woman's natural parts can well be contracted by medicinal means' (which opens another unexplored field of enquiry). So one of the matrons performed a local version of the traditional way to test for virginity, by examining – or in this case, breaking – the hymen. A matron inserted a finger covered in linen to stain it with virginal blood, which, as everyone knew, could not be washed out. If it did wash out, then the appropriate conclusion was drawn and the marriage contract annulled – though how on earth does anyone produce *non*-virginal blood? There's something about Marco's account that doesn't quite add up.

Preserving virginity demanded care. Girls had to take tiny little steps, for reasons that have received little attention. Indeed, one scholar at least has baulked at examining the question, saying that Marco offers 'an

arcane explanation, on which I do not propose to expatiate'.[1] That was a decade ago, times change, and these days expatiation is OK. In Marco's words, the girls minced 'because the privy parts of a virgin are very often opened if she take herself along too wantonly'. It is still widely believed that hard and prolonged exercise – like riding a horse – can damage the hymen, which is traditionally a bad thing, because without intact hymens there's no telling what the owners have got up to, and you are on a slippery slope to female emancipation. But this was not about the women's marathon. Chinese girls – or at least some upper-class ones – were apparently told to avoid walking normally, as a way of keeping them under tight control.

If the steps were as tiny as Marco says – 'one foot never goes before the other by more than a finger' – this may possibly be an oblique reference to the newish upper-class practice of foot-binding, one aspect of Chinese life Marco does not otherwise mention. Some scholars have seized on this fact to suggest that Marco was so ignorant of Chinese life he might never have gone there at all. In fact, if the girls he saw mincing their way along the street in their long gowns were as secluded as he suggests, it's not all that surprising that he knew nothing of foot-binding, especially if his source, who will be introduced shortly, had been removed from her family. Possibly also girls walked in this odd way not because their feet were bound, but *in*

[1] Jackson, 'Marco Polo and his "Travels"'.

imitation of that gait by upper-class fashion-conscious wannabes.

The astonishing details about virginity testing suggest objective research. True, the passage appears only in a single edition – the version labelled Z, which was copied in Latin in the late fifteenth century, 150 years after Marco's death. But this edition contains much that others do not, including opinions that show a positive view of non-Christian religions and of Mongol tolerance. In the view of some scholars, the Z edition and the closely related Italian text of Ramusio, represent (in John Larner's words) 'a more personal authorial statement'. If that is so, then these comments were cut out, perhaps by Marco himself, in correcting Rustichello's original.

Why?

Larner has one answer: the religious statements 'might well have been dangerous to broadcast at a time when the Roman Inquisition was flourishing'. Here's another: explicit material like the virginity tests carried out on Chinese girls could have been offensive to readers' sensibilities, particularly if this was seen as part of Marco's direct experience. By then, he was married. It would not look good in Venetian society for a well-off forty-something with a young family to confess to an intimate knowledge of Chinese virgins. Incidentally, the section was also omitted in both the text and the extensive footnotes of the Yule–Cordier edition, published in 1903, when readers' sensibilities were also acute.

Self-censorship to hide an embarrassing truth: could it be that Marco himself was in some way personally involved with the process that he describes?

The suspicion was planted quite early on in my research by a couple of passing references, and hardened by a single word in a single phrase. The phrase was an item in the list of Marco Polo's possessions, made shortly after his death in 1324. The list is in a mix of Latin and Venetian, with a lot of shortenings. It includes the phrase *It. bochta.j.doro con piere & perle*, which means 'Item: *Bochta* d[ecorated] with gold, with stones and pearls'. The word *bochta* means nothing in Latin, Venetian or any other European language, but it has a very specific meaning in Mongol. A *bogta* or *boqta* (as it is in modern Mongolian; transliterations vary) was a woman's headdress in medieval times. Many travellers mentioned these extraordinary hats, which the Chinese called *gugu*.[2] They went out of use at the end of the Yuan dynasty in the late fourteenth century, though upper-class Mongol women retained a love of exotic headgear. Like many aristocratic items of fashion down the ages and across the world, they symbolized wealth and status, for no one who had to engage in any physical activity could wear one. The *bogta* was described by the priest William of Rubrouck, who saw a lot of them when he was in Mongolia in 1253–4. In a typically fine

[2] There are lists of references in Olschki, *Marco Polo's Asia*, p. 106, and Jackson, 'Marco Polo and his "Travels"', pp. 88–9.

example of his anthropological observations, William shows what a large, delicate and richly furnished object we are talking about:

> They have a head-dress called a *bocca* and made of tree-bark or some lighter material if they can find it. It is thick and round, two hands in circumference and one cubit [that's about the length of a forearm, say 0.6 of a metre] or more, and square at the top like the capital of a column. They cover this *bocca* with expensive silk cloth: it is hollow inside, and on the capital in the middle, or on the square part, they put a sheaf of quills or of thin reeds, again a cubit or more in length. And they decorate this sheaf at the top with peacock's feathers and around its shaft with the little feathers from a mallard's tail and even precious stones [the type of decoration depending on the wearer's rank and wealth]. This decoration is worn on top of the head by rich ladies: they fasten it on securely with a fur hood which has a hole in the top made for this purpose, and in it they put their hair, gathering it from the back on to the top of the head in a kind of knot and placing over it the *bocca*, which is then tied firmly at the throat. Consequently, when a number of ladies together are out riding and are seen from a distance, they resemble knights with helmets on their heads and raised lance: for this *bocca* looks like a helmet and the sheaf above like a lance.

Marco carefully preserved this delicate object during a long sea voyage, and then kept it for another 30 years

until his death. It was special enough for him to speak of it sufficiently often for his heirs to know roughly what it was called. It was not valuable enough to warrant a mention in his will. He did not keep it for commercial reasons. Commerce was best served by jewels, of which the Polos had plenty. We have to ask: why did he keep it?

One answer is sentiment, as a couple of authors have suggested. One of them, Leonardo Olschki, hinted at a relationship between Marco and the young princess whom he accompanied to Persia for her marriage to a prince, a story told in the next chapter. He pointed to a tradition of 'offering a royal garment as both a parting gift and a sign of affection and esteem'. But, as Stephen Haw points out, this doesn't work. Giving clothes was a male tradition. For a princess about to be married to a prince – who was of course a relative of Kublai – 'to give such a personal item as a headdress to another man would surely have been almost equivalent to committing adultery'. Marco was an experienced official, and would have been well aware of the danger to the princess if she had offered it and to him if he accepted. No, it 'must have been a keepsake from someone else, from some woman with whom he had been closely intimate while in China, and someone he wished always to remember . . . The likelihood is that it was a parting gift from his wife.' John Larner has hinted at a similar explanation: 'Why did Marco want to return to Venice, to leave behind friends, *perhaps even a family*?' He answers: loyalty to his father and uncle, perhaps, or

perhaps fear of what might happen if his patron, Kublai, died.

Perhaps. But would this have been reason enough to abandon a wife and family? I think not. If we are dealing in 'perhaps', as we must, because there is no firm evidence, there is a better reason.

I heard the story from a persuasive source, a man who claims to be Marco's only surviving descendant, with forefathers spanning 34 generations back to their famous ancestor. He seemed to step out of a vanished time, a Venetian prince (in all but name) of old-fashioned culture, charm, wealth and such extreme discretion that he did not wish me to name him, nor go too deeply into an astonishingly distinguished career. In the late 1960s he was based in Moscow with the Italian embassy when an invitation came from China's foreign minister, Zhou Enlai, to visit Beijing to open a museum devoted to Marco Polo. One thing led to another. He became the first Italian ambassador to China, Minister Counsellor in the Council of Europe, Special Envoy for the UN, adviser to commissions involved in the creation of the European Union, recipient of a UN Peace Medal, a member of French and American academies of the arts and sciences, and founder and president of a portfolio of bodies advising on technology, trade and the future of mankind (no less), including an organisation, also not to be named, which fosters economic links between the two continents, employing 500 people in nine offices in China and Europe. He also runs the Marco Polo Society, founded by his great-grandfather to encourage

East–West relations. Strangely, I was unable to find many references to these positions and bodies on the Web, no doubt a consequence of his extreme discretion.

I met him in Monaco, where he has one of his four properties (the others are in Venice, China and Washington State). I was in jeans, and in a rush from London. He wore a beautifully tailored suit of a very fine check and a silk tie, the personification of taste. This was a man who, at 81, did not need to rush, despite a hectic schedule. He had just come back from China, he was just off to Korea, all for the cause close to the heart of a Polo: 'to explain China to the Europeans, and Europe to the Chinese', by getting both sides involved in projects in each other's areas. They need each other, he explained. Europe without China cannot do much; China without Europe can do even less. Actually, his heart lies more with China. He became quite messianic. 'Europeans are very arrogant people who think they know everything, and want to teach everybody everything, but they know nothing, and don't teach anybody anything.' Much has been accomplished. Euro-China, founded in 1986 when China had hardly begun to open up, had been involved in Shanghai Airport, in high-speed railways, in something like 700 other projects a year, some 16,000 to date. Clearly, there was much more to do, many more bridges to be built.

As he talked, I wondered if I should judge him as the Venetians judged Marco: Signor Milione, all tall stories and wild dreams. But no, he had proof of his ancestry.

'Look, I have brought you a copy of the only authentic picture of Marco.' It was a xerox of a well-known drawing, reproduced in the Yule-Cordier edition of a man approaching middle age, bearded, wise-looking but not yet wizened, mouth slightly offset, one eyebrow minutely raised, a direct gaze. 'It was done in China. I have the original. People say I look like him. You see the wrinkles there, at the top of the nose? Look, I have the same.' Perhaps the link was real. After all, Yule says the drawing was taken from a painting (long lost) naming the subject as 'Marcus Polus', never mind that the style suggests a sixteenth-century origin. In Italy. Two hundred years after Marco's death.

How appropriate, therefore, that the next Euro-Asia forum will be in Hangzhou – the old capital of the Song south, seized by Kublai when he united China in 1276 – of which Marco provided such a detailed portrait. Appropriate in two ways, because it was from this area that his supposed wife came.

'So you believe he was married?'

'Not really a wife, because I do not think they would have been married. A concubine. But they were together. This we know, this we have always known.' He spoke English, one of his seven languages, with hardly a hint of his origins, but with charming turns of phrase. 'Her name was Mei Li, and Marco met her at court in Beijing, because she was in the entourage of Kublai's senior wife, Chabui.'

I thought at first this had to be mere family legend. But as the story came out, so did bits and pieces of

circumstantial evidence. The timing fits. When Marco arrived in China, probably in 1275, the campaign against Song was nearing its end. Yangzhou fell in the autumn of 1275. At the end of January 1276 the empress dowager sent her note to Bayan acknowledging the overlordship of Kublai. On 21 February came the final, formal submission, and China was united.

Perhaps Mei Li was one of those awaiting a new destiny in the service of the empress dowager. When the columns of the defeated Song royalty, the 300 officials, the wives and the concubines reached the end of their long trek northward with the 3,000 wagons of booty, arriving in Xanadu in June, the Yuan court would have got its first sight of this young lady from the Song palace. She would probably not have qualified to join Kublai's own harem, for that privilege, as Marco says, was reserved for the beauties from the Ongirat, who traditionally provided marriage partners for the Mongols; the ones who were vetted by 'certain elderly ladies [who] make the girls sleep with them, in order to ascertain if they have sweet breath, and are sound in all their limbs'.

The system was established; the girls and women were Mongol; there was surely no need to make an exception for a young Chinese girl who spoke no Mongol. There were other retinues she could join. Kublai had several wives – Marco says four, history says six – each of whom 'had a special court of her own, very grand and ample; no one of them having fewer than 300 fair and charming damsels' among their huge retinues.

My eminent source insists she joined the entourage of
Chabui, Kublai's second and favourite wife. If so, we
can zero in on the years 1276–81, because Chabui died
in 1281, when Marco was 27.

It could have been towards the end of this period that
Mei Li appeared at court. After unification was
complete in 1279, there would have been a steady flow
of people and goods between Hangzhou, Xanadu and
Beijing. It would have taken a year or two for Mei Li to
get established in Chabui's immense retinue and learn
the language, as it must have taken Marco a while to
speak enough Mongol and become secure enough for a
relationship to be acceptable. So let's give them a few
years. Marco, remember, has a roving eye, though
carefully controlled. He is now an assured part of a
court at which he constantly glimpses young and
beautiful women, many of whom perform in the rituals
of music and dance organized by the Office for Imperial
Sacrifices and Rituals – but all of whom are constrained
by intricate rules. Somehow, the two meet. Perhaps an
official suggests that it is time Marco had a female
companion. In any event, they meet, and fall in love.
Chabui's chief eunuch says he can spare the girl, and
Marco has the means to set her up in his house.

Of course, in this scenario there would be no need to
establish links with Mei Li's parents, or see her sub-
jected to the pigeon's egg test of virginity. But here is the
perfect source for Marco's esoteric information – a girl
who had been destined for such treatment, and perhaps
for foot-binding, until events snatched her away from

the family home and took her off to Beijing and Xanadu.

They are in effect man and wife, in a relationship that will last a decade. There are no children. When Marco becomes 'governor' – I must add the quotes because it is so widely doubted – in Yangzhou, under his unrecorded Mongol name, she goes with him, back to her home town. There she dies, and Marco's heart is broken. There is nothing to hold him in China, and his father and uncle urge him to go home with them.

Well, perhaps. The scenario has elements that fit: Marco's interest in the opposite sex; his standing at court; the current practice of well-off men taking concubines; the Yangzhou connection, even if it is tenuous; and the eventual departure. As Stephen Haw says, 'Nothing would have been more natural than for the Great Khan to press this young, unattached man to marry,' or at least take a concubine.

But what evidence is there? Precious little.

Her name, for instance: where did that come from? The extremely tentative answer has to do with evidence concerning another young lady whose older family members may well have been contemporaries of Marco.

In the autumn of 1951, just after Mao's Communists had taken power, a workforce was busy knocking down the South Gate in the walls of Yangzhou, the place where Marco might or might not have been governor. They were using the rubble to build a new road. Some of the workers spotted a slab of stone embedded in the gate: probably marble, almost square, about half a

metre long, with some strange markings on it. It could
have been used in the construction of the wall, having
been taken from its original site, perhaps the nearby
district assigned to foreigners where Franciscan friars
had built a church. The slab was a tombstone,
decorated with scenes from the life of St Catherine, suit-
ably so, given the name of the deceased: Katerina
(Catherine), who, according to the Latin inscription,
died in June 1342. A local antiquarian heard of the find,
recognized it as Christian and carried it to the Roman
Catholic Mission. One of the fathers took a rubbing,
which he sent to a friend near Shanghai, a young Jesuit
named Francis Rouleau. Well aware of the delicacy of
researching religious imagery with the Communists
looking over his shoulder, Rouleau photographed the
rubbing, which has since vanished, as has the tomb-
stone itself. Shortly afterwards, Rouleau was thrown
out of China, but he had enough to write a report.[3]
Katerina's full name is given as 'Catherine, daughter of
the late [or late daughter of] Sir Dominic de Vilioni' [or
'Yilioni', the first letter being unclear]. The tombstone,
which depicts the first image of the Madonna and Child
to be found in China, also makes her the only European
woman recorded in China in the fourteenth century. A
few years later another tombstone turned up in
Yangzhou, that of Katerina's brother Antonio, who died
in November 1344. At first it was thought his name was
Viglioni and that he came from Venice. Later research

[3] Rouleau, 'The Yangchow Latin Tombstone'.

suggests that the family was named Ilioni, and came from Genoa. Dominic must have been a member of a Christian merchant colony, one well enough established for them to bring families with them, or build them up while in residence – a colony that could have received Marco, whether he actually governed or just stayed in Yangzhou in the 1280s.

So it is possible that, if he was there, he brought Mei Li with him. The story continues. It seems that close by the Ilioni tombstone was a wooden post, half destroyed by fire. On it was part of an inscription: the name Mei Li and, as my discreet informant put it, 'some words of Marco Polo' – a phrase he recalls as something like: 'My heart remained . . .' Somehow, someone (he says) removed the memorial, and because Marco came from Venice, it ended up in Venice, in the Correr Museum, where Marco's 34th-generation descendant has seen it 'just once'.

Well, the Correr Museum knows nothing of the wooden tombstone, and 700 and more years is a very long time for family memories to endure. One thing is certain: if there is ever a good film made about Marco, Mei Li will have a starring role.

12

LEAVING A TATTERED EMPIRE

CHARACTER, AS THEY SAY IN HOLLYWOOD, IS REVEALED
under pressure, and pressures were building. In the late
1280s Kublai was ageing, his genius waning, his dreams
unrealized, his realm undermined. His son and first
choice as heir was dead. He was obese, suffering from
gout and depressed. The Mongols had long ago reached
the limits of westward expansion. Central Asia had cut
itself adrift in permanent rebellion. His favourite wife
and companion for 41 years, Chabui, was dead. Still
obsessed with the need to fulfil his grandfather's
ambitions for world conquest, he was losing touch with
reality. He overrated himself, underrated the
opposition, made impossible demands and ignored
problems. Externally and internally, the empire was
tottering, and the Polos began to consider their options:
to stay, and hope for the best with Kublai's heir; or head

for home while they could still travel freely in guaranteed safety.

Kublai's long-term aim of world domination meant receiving the submissions of those who did not fight, conquering those who resisted, and the permanent absorption of both into Heaven's own empire. Yunnan had become Chinese; Tibet was next; the western regions of Xinjiang were his by right; Burma would follow.

It was the Japanese campaign of 1281 that revealed Kublai's faults and the limits to empire. Accounts of this campaign have until recently been dominated by the Japanese point of view, because they were the victors, and history belongs more to winners than losers. The story has been often told: how the mighty Chinese fleet was about to crush the hapless, outmoded Japanese samurai when the Heavens themselves came to the aid of the Japanese by unleashing a typhoon that swept Kublai's fleet to oblivion. Soon thereafter, the Japanese called the storm the Divine Wind, the *kamikaze* (*kami* also having the sense of 'god', 'spirit' and 'superior'), referring to it as proof that Japan was under the protection of Heaven. It was to evoke the idea of heavenly protection that the suicide pilots of the Second World War were called *kamikazes*, represented as a new divine wind. Yet recent research has revealed that the original *kamikaze* was a myth. After almost 800 years, it turns out that the Japanese were far more capable than they themselves believed. It was not the Divine Wind that

saved them, but Mongol incompetence and Japanese fighting strength.

Kublai had tried once before, in 1274, around the time of Marco's arrival. That first disaster was caused by a storm which could be put down to bad luck. Now he needed a bigger fleet and more land forces; and for that he needed the compliance of Korea, his unwilling vassal. But Korea had borne the brunt of the 1274 débâcle. Her grain had been commandeered, her young men drafted as shipbuilders and warriors, leaving only the old and the very young to till the fields. There was no harvest, and no manpower to rebuild the fleet. For five years after that failed campaign Kublai had had to send food aid to keep Korea alive. Now he needed Korea again, and more. Ships would also have to come from the newly conquered south, the former Song empire, and its unwilling inhabitants.

It would be simple, of course, if only the Japanese would acknowledge his overlordship. They would not. Three Chinese ambassadors demanding surrender were beheaded, and Japanese resolve strengthened. Foot-soldiers and cavalry prepared for action, and a wall rose to guard the obvious landing beaches at Hakata Bay.

Kublai's plan was to send two fleets, one of 40,000 troops in 900 ships from Korea, the other of 100,000 in 3,500 vessels from Quanzhou in Fujian. The two would link up at the island of Iki, 30 kilometres off the Japanese coast, and then invade the mainland together. It would be the biggest fleet in history, and would remain the biggest until exceeded by the

Allied invasion of Normandy on D-Day, 6 June 1944.

That was the plan. But it was highly optimistic. True, Kublai had access to huge numbers of ships, because they had been massed for the assault on Song down the Yangtze. But except for a few massive warships, mainly from Korea, this was a fleet of small landing craft. It was crazy: Kublai would be relying on wind power and oars to cover 200 kilometres in the case of the Korean fleet, but a formidable 1,400 kilometres for the 3,500 smaller vessels from the south. Even with a good wind in the right direction, it would take them six days to reach the rendezvous on Iki. Obviously, Kublai and his commanders aimed to get the conquest over before the typhoon season started in August. But Kublai had hardly ever glimpsed the sea and never sailed it, let alone seen what a typhoon could do. Blinded by desperation and isolated by power, he was taking a fearful risk, and there was no one to tell him the truth of how great that risk was.

Things went wrong from the start. The Korean fleet reached Iki as planned around the end of May, and waited – and waited. The southern fleet in Quanzhou didn't even manage to start on time. A commander fell ill, food rotted, epidemics spread. When it finally got going, contrary winds drove many ships into ports along the coast. Eventually the Korean fleet on its own made a brief landing, only to be forced back to an island in the middle of Hakata Bay. A month behind schedule, the commander of the southern fleet decided to go straight for the mainland via the little island of

Takashima, 50 kilometres south of Hakata, intending to march north to meet the others on land. But the assault never gained momentum. Every likely site for 20 kilometres round the bay of Hakata was blocked by the wall and Japanese cavalry.

On 15 August nature stepped in with the first typhoon of the season. Some 15,000 of the northern force and 50,000 of the southerners died at sea, while hundreds of others perished at Japanese hands, or were tossed to their deaths in the small boats that had remained near the rocky shore. The armada vanished into the belly of the ocean. It was a catastrophe never matched in scale on a single day at sea before or since, and never on land either until the atom bomb destroyed Hiroshima, killing 75,000 at a single blow, in 1945. Some 1,500 of the Mongol survivors were taken into slavery. Three were allowed to return, to tell Kublai of the fate of his great armada and its all-conquering army.

Of all this Marco seems to have heard random snippets of truth and rumour; hardly surprising given the lack of official contact between Kublai's empire and Japan. He himself had never heard of the place before coming to China. No one in the West had. His report was the first mention of 'Chipangu', as he called it, in any European language. So he had no way to check what he heard, like the assertions that some Japanese made themselves invulnerable by inserting 'certain stones' under their skin and that the emperor's palace was entirely covered with gold. It was to seize Japan's wealth that Kublai sent a fleet, he said, which was duly

struck by a wind that 'blew so hard that the Great Kaan's fleet could not stand against it'. The rest of the story is told in terms of the rivalry between two commanders and the fate of 30,000 survivors who landed on an unnamed island and then, by a ruse, returned to the Japanese mainland and seized the capital, again unnamed, holding it for seven months until it was retaken. Well, there are islands, there were survivors, there was rivalry; but if Marco's version has a factual basis, it was transmuted into myth before he ever heard it.

The Japanese, too, turned truth to myth, seeing their victory as an act of the gods. Yet there is growing evidence that they overrated the opposition and under-rated themselves. The evidence began to emerge in 1980, when fishermen on Takashima showed Torao Mozai, a Tokyo University archaeologist with an interest in Kublai's fleet, a solid little square of bronze with writing engraved on it. It turned out to be the official seal of one of Kublai's commanders. Since then marine researchers under Mozai's successor, Kenzo Hayashida, have raised swords, spearheads, stone hand-mills, anchor-stocks, stone catapult balls and ships' splinters from the muddy bottom.

The work suggests a startling but logical conclusion: in response to Kublai's insane demands for mass build-ing at high speed, his naval craftsmen improvised. They took any ships available, seaworthy or not. The good ones they put into service, the poor ones they re-fashioned with the same material. The vast proportion

of Kublai's fleet were keel-less river boats, utterly unsuited to the high seas. The typhoon did not save the day; it brought a long-drawn-out collapse to a quick end. The Japanese were, in the words of a recent book on the invasion, in little need of divine intervention. Kublai had in effect scuppered his own fleet before it set out.

Kublai's empire was a monster with a prodigious appetite for men, materials and money, and it had to be kept fed. One man seemed to have the secret, and for Kublai that was reason enough to back him, despite the hatred that spread like a plague around this power-obsessed and deeply repellent minister. For 20 years disaster brewed, until it cooked up a melodrama more sensational than fiction, involving a suicidal fanatic, a mad monk, a farcical plot and the murder of the man himself. It is a story that Marco tells with glee.

The villain was Ahmad, an Uzbek (as we would now call him) from Banakat, near Tashkent, a town taken by Genghis at the start of his invasion of the Muslim world in 1220. As a boy, Ahmad was in the entourage of Chabui, then graduated to Kublai's household, helping with budgets and military expenditures, which engendered in him a 'relentless craving for total control over government finances', in the words of his biographer, Herbert Franke.

He rose fast, being given two jobs: a senior position in Kublai's Secretariat and that of transport commissioner. He hated supervision, always a bad sign

in an administrator, and loathed his boss, Kublai's son and heir Zhenjin (Jingim in another spelling). Ahmad's job was to increase government income, and he was never short of ideas on how to do it: raising the production of iron tools in government-owned smelting works, introducing a sales tax on silver transactions, cancelling tax exemptions for monks, penalizing the salt producers of Shanxi to stop them undercutting the government's salt price.

Kublai loved the result, and Ahmad prospered. His growing power was matched by his arrogance, and his arrogance by his unpopularity. What of that? Most foreign officials were unpopular, Mongols and others alike, as Marco recorded: 'All Cathayans [northern Chinese] detested the Great Kaan's rule because he set over them governors who were Tartars, Saracens, or Christians.' Shortly before Marco's arrival, Ahmad had become Kublai's top official. There were several attempts to impeach him, but complaints were sidelined by Kublai, who needed all the cash he could raise for his campaigns of conquest.

After victory in the south Ahmad became a law unto himself, declaring state monopolies on salt, medicinal herbs, copper tools and the sale of iron, which enabled him to manipulate their prices and reap fortunes for himself. One son was mayor of Beijing, another was governor of the former Song capital, Hangzhou. He set up transport bureaus in each of the eleven provinces, nominating Muslims to head five of them – a slap in the face for his Chinese colleagues.

Critics were demoted or imprisoned, or simply vanished.

Ahmad might have got away with it all had he not been so eternally, fatally acquisitive, proposing through associates that a property here, a jewel there, or a beautiful horse for his stud would oil the way to this or that appointment. He had a particular eye for women. In Marco's words: 'Whenever he knew of any one who had a pretty daughter, certain ruffians of his would go to the father and say, "What say you? Here is this pretty daughter of yours; give her in marriage [to Ahmad], and we will arrange for his giving such a government or such an office."' All told, according to the Persian historian Rashid al-Din, he acquired 40 wives and 400 concubines. After his death, when his possessions were listed, he was found to have 3,758 horses, camels, oxen, sheep and donkeys.

Still Kublai remained in thrall to Ahmad's financial acumen, drive, self-confidence and plausibility. The dreadful possibility arose that if he was not stopped he and Kublai would end up running the empire together.

Now, at last, a plot was hatched. There were two conspirators, both highly unstable characters. The driving force was Wang Zhu (Vanchu as Marco spells him), a hard military man, a regimental commander so obsessed with Ahmad that he had acquired a big brass club to kill him with. His accomplice was a shady Buddhist monk named Gao, who claimed to be a magician (Marco calls him Chenchu, and gets his details wrong). The two had met on a campaign, when Gao cast spells that hadn't worked, then killed a man and

used the corpse to fake his own suicide. He was now on the run.

In late April 1282 Kublai had gone to Xanadu earlier than usual (Marco states that the emperor normally went there for three months at the end of May, but several Chinese accounts of this whole episode agree on April).[1] Beijing was left to Ahmad. The plotters seized their chance, as the official history relates, though in four different and often contradictory versions, which conflict again with Rashid al-Din and Marco. What happened was something like this:

The two plotters hatched a lunatic scheme, involving a crowd of 100 or so, who would turn up at the city gates purporting to be the entourage accompanying Zhenjin, the heir apparent, who (they would say) had suddenly decided to return to Beijing for a religious ceremony. It would be night-time, too dark for a quick check of who these people were. The idea was that Ahmad, galvanized by the approach of the one man he feared other than the emperor himself, would lead the way out to greet them, and that would be the moment to strike. This was to be the signal for a general uprising in which the Chinese would massacre 'all the men with beards', i.e. foreigners.

On 26 April the two put their complicated scheme into effect. Ahmad sent out a small advance guard to meet the mock-prince and Wang's rent-a-crowd of horsemen, a meeting that took place some 5 kilometres

[1] The sources are quoted in Moule, *Quinsai*.

out of town. The guards saw at once that the whole thing was a scam. The rebels had no alternative: blaming them 'for want of manners', they killed the guards, and proceeded. At about 10 p.m. they gained entry to one of the city's north gates, and made their way to the prince's palace. The suspicions of the guards here were allayed by a forged note from the mock-prince demanding an escort of troops, which, astonishingly, was supplied.

Now Ahmad and his entourage came out. The rebels dismounted, leaving the lone shadowy figure of the mock-prince on his horse. The figure called out to Ahmad. Ahmad stepped forward. Wang and a few followers were right behind him. They led him further forward, then away into the shadows, out of sight. Wang drew from his sleeve his brass club with which he struck Ahmad a single blow, and 'knocked out his brains'. (Marco says the accomplice struck the blow, with a sword, cutting off Ahmad's head.)

Ahmad's No. 2 was called next, and was killed.

Now Ahmad's retainers, realizing something was amiss, yelled for help. All was sudden chaos, with guards and rebels mixed up in the dark. Gao, the counterfeit prince, galloped off into the darkness, arrows flew and the crowd scattered, leaving Wang begging to be arrested, certain that his noble act would be recognized. No such luck. The monk Gao was found two days later. Both were beheaded and quartered.

The commander of the Beijing guard set off in person to take the news to Kublai. After a non-stop gallop of

some 300 kilometres in two days, changing horses along the post-road, he reached the emperor three days out from Xanadu in the way-station of White Lake. 'When he heard the news he burst into a passion, and, going the same day to Shangdu [Xanadu],' he sent a senior minister, Bolad, and two others to Daidu to hunt down the rebels and ensure that Ahmad had a proper state burial.

When Bolad returned ten days later, he brought the truth about Ahmad. Kublai flew into another rage, this time with the opposite target, exclaiming: 'Wang Zhu was perfectly right to kill him!' He ordered the arrest of all Ahmad's clan members and associates, right across the empire. All his actions were reversed, all his property confiscated. Investigators made some unsettling discoveries, suggestive of exceptional cruelty and downright weirdness. In one cupboard they found two tanned human skins 'with both ears remaining'. These disturbing details inspired much talk of magic, which accounts for Marco's remark that Ahmad 'had so wrought upon the Kaan with his sorcery that the latter had the greatest faith and reliance on everything he said'. Kublai ordered Ahmad's tomb to be opened, his corpse to be beheaded in public and then his remains to be thrown outside Beijing's main north gate to be consumed by dogs.

In the thirteenth century Vietnam was two kingdoms, Annam (in the north) and Champa. On the assumption that both were already part of his empire, Kublai had

given them the opportunity to acknowledge their submission. Annam agreed, Champa declined. In 1280 he had decided it was time to insist. His 5,000 troops and 100 vessels landed on the bulge of southern Vietnam, hoping for quick victory in open combat. Instead, they got death by a thousand cuts at the hands of Vietnamese guerrillas. Reinforcements – another 15,000 – had no effect. The king remained uncaught, his troops undefeated, though you would never know it from Marco's biased account of an ageing monarch with 326 children begging for mercy and promising to send 20 elephants every year in tribute.

Some new strategy was called for. Since Annam was already by implication Chinese – i.e. Mongol – Kublai could surely send troops across his kingdom with impunity. But Annam's new ruler, the third of the ruling Tran dynasty, Tran Nhan Tong, saw the proposal as a cover for invasion, and refused permission. Vietnam geared itself for action, which, under Tran leadership, it could do very well by calling up a trained army in days. When the Mongol army, reportedly 300,000 strong, making it twice the size of the Vietnamese force, reached Hanoi – Thang Long, as it then was – they discovered that Annamese tactics were exactly the same as Champa's. The houses were empty, the gardens stripped of food; the court and people had fled. The Mongols, now reinforced by ships sailing up the Red River, commanded the coast, but not the interior, the forests and mountains. Guerrilla action, disease, lack of food and the fearsome summer heat began to take their

toll. Two battles sealed the Mongol defeat – 50,000 captured, the Mongol leader killed and beheaded, the remnants harried back to the border, guaranteeing that one day Kublai would have to try again.

It took two years for Kublai to reform his shattered force. This time, the strategy would be different: a huge base was to be established just inland from Haiphong, and the ground attack accompanied by a large-scale naval assault. Under a Vietnamese hero, Tran Hung Dao, the response in 1287–8 was sheer brilliance. First came a scorched-earth withdrawal from inhabited areas, leaving the Mongols with nothing to conquer. In reply, the Mongol general, Kublai's son Toghan, planned on a huge operation with some 500 vessels to bring reinforcements and food up the Bach Dang river from Haiphong. It was on the fleet that Tran Hung Dao focused his attention, repeating a tactic first used 300 years before to defeat a Chinese fleet and ensure Vietnamese independence. He ordered troops to cut and sharpen hundreds of ironwood stakes. These were then ferried 5 kilometres to one of the hundreds of little off-shore islands. Here Vietnamese troops settled with their stakes to watch as Toghun's ships slid past on their way upriver.

Once the ships were out of sight, a Vietnamese boat picked up the troops and their sharpened stakes. A few kilometres upriver, in an area where the river broadened into mud flats at low tide, they waited for the tide to go out and planted their stakes, points up, set just below the level of high water so that small boats would float

clear of them. When the Mongol fleet, harried from the banks and shoreline, retreated downriver, its vessels were impaled and torn open by the stakes, as Vietnamese fire-boats drifted in from upstream. Sloshing ashore through mud and water, the Mongols were easy prey for the forces ranged along the banks. For the Vietnamese, it was a famous victory (still celebrated today: the Bach Dang Stake Yard is a historic site). Toghan escaped, but was banished by his father in punishment.

And of all this Marco says absolutely nothing, which suggests that he was away from court for the two crucial years during which the disaster unfolded. By the time he got back, it was all over and he had other things to attend to, namely news of another battle on the grasslands of Mongolia and his own departure from China.

All this while Kaidu had been active, often almost forgotten amid the business of administration and foreign adventuring. But he had been busy building support all around the fringes of the empire, reaching out southward into Tibet and at the same time eastward to Manchuria. In 1287 he threatened to link up with a new challenger there, a feisty 30-year-old prince named Nayan, a descendant of Genghis's half-brother Belgutei. Kublai was faced with the grim prospect that all the northern reaches of his empire, a great arc of steppe-land from Xinjiang across his original Mongolian homeland and into Manchuria, would fall away to

become the pastoral-nomadic empire to which the rebels aspired. Kublai sent a force to occupy Karakorum, while he himself led another army against Nayan.

Marco tells the story in his usual overblown way, giving the impression that he was on the spot. Kublai gathers his force in twelve days, 360,000 cavalry and 100,000 infantry – impossible numbers that should be cut by 90 per cent. Even so, 46,000 is a significant force. Astrologers are consulted, and predict victory. Scouts are sent ahead to arrest anyone they see, thus preventing word of the advance leaking out. Kublai is lifted into his mobile battle-station, a miniature fortress borne by four elephants harnessed together abreast. A 20-day march brings them to a plain, probably somewhere in the vast open spaces of Mongolia's south-eastern steppes. The rebels are surprised, but form up, both sides singing to the accompaniment of 'certain two-stringed instruments'. Then kettle-drums – cauldrons a couple of metres across covered in buffalo-skin – boom out the order to attack. Arrows fall like rain, men clash with mace, lance and sword, the wounded cry, the battle sounds like thunder, as battles commonly did in the clichés of medieval romances. Kublai wins; Nayan is captured, and executed in the traditional way for princes, without the shedding of blood. 'He was wrapt in a carpet, and tossed to and fro so mercilessly that he died.'

Incidentally, Marco's account adds to his attempt to portray Kublai as a closet Christian. It might have looked

bad to crush to death a man who was a Nestorian, like Kublai's mother. So Marco gave his account an inventive Christian spin. The Mongols started by mocking the Christians: 'See now what precious help this Cross of yours hath rendered Nayan!' It was Kublai himself who rebuked them. Of *course* God (Christian or Mongol, it hardly matters) had not helped Nayan, because he was 'a disloyal and traitorous rebel against his Lord ... Wherefore the Cross of your God did well in that It gave him no help.' And the Christians replied, as of one accord, 'Great King, you say the truth indeed, for our Cross can render no-one help in wrong-doing.'

Marco never knew the much-delayed outcome of this conflict. The stalemate would last to Kublai's death in 1294, and beyond. Kaidu died, perhaps of wounds, perhaps of sheer exhaustion after 45 years of campaigning. Kaidu's heir surrendered in 1310, but his lands fell back into the hand of the Central Asian branch of the family, proof that no Chinese ruler could hope to hold such a vast empire together.

Personal losses, rebellion, defeat and old age were all taking their toll on Kublai. In his last decade, he turned to food and drink. At court banquets he gorged on boiled mutton, breast of lamb, eggs, saffron-seasoned vegetables in pancakes, sugary tea and of course *airag* (fermented mare's milk, otherwise known by its Turkish name, *koumiss*), the Mongolian drink of choice. It was the drink in particular, *airag* and wine in prodigious amounts, that undermined him. As activity declined, as

his powers waned, he put on weight, ballooning year by year into extreme obesity. He must have known it would kill him, but he didn't care.

The Polos, however, cared very much. Marco says almost nothing about his father and uncle, but (as we shall see) they had been busy as merchants, trading their way to wealth with Kublai's blessing. They still presumably had their golden *paizi* – or perhaps Marco had it, because Maffeo and Niccolò needed two more to ensure that they could travel for free and in safety. But there was no certainty that Kublai's heir would support them in the same manner. If their privileges vanished, if they were not granted two more *paizis* very soon, they would not get home at all. We are now in the late 1280s. With overlapping crises tearing at Kublai's flanks, time was of the essence.

In one edition, it is Marco's father, Niccolò, who takes action. 'One day, seeing that the great Kaan was very cheerful, [he] took occasion to beg him on his knees in the name of all three leave to depart to their home.'

The request upsets the old man. 'Why do you wish to go to die on the way?' he asks. 'Tell me. If you have need of gold, I will give you much more of it than you have at home, and likewise every other thing for which you shall ask.'

'O Lord,' replies Niccolò. 'That which I say is not for want of gold, but it is because in my land I have a wife—'

What? This is the first we have heard of a new wife.

Wife No. 1 – Marco's mother – had died during their first journey. Had he married again before returning to China? Not likely, because on his final return home he *did* marry again, which would mean that this wife would also have died in his absence. Besides, there is no record of her. If Marco's story is true, then Niccolò's wasn't.

Anyway, Kublai refuses. 'On no condition in the world am I willing that you depart from my realm, but I am well content that you go about it where you please.' Another version comes to the same conclusion. Despite repeated requests, 'nothing on earth would persuade him to let them go'. This must have been an agonizing process, because there's a danger that when a petition to the powerful is refused, a repeat request will generate impatience. Then all is lost.

It was luck that directed them to China, luck that showed them the way home. The unlikely sequence of events started long before and far away, in Persia. In brief, here's what happened:

In 1282 the Persian ruler, a grandson of Genghis, died. His brother inherited. He turned Muslim and renamed himself Ahmad, the better to rule his people, thus sparking revolt led by a nephew, Arghun. Ahmad had Arghun arrested and sent an assassin to kill him. Instead, the assassin freed him. Arghun won his rebellion, executed Ahmad and reigned for seven years (1284–91). These events were well known to Kublai – and to Marco – from embassies that hastened back and forth. Arghun was successful in part because he had

Kublai's backing, referring to himself as Il-khan, subsidiary khan, a title that was later applied to the whole Persian Mongol dynasty.

In April 1286 Arghun's queen, Bulugan, died. The will of this powerful and respected lady stipulated that her husband should marry again, but take as his new queen only a member of her own family. Many months later, probably some time in 1287, an embassy headed by three of Arghun's nobles arrived overland at Kublai's court (Beijing or Xanadu, Marco does not say) with their lord's request. Kublai's relationship with the empire's Persian wing had not been easy, but was at least better than those with more rebellious family members closer to home. Arghun was a favoured great-nephew. There was a grand reception for the ambassadors. Kublai agreed to the request, and sent out for a suitable candidate. By good chance, there was one, 'a maiden of seventeen, a very beautiful and charming person' – *nobile et belissima dona* in a Latin version – named by Marco as Cocachin, perhaps Khökhjin in a modern transcription, which is a personalized form of the Mongolian for 'blue', but which has the additional meaning 'dark' in complexion. She was, if you like, The Dark Lady.

It must have taken many more months to prepare 'a great brigade to escort with honour this new bride to king Argon'. The return journey overland would take the best part of a year. Off they went, only to be halted on the fringe of Kublai's empire. Kaidu, the eternal rebel against Kublai, had just forced Kublai to pull his troops

back from much of Xinjiang. It would never do to have the next queen of Persia taken hostage by Kaidu. He could hold both China and Persia to ransom. So a year and many months after their departure – we are now into 1289 or even 1290 – back came the princess and her retinue. If this went on, the queen-to-be, now no longer a teenager, would die an old maid.

It so happened that this was the time when Marco arrived back from some journey or other. The Yule–Cordier version states firmly that he was returning from India. Perhaps he had completed his expedition to Sri Lanka for Adam's hair and teeth, an expedition on which he gives considerable, but totally impersonal, detail. The relics had been lodged in a high mountain, which could be climbed only by the use of 'great and massive iron chains'. It was a multi-faith site, worshipped by both Muslims and Christians, though Buddhists claimed the relics were those of the Buddha. Somehow, Kublai's men managed to buy some relics and a dish of green porphyry that magically multiplied food for one into food for five, and headed for home. Was Marco with them? We really have no idea. His words are too garbled to get at the truth, as the Moule–Pelliot translation shows, with its interpolations from various editions: he returns 'with a certain embassy from Indie', he (or someone or other) had 'gone as ambassador of the lord', he (or someone) had been 'through the province of king Arghon' (i.e. Persia, which in a sense he had, on his way to China, over seventeen years before). In any event, he could

have returned from the south, and could have used the newly opened Grand Canal to return to Kublai with fascinating accounts of his travels, wherever they had taken him.

The need to deliver Cocachin halfway round the world, Marco's arrival, his travelling experience, the Polos' request to leave, the completion of the Grand Canal – everything conspired to plant an idea in the heads of Arghun's ambassadors: they could travel down the Canal to Hangzhou, proceed to Zaiton (Quanzhou) and leave from there by sea, with the Polos, particularly Marco, as their guide. Here was a suggestion that Kublai could not refuse. Though still reluctant, 'at last he did give them [the Polos] permission to depart, enjoining them to accompany the three barons and the lady' on condition that they would return to him when they could.

They promised, of course. And it all fell into place. Kublai gave them their two golden *paizis*, each inscribed with its order in God's name that the bearer be allowed free passage on horse or boat, with escorts if necessary. The three Polos, businessmen to the last, exchanged the accumulated wealth of seventeen years for 'rubies, emeralds and other jewels, being well aware of the impossibility of carrying with them so great an amount in gold over a journey of such extreme length and difficulty', sewing all these gems for safety's sake into their travelling clothes (remember this detail; it is part of the story of their homecoming by Marco's earliest biographer Ramusio, which we will get to at the proper

time). The mission was now much grander: three ambassadors, a princess, a second princess presumably as friend and confidante, the three 'Latins', servants, accompanying officials and a military guard, all with a far more significant purpose. Not only were all of them to deliver Cocachin to Persia, but the Polos were to be part of an embassy to the pope, to the rulers of France, England and Spain 'and the other crowned heads of Europe'.

To do what exactly? Marco does not say. But Kublai would almost certainly be hoping, even expecting, that Europe's kings would listen to Marco, and with one accord submit, coming themselves or at least sending embassies and gifts and professions of eternal service. The world would move one huge step closer to rule under Tengri, the God of Karakorum, Xanadu and Dadu. Marco, of course, would have known this was pure fantasy. But, because nineteen years before he had actually spoken with a man who had become pope, he would also have known that the current pope would have equally fantastic hopes: that all China would instantly be open to conversion, and the whole world would be ruled by the God of Rome.

Early in 1291 this immense delegation – 160, according to Chinese sources[2] – made its stately progress down the Grand Canal, which for an embassy of this size and

[2] Cleaves, 'A Chinese Source Bearing on Marco Polo's Departure from China and a Persian Source on his Arrival in Persia'.

status had an advantage over the road. True, the post-roads had way-stations; but they were not big enough to cope with this crowd of VIPs, carriages, guards and horses. Better to send the retinues by road, and the dignitaries by boat, in comfort, camping overnight wherever they wanted.

A month later, they arrived at the canal's end, in Hangzhou; regrouped for road travel; and moved on southward for another 700 kilometres, to the even more international port that foreigners knew as Zaiton (today's Quanzhou). Marco says the last leg of the journey took five days. True, the main road was paved, but even so it surely took longer than that, more like three weeks.

Quanzhou's non-Chinese name proclaimed its international credentials. *Zaitoun* is the Arabic for olive-tree, a reminder of those that lined its well-shaded streets. Its deep harbour and long, protected estuary made it ideal for sea trade with Taiwan, south-east Asia, India, Persia and Arabia. According to the great fourteenth-century Moroccan explorer Ibn Battuta, its harbour was 'one of the greatest in the world. I'm wrong! It is the greatest. I have seen there about an hundred first-class junks together; as for small ones, they were past counting.' Arab merchants settled there by the thousand, and Chinese counterparts flocked to do business with them. Much of China's porcelain, popular in the Muslim world, flowed out through Zaiton. The conquest had largely destroyed ceramic production in the north, and when Kublai came to

power he showed no interest in tableware, which you might think would put a damper on the trade. Not so. The fourteen southern kilns continued to fill wagons rolling into Zaiton. Imports matched exports. As Marco says, the port was

> frequented by all the ships of India [i.e. Asia], which bring thither spicery and all other kinds of costly wares . . . hither is imported the most astonishing quantity of goods and of precious stones and pearls, and from this they are distributed all over Manzi. And I assure you that for one shipload of pepper that goes to Alexandria or elsewhere, destined for Christendom, there come a hundred such, aye, and more too.

As a result, its customs taxes – up to 40 per cent on some goods – were another vital source of income for Kublai. In all, it was a smaller version of Hangzhou, with equally attractive people: charming, quiet, fond of an easy life.

It might have been hard to leave, if the ships ordered by Kublai had not made it easy.

13

HOMEWARD BOUND

WHY SHOULD THIS HUGE DELEGATION HAVE GONE ON TO Zaiton at all? Why subject the princess and the Muslim ambassadors to the inconvenience of another three weeks on the road when Hangzhou should have had as many ships as anyone could want? There is a reason: it was in Zaiton that a truly immense operation was already under way, in preparation for yet another foreign adventure.

In 1289 Kublai had sent an envoy to Java bearing a demand for submission. The king, Kertenagara, had the envoy's face tattooed, so that when he reported back to court the insult was so plain and public that it demanded revenge. Kublai ordered a battle fleet to be made ready in the south, asserting that an invasion would be a walkover: 'If you occupy that country, the other smaller states will submit of themselves; you have

only to send envoys to receive their allegiance.' For three years a naval force mustered in Zaiton: 1,000 ships, 20,000 troops, a year's supply of grain, 1,000 kilos of silver for new supplies. This force may have played a role in Kublai's thinking from the moment it became clear that Princess Cocachin would have to go by sea. She and her retinue would need several enormous ships and an escort. No problem. If they went to Zaiton, they would find that the naval force preparing to invade Java could spare enough ships. Everyone would leave together, and the embassies could continue on their own in due course.

By European standards these ships were enormous, as befitted the world's most advanced culture. 'The ocean-going ship', writes the Canadian marine archaeologist James Delgado, '[was] arguably China's greatest creation.' Columbus's *Santa Maria* was a mere 26 metres long, under half the length of a 60-metre Song junk. Not for another 500 years did European vessels reach this size and complexity of design. These junks had four or six masts, and double hulls with watertight bulkheads, which were unknown in Europe until the coming of steam (and even then were not always effective, as the fate of the *Titanic* showed). Anyone who has been aboard Nelson's flagship, HMS *Victory*, knows the miserable living space allotted to the men. By contrast, the Chinese vessels, as Marco noted, had 50 or 60 cabins 'wherein the merchants abide greatly at their ease, every man having one to himself'. Crews numbered 200–300. Sails were bamboo mats, which

could be swung about to catch the wind. There were also four-man oars deployed on windless days or in harbours. Two or three smaller ships, each capable of holding 50 or so men, tended the mother ship, sailing or rowing nearby, helping to haul her if necessary. All these ships carried dinghies slung about them, which were dropped when needed to help with anchoring, fishing or fetching supplies.

Marco says thirteen ships were prepared for the embassy, all of them mother ships with four masts and up to twelve sails. If this was so, then there must also have been another 30 or so smaller vessels in attendance, pushing the total crew up to almost 5,000. This seems an unnecessarily large number for the several hundred passengers, not all of whom required single cabins. Possibly, Marco means three mother ships attended by nine or ten smaller ones, making a crew of about 1,300 (he refers later to 2,000, which could be the total of passengers and crew). If this still seems excessive, remember it was a tiny fraction of the 20,000-strong force then being prepared for the invasion of Java.

There is in the vast expense of the princess's naval delegation a very strange irony, which we can appreciate with the advantages of hindsight. Arghun, the Persian ruler, had died in March 1291, murdered while in a coma. The whole expedition had been rendered unnecessary. It left only because of the delay caused by the unrest surrounding the succession and the time it took, first, to decide on the message to be sent,

and then to convey it to Kublai's court. By late 1291 Kublai would have known it was too late for Cocachin to become Arghun's queen. But it was also too late to stop her.

The Java campaign didn't quite turn out as planned. Having covered the 4,000 kilometres to their target non-stop, the Mongol forces landed unopposed because meanwhile Kertenagara had become involved in a war with a neighbouring state and been killed. All the native troops were off fighting in the south. It should indeed have been a walkover, but the Mongols were instantly caught up in local politics. Kertenagara's son-in-law, Vijaya, an equally ambitious and far more devious character, sent a message offering submission in exchange for help, backing his offer with gifts of incense, perfume, rhinoceros horn and ivory. The Mongol commander agreed, walked into a trap, lost 3,000 men and ended up fighting a rearguard action back to the coast before fleeing for home.

Marco does not mention this débâcle. He does hint obliquely at the tensions: 'The Great Kaan could never get possession of this island, on account of its great distance and the expense [or danger, in other editions] of an expedition thither.' He must have at least seen the preparations, must have heard of the very public challenge to Kublai's authority three years before. But of the disaster he knew nothing, because he was on his way across the Indian Ocean when it happened. As the men-of-war returned with their bad news, the princess's little navy sailed on southward and westward.

For many, the princess among them, this must have seemed like falling off the edge of the world. But Marco had been this way before and was concerned to distinguish fact from fallacy. This he did well enough, if he could see what he was talking about. In Sumatra he recorded unicorns, stuffed pygmies and giant nuts. All true, based on experience. The expedition was 'detained five months by contrary winds', and Marco spent much of the time ashore on Sumatra's northern tip, where the expedition's 2,000 men made a fortress surrounded by a ditch and palisade. He got to know a good deal about the people and the wildlife. The unicorn had hair like a buffalo, feet like an elephant and 'a horn in the middle of the forehead, which is black and very thick . . . they delight much in mire and mud. Tis a passing ugly beast.' This creature, very unlike the unicorn of European stories, which can be captured by virgins, was, of course, the Sumatran black rhino. He also punctured legends about tiny men, whose bodies were on sale in India: It's all a cheat, 'for those little men . . . are manufactured on this island'. They were in fact Sumatran monkeys, which are killed, plucked, dried, stuffed and sold as 'pretended pygmies'. His 'Indian nuts' as big as a man's head – sweet and savoury, white as milk, filled with clear liquor – were coconuts. So we should also take seriously his account of cannibals who eat their dead 'rump and stump' before giving the bones a ceremonial burial.

But there are wonders he accepts as true without seeing them – like the wild men with tails 'about the

thickness of a dog's'; and the islanders of the Andaman groups ('Angomanain'), 'no better than wild beasts . . . heads like dogs, and teeth and eyes likewise . . . in the face, just like big mastiff dogs . . . they are a most cruel generation, and eat everybody that they can catch, if not of their own race . . . they live on flesh and rice and milk'; and a ruby in Sri Lanka 'a palm in length and as thick as a man's arm'; and the magical dish that multiplied food. (But he gives a good account of the life of Buddha, which he probably got to know about in China, not in Sri Lanka.)

Before we pass to southern India I must tell you, as Marco might say, more about the Andaman islanders to correct his slanderous comments. For by coincidence a namesake of mine lived there when traditional ways were still little touched by the outside world. In 1789 the East India Company, which ruled Bengal and many points east, set up a short-lived penal colony there. A second one opened in 1858, to house prisoners taken during the Indian Mutiny. This one was run by the British government, which had taken over from the East India Company. In 1872 both the Andaman islands and the neighbouring Nicobar islands acquired a chief commissioner, Edward Horace Man. He was there for the next 20 years, running the prison and doing his bit to suppress Indian nationalism – which makes me glad he was a namesake and not a relative – but also studying his island subjects.

By the time his paper on the Andaman islanders was published in 1883, he spoke the language, and had

acquired some affection and respect for the islanders. So he took issue with Marco's words. Beasts? Certainly not. These little people (average male height: 4 feet 10 inches / 1.492 metres) were fine specimens: 'the remark which is commonly made by strangers who see them for the first time, is "how well these savages are developed" '. Savages? Yes, in my Victorian namesake's world-view, in the sense that they were considered to be on the bottom rung of the evolutionary ladder and lived a basic existence, with an average life expectancy of just 22 years. But cannibals? 'Not a trace could be discovered of the existence of such a practice in their midst, even in far-off times . . . They express the greatest horror of the custom, and indignantly deny that it ever held a place among their institutions.' But many said that *other* tribes were cannibals, 'and to this cause is chiefly ascribed the dread which they and their fathers have, from a distant period, evinced of their neighbours, and the animosity displayed towards strangers'. This conclusion points to a widespread truth: though there have indeed been communities that eat human flesh, the accusation of cannibalism was generally an insult thrown at outsiders whose ways were unknown but suspect. Marco never saw them, just heard about them.

And so, past the pearl-fishers who work the oceans north of Sri Lanka, to southern India. Here, in a land of kaleidoscopic traditions and bizarre behaviours, Marco picks up an inextricable mix of fact and fiction, perhaps from traders and fellow travellers on board. The king goes as naked as his people, except for a loincloth and

strings of pearls. He has 500 wives. When he dies, his top officials cast themselves on the funeral pyre. They import horses, but cannot breed them because they feed their horses on rice and meat until they die. They smear their houses with cow dung, but wash twice a day. They draw circles round debtors, who can only free themselves by paying up; if they escape, they are condemned to death. Children are expelled from the house at the age of thirteen. All birds and beasts are entirely different from European ones, except one, which is the quail. Rich people sleep in extremely light cane beds which are drawn to the ceiling to avoid tarantulas.

Why he should be going *north* up the *east* coast of India is a mystery. It's not on his route. Perhaps he didn't. In the same way as he mixes fact and fiction, he mixes direct experience and hearsay, past and present, outward and return trips. In Mailapur (though he doesn't name the place), near Madras, he comes across, or hears in detail about, the supposed tomb of St Thomas the Apostle, 'Doubting Thomas' who would not believe in the Resurrection until he felt Christ's wounds. According to an apocryphal story, an Indian king sends a merchant to the Holy Land to seek an architect. Thomas being an architect, Jesus sells him as a slave, who converts the king, and goes on to Madras where he is martyred in AD 53. Marco has him shot with an arrow by mistake while saying his prayers. This ancient legend was elaborated into even wilder tales, until Thomas had travelled as widely as Marco. Yet the core of this story – that St Thomas's tomb lay near

Madras – was confirmed by another traveller to China, John of Montecorvino, who was on his way to China almost at the same time as Marco was returning.

The tales get wilder. Here's one, as Marco tells it. 'One thousand miles' north of Madras – in fact, one-sixth that distance, otherwise we would be in Tibet – lies Mutfili (Mutapali), where they mine diamonds in a wondrous fashion. You must understand that the diamonds are found in steep ravines, where serpents, the most venomous in existence, are rife, owing to the great heat. Nobody can get down into the ravines; and if one could, it would only be to be incontinently devoured by the serpents. To get the diamonds, one takes pieces of meat and casts them into the ravines. The meat sticks to the diamonds. There are white eagles round about. When the eagles see the meat, they pounce upon it and carry it to hilltops. Diamond-hunters scare the eagles away with shouts, and find the diamonds which had stuck to the meat in the bottom of the ravines. Or else they find the eagles' nests, which are full of droppings containing diamonds swallowed by the eagles when they eat the meat. Or, finally, they catch the eagles, kill them, open them and find diamonds in their stomachs.

After returning from this diversion (or, more likely, never having taken it in the first place) and proceeding rather erratically up the west coast of India, with reports of places along the way, Marco takes us across the Indian Ocean to the east coast of Africa, via the Gulf island of Socotra, then Zanzibar and Madagascar. Again this is second-hand stuff, tales told by drunken

sailors eager for attention, including one reference to two legendary islands, one of which supports men, the other women. Speaking of Zanzibar, he repeats the xenophobic views of his source: the inhabitants have huge mouths, upturned noses, thick lips and bloodshot eyes, 'so hideously ugly that the world has nothing to show more horrible', especially the women who have breasts four times normal size, 'a very disgusting sight', one that he clearly had not seen for himself. Its warriors ply their elephants with wine to give them Dutch courage in battles. Oh, and another thing about elephants he almost forgot: when they mate, the male digs a pit and lies the female down on her back human-fashion. You would think he knew better, having seen Kublai's elephants.

One other tale, though, cannot be written off as complete nonsense. It concerns the legendary giant bird known as the *ruc*, 30 paces across, and 'so strong that it will seize an elephant in its talons and carry him high into the air, and drop him so that he is smashed to pieces'. Marco adds authenticity by 'correcting' the widely held notion that this creature was a gryphon, half-lion and half-bird. No, his sources agreed, it was actually like a giant eagle. His source for this fable? 'Persons who had been there and had seen it,' perhaps even one of the three men he says were sent out by Kublai, one to research the rumoured birds, the second to negotiate the release of the third, an envoy who had been captured (a story which would surely be wonderful, if only he had interviewed them). Was it one of these

who brought 'to the Great Kaan a feather of the said Ruc', which was stated to measure 90 spans, while the quill part was 'two palms in circumference, a marvellous object' – which sounds more like a palm-leaf than a feather.

Nevertheless, his sources *had* seen something like the 'said Ruc', or heard about it, because they were probably referring to *Aepyornis maximus* of Madagascar, the world's largest bird. Related to the ostrich, the elephant bird, as it is known, stood 3 metres tall and weighed close to half a tonne. It was flightless, of course, and a vegetarian, with no natural predators but people – modern people, not the island's aboriginal inhabitants. It became ever rarer when Europeans settled on the island after 1500, probably because its huge eggs (a metre round, 200 times the size of chicken eggs) were vulnerable.[1] For 150 years its numbers declined. A report in 1658 said the bird 'seeks the most lonely places'. By about 1700 it was extinct. In Marco's day, these great creatures would still have been pacing around, unharassed. Even the sight of an egg would have been enough to inspire some very creative nightmares.

This, and all Marco's comments about other places along the east African coast – Zanzibar, Ethiopia, Aden – must have been hearsay, because these places were off the expedition's route. They were heading for the Gulf, for Hormuz – the place with the rickety ships that had put

[1] There's one in London's Natural History Museum, and many more in other museums.

the Polos off a sea voyage some twenty years previously – and for Persia. There was no need to tangle with the open ocean. A coastal journey was quite risky enough. The texts conflict on the number of deaths, but one (Ramusio's) sounds credible: in the eighteen-month journey, of the 2,000 members of the crew and passengers, some 600 died, including two of the ambassadors and one of the women – but not, thank the Blue Heaven, Princess Cocachin herself.

The arrival in Persia in early 1293 is marked by a long account of the civil war that brought Arghun to power. It's a story Marco tells at inordinate length, perhaps under pressure from his ghost-writer to indulge in some highly imaginative narrative, complete with fabricated dialogue and the stock phrases of medieval romances. Its subtext is to assert Marco's authority and knowledge, which, to modern readers, is wasted effort because it relates events that are ten years old. He gives no hint either of current conditions in Persia or of his own experience, except the one grand truth: that Arghun, the princess's intended, was long gone.

In his place was his brother, the 'amiable if dissolute Geikhatu'.[2] What would become of Cocachin? Not a problem. Under Mongol law she could be treated as stepmother (at 23!) to Ghazan, son of the dead ruler, and could thus become his wife.[3] So Cocachin married

[2] Morgan, *The Mongols*, p. 165.
[3] There was a precedent: the founder of the Il-khanate, Hulegu, had married his stepmother 40 years previously.

Ghazan, and was honoured with royal estates tradition-
ally owned by the Persian Mongol queens (traditionally,
that is, since the conquest in 1258). She owed the Polos
a debt of gratitude.

> They watched over and guarded [her and the other
> unnamed Chinese princess] as if they had been
> daughters of their own, until they had transferred them
> to the hands of their Lord; while the ladies, young and
> fair as they were, looked on each of these three as a
> father, and obeyed them accordingly. Indeed, both
> Casan [Ghazan] . . . and the Queen Cocachin his wife,
> have such regard for the Envoys that there is nothing
> they would not do for them. And when the three
> Ambassadors took leave to return to their own country,
> she wept for sorrow at the parting.

Incidentally, these events and the names of both the
princess and the surviving ambassador are confirmed in
Chinese and Persian sources. The Chinese evidence is of
particular significance. It emerged in 1941, published by
a Chinese scholar, Yang Chih-chiu (Yang Zhijiu), and is
now considered incontrovertible proof, as if any more
were needed, that Marco was in China.[4] The Polos
spent nine months in Persia, being well treated by
Geikhatu, before taking their leave. The Il-khan sent
them off with another four *paizis*, all inscribed with the

[4] See Cleaves, 'A Chinese Source Bearing on Marco Polo's Departure
from China and a Persion Source on his Arrival in Persia' and de
Rachewiltz, 'Marco Polo went to China'.

demand to provide services, horses and provisions. Accompanied from station to station by up to 200 horsemen, they picked their way through a realm verging on civil war to the edge of the empire and beyond, to the shores of the Black Sea. Here the *paizis* no longer protected them, as they found to their cost in Trebizond (today's Trabzon, in Turkey). At that time a miniature kingdom which had been carved out of the Byzantine empire in the early thirteenth century, it was ruled by a Greek who hated both Venice, which had forced his family's flight from Constantinople a century before, and Mongol-ruled Persia, his nominal overlord. When the Venetian travellers from the Mongol court turned up, therefore, he seized his chance. Maffeo refers in his will to the loss of about 4,000 hyperpera 'inflicted on us by the lord Comnenus of Trebizond'. The hyperpyron, to put it in the singular, was a Byzantine gold coin weighing 4.45 grains; in today's terms, they lost 37 ounces of gold, in the region of $25,000–35,000, though it's almost impossible to work out a modern equivalent. Apparently, though, the lord Comnenus failed to find their real treasure, which was in the form of the jewels they had sewn into their clothes back in China.

Travelling, they missed some significant events. Kublai died in February 1294, and was taken with great ceremony 1,000 kilometres northward, first over the route he knew so well through the pass where the Great Wall now runs, up on to the Mongolian plateau; then, instead of turning right to Xanadu, the funeral

procession continued on north-west across the Gobi to northern Mongolia to bury him with his grandfather, perhaps on the sacred mountain of the Mongols, Burkhan Khaldun, perhaps more discreetly in a secret site as yet undiscovered. The Polos also missed yet another rebellion in Persia, where six months of chaos, plotting and counter-plotting ended in November 1295 with Ghazan as khan. This somehow they heard about, because Marco's book refers to Ghazan as 'now the reigning prince'.

But they did not hear of Cocachin's fate the following year. After all she had been through – plucked from obscurity to marry a king, transported in luxury for eighteen months across half the world, marooned for five months on Sumatra, amazed by adventures, new peoples and fantastic tales from Marco – she died, of unknown causes, at the age of 26.

So, in 1296, after an absence of twenty-five years, the Polos arrived back in Venice, intending to reclaim their rightful place in Venetian society. They faced a problem, and found a dramatic solution, as revealed in a famous story told by Ramusio in the sixteenth century. That's 200 years after Marco's death, which strains belief. Would anyone take seriously a story told today about the Battle of Waterloo, based solely on a family anecdote passed down by word of mouth? Ramusio counters doubt by insisting on its truth. He claims he often heard the story as a boy from a very old man, Gasparo Malpiero, 'a senator of eminent virtue and

integrity', who in his turn said he heard it from his father and grandfather, and 'other old men of the neighbourhood'. This is possible, just. Ramusio was born in 1485. Assuming an 80-year-old Malpiero repeating the story to the 10-year-old Ramusio, and assuming that Malpiero's father and grandfather's generations were of 40 years each, we step back 150 years to 1335, only a decade after Marco's death. Events can pass from memory to memory over a much greater time than this, if nurtured and repeated detail for detail, as good stories often are. This one is so vivid, even in translation, that it has the ring of truth.

Here is the story as Ramusio tells it:

And when they got thither . . . those three gentlemen who had been so many years absent from their native city were recognized by none of their kinsfolk, who were under the firm belief that they had all been dead for many a year past, as indeed had been reported. Through the long duration and the hardships of their journeys, and through the many worries and anxieties that they had undergone, they were quite changed in aspect, and had got a certain indescribable smack of the Tartar both in air and accent, having indeed all but forgotten their native tongue. Their clothes too were coarse and shabby, and of a Tartar cut.

They proceeded on their arrival to their house in this city, a very lofty and handsome palazzo. Going thither, they found it occupied by some of their relatives, and they had the greatest difficulty in making the latter

understand who they should be. For these good people, seeing them to be in countenance so unlike what they used to be, and in dress so shabby, flatly refused to believe that they were those very gentlemen of the Ca' [house] Polo whom they had been looking upon for so many years as among the dead. So these three gentlemen devised a scheme by which they should at once bring about their recognition by their relatives and secure the honourable notice of the whole city; and this was it:

They invited a number of their kindred to an enter-tainment, which they took care to have prepared with great state and splendour in that house of theirs; and when the hour arrived for the sitting down to table they came forth of their chamber all three clothed in crimson satin which during the meal were exchanged for other crimson clothes first of damask then of velvet, each set of suits being divided among the servants, to the amaze-ment of the guests. But when the cloth had been drawn, and all the servants had been ordered to retire from the dining hall, Messer Marco, as the youngest of the three, rose from the table, and, going into another chamber, brought forth the three shabby dresses of coarse stuff which they had worn when they first arrived. Straightaway they took sharp knives and began to rip up some of the seams and welts, and to take out of them jewels of the greatest value in vast quantities, such as rubies, sapphires, carbuncles, diamonds and emeralds, which had all been stitched up in those dresses in so artful a fashion that nobody could have suspected the fact . . .

Now this exhibition of such a huge treasure of jewels and precious stones, all tumbled out upon the table, threw the guests into fresh amazement, insomuch that they seemed quite bewildered and dumbfounded. And now they recognized that in spite of all former doubts these were in truth those honoured and worthy gentlemen of the Ca' Polo that they claimed to be; and so all paid them the greatest honour and reverence. And when the story got wind in Venice, straightaway the whole city, gentle and simple, flocked to the house to embrace them, and to make much of them, with every conceivable demonstration of affection and respect.

This is not entirely watertight. How, for instance, did the Polos finally gain access to their house? What did they do with their doubting relatives? But at least the story captures a core of truth. Undoubtedly the Polos arrived with startling wealth, and resumed their life in Venice as respected citizens, and Marco became famous for his stories, and so acquired the name Milione.

14

THE MAKING OF
THE BOOK

STILL, THERE WAS NO BOOK. MARCO HAD NOTES AND HE had a story, but he didn't know what to do with them. I imagine countless people telling him he should write a book, and him sighing yes, yes, one day. He would have remained a local wonder, if luck had not played her role once again.

Venice had not fared well in the Polos' absence. Minor wars, a threatened invasion, a papal ban on church rituals, an earthquake, floods – all ate away at her supremacy. In 1291 an Egyptian army stormed the greatest surviving outpost of the crusaders, Acre, destroying the trading quarters of several Italian cities, including Venice's. Acre was her key to trade with Asia. Now the only route was through the Black Sea, which was dominated by Venice's old rival Genoa. Genoa was determined to preserve that dominance, Venice set on

gaining it. The two loathed each other, each vowing destruction, pouring their hatred into song. Eventually, there would be a showdown.

It came in 1294, in a series of tit-for-tat actions spread over four years.[1] Venice called up all able-bodied men between 17 and 60 – including Marco – and insisted that the rich families fund a galley or two. The two fleets met in an odd battle, in which the Genoese roped all their ships together to form one huge pontoon, across which their warriors could leap wherever required, yelling their battle-cry 'Alor! Alor!' Venice's navy broke against this artificial island, and lost over a third of its force, 25 galleys out of 68. Soon, the Genoese crowed their victory in a popular song of the day (now reproduced on the internet):

Como 'li fom aproximai,	On they come! But lo their blunder!
queli se levàn lantor,	When our lads start up anon,
como leon descaenai,	Breaking out like unchained lions,
tuti criando: – A lor! A lor!	With a roar, 'Fall on! Fall on!'
	(Trans. Yule)

[1] This is all part of a wider picture that also involved Pisa, which for the sake of simplicity I ignore. For the details see Norwich, *A History of Venice*, my major source.

The Genoese then sacked Venice's base in Crete, shattered another naval force in Modone in Greece (now the port of Methoni), which guarded the entrance to the Adriatic, and massacred Venetians in their colony in Constantinople, killing the leader by tossing him from the roof of his house. Outraged, Venice responded by sending a naval force to raid Genoese ships from the Adriatic into the Black Sea. Attacks and counter-attacks ended in an encounter off the coast of Dalmatia in September 1298.

This is an engagement central to our story, because Marco, now in his mid-forties, was there, aboard the big two-masted galley financed by the family: 120 oars, a catapult on the forward castle.[2] The Genoese fleet was scattered by a storm, which separated sixteen of their ships from the main fleet – luckily for them, as it turned out. To start with, therefore, they were outnumbered by the 96 Venetian vessels, the largest fleet the city had ever mustered, under the command of Andrea Dandolo, son of a former doge. But the Venetians had built their ships too quickly, and the Genoese ones were better: 40–60 metres long, with up to four banks of oars, good stern rudders, castles at each end for bombarding the enemy, and a bridge on the bows for boarding. And they had a fine leader in Lamba Doria, a member of a famous Genoese family that was central to the city's life over several centuries.

[2] Practically everything about this section can be disputed. Sources conflict. This is the best I can do without a volume of caveats and footnotes.

On the morning of 7 September, a Sunday, the two fleets met off the island of Curzola, or Korčula as it is in Croatian, halfway down the Balkan coast. The Venetians, with the wind behind them, captured ten Genoese vessels but lost several of their own, one of which was seized and turned against them. Both fleets fell into a confusion of vessels fighting individually. Among those who died was Doria's son, Octavian,

> shot by an arrow in the breast . . . Lamba, hot with the spirit of battle, and more mindful of his country's service and his own glory than of his son, ran forward to the spot, loftily rebuked the agitated crowd, and ordered his son's body to be cast into the deep, telling them for their comfort that the land could never have afforded his boy a nobler tomb.[3]

Doria was bringing his fleet together to pick off the Venetian vessels one by one when his missing 16 ships arrived and joined in. By nightfall it was over, with Venice humbled: 18 galleys sunk and 66 captured (other sources say 65 taken or sunk), all of which were beached and burned; 7,000 dead and 7,400 captured (or perhaps 9,000 killed and wounded and 5,000 captured; anyway, about 14,000 in all). Among the captured was the Venetian admiral and – by happy chance for us – Marco, both being taken away in chains.

[3] The battle is summarized by Zivan Filippi, at www.korcula.net/mpolo/. The quote, with its source, is from the Yule–Cordier introduction, p.48.

After four days of celebration on the island, the victorious fleet set off for Genoa. During the six-week voyage round Italy's heel and toe, Dandolo, in despair, went on hunger strike and then committed suicide by dashing his head against a bench. In mid-October, the Genoese arrived home to great rejoicing. Lamba Doria was given a palace opposite the church of the city's patron, St Matthew, which from then on celebrated 8 September as a feast day to commemorate the victory. Marco meanwhile, found himself a prisoner awaiting a ransom or an exchange or a settlement, for both sides were war-weary and ready for peace. His prison was no dank dungeon, but some building where dignitaries could remain in reasonable comfort, or perhaps even a private house where he could be held under house arrest pending an exchange of prisoners.

Of the many others in a similar predicament, one just happened to be a minor writer of romances called Rustichello or Rusticiano (there are various spellings). His name is always associated with Pisa, which would explain his presence in Genoa, for Pisa was another of Genoa's enemies. In one battle fourteen years previously, Genoa had captured 9,000 Pisans, many of whom it kept for years. Some were ransomed, most died; some languished in captivity, among them perhaps Rustichello. Not much is known about him, except that he was the author of *Méliadus*, a collection of stories about Arthurian knights, a subject that was popular in both verse and prose, in French and Italian and a mixture of the

two.[4] Yule assesses him as 'an industrious simple man, without method or much judgement'.

So here we have a middle-aged hack writer almost dying of boredom without much of a future; and a talkative patrician with a fascinating past and a desire to write his story. Rustichello offered to act as Marco's ghost. It would pass the time; it was important; it might do them both some good by attracting publicity. For Marco, this was an answer to his prayer; this was how to make the book he knew was in him. Imagine him telling Rustichello he knows what to write but not how to write it, and Rustichello saying not to worry – he, Rustichello, knows the style and language that will appeal to readers. Marco spoke Venetian, but the book would have to be in French, then widely considered western Europe's most fashionable and literary language, though what Rustichello did not say was that his French was pretty hopeless. So why make a long story? Marco – in touch with his family, who are eagerly looking for ways to rescue him – sends for 'the few small things' he wrote 'in his notebooks', and the pair set to work. As Marco begins to dictate, Rustichello recasts what he hears in what he thinks is courtly French, designed to make Marco sound like a story-teller in the tradition of those who wrote of marvels and wonders, buttonholing listeners with stock phrases and mock-spontaneity – 'oh, I forgot' and 'oh, another thing'.

[4] This section summarizes Larner, *Marco Polo and the Discovery of the World*, ch. 3.

It is usually assumed the spontaneity was mock. But I wonder: given the speed at which they had to work, it is possible that, if a sudden memory flooded Marco's mind, Rustichello simply scribbled down his words without taking correction. There was, it seemed, no time to lose. As things turned out, they had seven months. Genoa would be signing a peace treaty with Venice the following May, and Marco would be on his way home.

Scholars think that Rustichello was the writer behind both *Méliadus* and Marco's book because both begin with a very similar address to a noble audience: 'Lords, emperors and princes, dukes and counts, and barons and knights . . .' says *Méliadus*; 'Lords, Emperors, and Kings, Dukes, and Marquesses, Counts, Knights, and Burgesses . . .' says Marco's book, in the Moule–Pelliot edition; then in both: 'take this book and have it read' (as if his audience couldn't read, as if reading were still a public act, as it used to be once upon a time). Both books have styles – the mixture of past and present tenses, the same catch-phrases, like 'What shall I tell you?' and 'Why make a long story?' – that were common in the oral traditions of courtly epic.

The style doesn't quite work for us, for two reasons. First, as modern readers we desperately want more – more colour, more personal detail. What was it *like*? How did you *feel*? Second, Marco and Rustichello have different agendas. Marco wants to give the objective if selective truth – as geographer, explorer, businessman,

Christian – whereas Rustichello would be happy with marvels and good stories. For much of the journey as Marco recalls it, the truth is tedious, and he has forgotten the details, and his notes are not good enough, and there is no juicy story. So Rustichello improvises, embroidering Marco's scant information with romantic embellishments. When there is room, marvels are included (like magicians who control the weather, or the *ruc*). When there is nothing to go on, the result is often lacklustre, or rather, let's be frank, unreadable. Introducing the last part, Yule loses patience: 'A considerable number of the quasi-historical chapters in this section are the merest verbiage and repetition of narrative formulae without the slightest value. I have therefore . . . given merely the gist, or an extract, of such chapters.' And in a note about a battle with Kaidu: 'The armies are always exactly or nearly equal, they are always divided into corps of 10,000, they always halt to prepare for action when within ten miles of one another, and the terms used in describing the fighting are the same. We shall not inflict these tiresome repetitions on the reader.' Luckily for both source and ghost, Kublai is a godsend, because the truth is as fantastic as any traveller's tale.

So fantastic, of course, that some wondered at the time, and many more have wondered since, if Marco was just a superb fantasist, spinning a yarn with Rustichello on the basis of what he'd heard from other travellers. This idea was put forward by the eminent Sinologist Frances Wood in 1995 in *Did Marco Polo Go*

to China? Since the one thing that almost every school-child knows about Marco is that he went to China, the book sparked a perfect storm of media controversy, which was wonderful for the publishers. Newspapers loved it: a simple proposition, a good academic spat and lots of clichés. Why did Marco not mention the three things that every westerner has heard of in China: the Great Wall, tea, foot-binding? The answers are that the Wall was a muddy wreck, foot-binding was new and non-Mongol, and tea was not only non-Mongol (they preferred fermented mare's milk) but also dull. What about his errors, like his bare-faced lie about being responsible for the catapults that broke the siege of Xianyang? Why was he not mentioned in any Chinese sources? These are all subjects discussed by scholars down the years, and covered in this book. None of the objections proves anything except that he exaggerated, got things wrong, allowed himself to be guided by his ghost and occasionally made things up.

Well, few travel writers are totally free from such accusations. One of the most famous of the modern genre, Bruce Chatwin, stands accused of making up much of his book on the Australian aborigines, Songlines; to which his admirers reply that he was a post-modernist aiming at truth beyond the literal. In a critique of Dr Wood's book, David Morgan points out that Christopher Sykes, Robert Byron's companion in a famous travel book of the 1930s, The Road to Oxiana, tells us that 'all the non-English conversations recorded in his book are invented'. For this book, as always, I

made tape-recordings, but the conversations I play back are edited in transcription, and I make the interpreters almost invisible. If I was telling the utter truth, I would have to transcribe and include all the Uighur, Chinese and Mongol bits as well, every *um* and *er*, and the whole thing would be catastrophic. What kind of truth is that? In travel, as in history, there is no absolute. We try to circle in on truth. But we keep our distance, because if we get too close it vanishes, like a picture dissolving into dots and brushstrokes.

As far as Marco is concerned, the dispute about whether he went to China or not is, at heart, no more than a media controversy. It is not a real one. Dr Wood does not really believe Marco did not go; she was pulling together a number of well-known problems under a provocative title, and has been mildly embarrassed by the fuss ever since.

Did he go? The short answer is: *of course* he went. Marco was no fantasist. The long answer is this and many other books, which show overwhelmingly that much of the information he delivers was simply not available except through personal experience. And then there is the independent evidence, like the Mongol words no one else could have known, the Chinese and Persian sources that back his account of the return journey, the 'tablets of authority' brought home by the Polos, the scores of obscure names that have now been identified, and his mention of Japan, the first and only one in the West until the sixteenth century.

Finally, there is Marco's reputation for truthfulness.

To quote from the introduction to a Latin translation done in Marco's lifetime by a Dominican friar, Francesco Pipino: 'Lest the inexperienced reader should regard as beyond belief the many strange and unheard of things that are related in sundry passages of this book, let all know that Messer Marco Polo, the narrator of these marvels, to be a most respectable, veracious and devout person.' Moreover, says Pipino, what he says is backed up by his father Niccolò, 'a man of the highest respectability', and his uncle Maffeo, 'a man of ripe wisdom and piety'. Much may be problematical. But the only way to deny the factual foundation of his story is to resort to explanations even more fantastic than the tale itself.

Rustichello takes the trouble to assert the essential truth of the book with an introduction in his own voice: Marco

> bethought himself that it would be a very great pity did he not cause to be put in writing all the great marvels that he had seen, or on sure information heard of, so that other people who had not these advantages, might, by his book, get such knowledge . . . Now therefore being an inmate of the prison at Genoa, he caused Messer Rusticiano of Pisa, who was in the said prison likewise, to reduce the whole to writing; and this befell in the year 1298 from the birth of Jesus.

How then do we account for the book's factual inadequacies, the errors, the vagueness, the exaggerations,

the omissions, the rough language? There are many reasons. The passage of time. Forgetfulness. Selective memory. Rustichello's urging (I can imagine the old hack pushing him: 'Come on! No one will ever know!'). A desire to give as much information as possible, even if it was hearsay. The need to suppress some aspects of his experiences and gloss others. The conflicting impulses within himself as a Christian both to honour Kublai and yet to condemn idolatry. Linguistic in-adequacy. Lack of rigour. The pressure: 1,000 words a day, and time running out. Our own ignorance, which, once dispelled, also dispels some of the objections (once you know the Mongol for 'Earth Mother' you can't accuse him of making it up). Compression—

Let's look at compression for a moment. The book in its various editions is between 60,000 words and 140,000,[5] a good length today for a novel or a work of non-fiction on a restricted subject, but hardly sufficient for 20 years of experience across half the globe, over unknown territory, into an unknown empire that was the world's richest and largest, and ruled by the world's most powerful man, plus the historical background. Today such an experience would demand four books: the land journey out, the Mongols and their court, the land they ruled, and the sea journey home. They must both have known this, pushing each other to talk and

[5] The Moule–Pelliot translation is about 250,000 words, but it includes variations and additions from eighteen different versions, with a few insertions from other MSS.

scribble and revise, knowing that time was short, but not knowing exactly how short. And of course all the time Rustichello was both recording Marco's words and subverting them to fit his language and his purpose.

It's a commonplace of literary criticism to quote Marshal McCluhan: 'The medium is the message.' Not quite so, in this case. The medium – paper, pen, scribes waiting to make copies – could have carried a far more sophisticated message. But both the message and the medium were influenced by something more basic: the conditions. Here were two men with different agendas, working with paper and quill pens, under house arrest in a foreign city, with no sources other than Marco's faulty memory and a few notes, frantic to finish before fate threw them apart. Perhaps what they produced should really be considered not the finished book, but a rough draft.

Given the conditions, it is remarkable there is a book at all, let alone one of such originality.

Was Marco pleased with the result? Half and half.

He liked it well enough to give a copy of a French version to a knight named Thibaud de Chépoix (also spelled Thibault de Chépoy or Cepoy), who was in Venice in August 1307 on behalf of his boss, Charles, count of Valois and Anjou, son of Philip III of France. According to a note in the Bibliothèque Nationale's edition of Marco's book, Marco gave Thibaud 'the first copy of his said book after he had made the same'. Charles himself later received a copy of the copy, as

Marco would have foreseen. He would not have handed the book over to someone so well connected if he had not been reasonably happy with it.

But there are also hints that he tinkered with the text. One version, known as Z, discovered in the Chapter Library of Toledo in 1932, omits two of the most contentious claims, that Marco devised the Xianyang catapult and was governor of Yangzhou. Many scholars, believing Z to represent Marco's intentions better than other surviving texts, suggest that the translation was done from an original from which Marco himself had cut the offending lines.

We are dealing with hints only, because the original as written by Rustichello from Marco's dictation was lost. No one knows how or why. Perhaps because it was 'in an uncouth French much mingled with Italian' – as Moule and Pelliot put it – and marred by serious clerical errors. From the surviving Franco-Italian version it's clear that Rustichello's 'command' of his chosen language was pretty appalling. As Yule says, 'The author is at war with all the practices of French grammar; subject and object, numbers, moods and tenses are in consummate confusion . . . Italian words are constantly introduced, either quite in the crude or rudely Gallicized.' A language teacher would have shaken his head in horror at the style, now curt, now wordy; at the repetitions of clichéd phrases; at the lack of consistency in spelling; at the alternating use of 'he' and 'I' when referring to Marco. Frankly, it was a mess.

From this invisible source tumbled a mass of

translations in various versions, like particles in a cloud chamber. The copiers did not really copy: they misread, shortened, omitted, corrected and translated, sometimes well, sometimes wrongly or badly, so that changes multiplied with every version, and no one could tell what was Marco's and what wasn't. As Moule and Pelliot say in their introduction, the book's popularity 'resulted not in the preservation but in the destruction of the book . . . till there has survived no single known copy which can claim at all to be either complete or correct'. The 150 surviving manuscripts, no two of which are alike, are in Franco-Italian, Italian, French, Tuscan, Venetian, Latin, German, Czech, Irish and Spanish; several of them are translations of translations, sometimes several times over – from Tuscan into Latin, from Venetian into Tuscan and Latin and then back into Venetian, and, in the most extreme case ('a curious and vicious circle' as Yule calls it), a sixfold sequence: from French into Italian, into Latin, into Portuguese, into Latin again, and finally back into a French vastly different from the first French version. Not to mention shortened versions in Catalan and Aragonese (which I didn't know was considered a language until I saw the book). Scholars agree that the surviving Franco-Italian version was probably copied from the lost original, with some passages left out, perhaps because they were con-sidered dangerous. It was these passages that were then re-included in the more rigorous Latin translation known as Z.

There is one final complexity. Two hundred years

after Marco's death, Giambattista Ramusio produced an Italian edition which includes material not found in any other, as well as much new biographical matter he says he gleaned from local sources, including the long tale of how the Polos found themselves strangers in their own home. Some of the 'biography' may be folklore, or just plain wrong (like his claim that Marco wrote in Latin with the help of a 'Genoese gentleman'); some of his textual extras introduce more errors; but others he says were taken from notes made by Marco himself. Indeed, many seem to be genuine: for example, the mention of the yak–cow cross ('wonderful beasts, and better for work than other animals') and the story of the corrupt finance minister Ahmad and his murder. These and other additions appear nowhere else, concern subjects not known in Europe, and are corroborated by Chinese records. It looks very much as if Ramusio combined several secondary sources, some of which really do seem to have included annotations made by Marco, all now lost. Therefore, some scholars argue, to get closest to Marco look at Z and Ramusio and the French version with Italian trimmings.

But still no one knows exactly what Marco dictated, or Rustichello wrote. That is the black hole at the centre of Polo research, infinitely attractive to scholars, invisible, but sensed through its effects.

Marco returned to Venice in 1299, and settled at last to a stable life. For the next 25 years we have little but random glimpses of doubtful reliability. Ramusio says

that in his absence his father, fearing that Marco would die in captivity and leave him without an heir, took a new wife and produced three sons, which is a remarkable achievement for an old man in just seven months. Marco acquired a servant, called Peter the Tartar: probably not a Mongol brought back from China but one bought from Black Sea slavers who traded with the Mongols in Crimea (he was well treated, apparently, because he had his own house). Marco himself married a lady named Donata, with whom he had three daughters (Fantina, Bellela and Moreta). In 1311 he sued a fellow-merchant who had acted as an agent in a deal to do with musk and failed to do a proper job of accountancy. In 1323 he was involved in some dispute over next-door's stairs and porticoes.

Late in that year he fell ill, and in early January 1324, 'finding myself to grow daily feebler through bodily ailment', he dictated his will to a notary, who took it down in cramped Latin. The various bequests included one of 100 lire (perhaps around £1,500 in modern terms) to Peter the Tartar, who was also given his freedom. His estate, including the silver belts, *paizis* and 200 or so other items listed in the inventory of his goods, was estimated at £3,000 in 1924 terms by Moule and Pelliot, perhaps something like £300,000 today: a useful sum, but not enough to term him rich.

He died about the time he dictated his will, at the age of 69 or 70, possibly even the day before the will's date, 9 January. He was probably – since he requested it – buried in the nearby church of San Lorenzo. Ramusio

says there was a stone tomb, on the right as you enter; but it was a family tomb, with no memorial to Marco. And anyway it's now long gone.

His memorial, of course, is his book, which will outlast anything of stone.

15

MARCO AND THE
NEW WORLD

OF ALL THE MANY WAYS IN WHICH MARCO MARKED THE
world, the most intriguing is his role in the event that
changed that world fundamentally: Europe's re-
discovery of America.

There should really have been no need for a re-
discovery. Europeans should have known that a few of
them had been there before at least once. Vikings had
colonized their way across the northern Atlantic –
Scotland, Iceland, Greenland and finally Newfoundland
– 300 years before Marco went to China. The 'Vinland'
colony, the remains of which are now a tourist
attraction in Newfoundland, didn't last long. It was too
far from base in Greenland, and too vulnerable to
native attacks. But it was recorded in Norse sagas,
known to relatives back in the Norwegian fjords, and
should have been remembered by missionaries who

brought Christianity to Iceland around the year 1000. Yet the news did not make the leap south, which was odd, because Vikings ravaged their way round the coast of Europe and across the Mediterranean. But times changed; Vikings settled to become French and Sicilian, and forgot what they had been.

Perhaps there was another pre-Columbian presence in the New World. The Basques were Europe's greatest fishermen, much interested in cod. The great cod banks off Newfoundland were to draw British explorers in the late fifteenth century, but when the first one, John Cabot, arrived in 1497, he may have found that Basque fishermen had got there first. Basques were canny people, and had no wish to share their wealth. They kept quiet, and no one knew the rewards to be reaped by those daring the Atlantic until Cabot reached home.

In any event, no king – and it was kings who put up the money – dreamed of funding an expedition over the western ocean until a rough-and-ready Genoese sailor, Cristoforo Colombo, presented his idea – his obsession – to the Spanish rulers. His first choice as patron had been the Portuguese king, Afonso V. How he came to make the switch, what he brought with him as evidence and what role Marco played in the episode: this is the story told in the next few pages. Virtually nothing in it is undisputed. But by ignoring academic byways it is possible to join the dots into a historical narrative that links Marco to Columbus's great venture and to conclude that this was Marco's greatest legacy.

* * *

Marco's book quickly made a name for itself among the small number of people able to obtain it or borrow it or have it copied, for within 25 years it had been translated and re-edited into Tuscan, Venetian, German, Latin and French. Does this amount to being a best-seller? Hard to say, because no one knows how many copies were made, who read them, or how many heard the book being read out loud as if it were an epic being recited by a bard. As one historian of printing, Elizabeth Eisenstein, has written: 'Just what publication meant before the age of printing or just how messages got transmitted in the age of scribes are questions that cannot be answered in general.' All that can be said is that by the time Marco's story was set down the demand for handwritten books had been growing steadily for two centuries, though from a very low base. Most books were religious, and great cathedrals had *scriptoria* of copyists who continued, very slowly, to build libraries that were meagre by later standards, intellectual treasures at the time. Cathedral libraries seldom contained more than 200–300 books. The few great universities boasted not many more. In 1338, fourteen years after Marco's death, the Sorbonne had just 338 reference books, carefully chained, and 1,728 books for loan.

Still the copies of Marco's book multiplied, many with glorious and utterly spurious illustrations, turning the book into a work of art rather than reportage. Those who took Marco most seriously were the church-men translating it into Latin, who were trying to assess

China for possible conversion. Remember that Francesco Pipino of Bologna described Marco as 'respectable, veracious and devout' and his uncles in similar terms (a judgement which Pipino artificially strengthened with additions to the text describing non-Christian religions as abominations). For Latin clerics at least, Marco was reliable. It was a Dominican friar, Jacopo d'Acqui, who told the story about the dying Marco insisting he had not told one-half of what he had really seen.

Merchants, too, responded to the possibilities suggested by Marco. There was enough interest in the overland journey by 1340 for Francesco Pegolotti, a commercial agent from Florence who had covered some of the same ground as Marco, to offer practical advice, with rather off-putting casualness: the road to China was 'quite safe by day and by night', he said, unless you happened to die en route, in which case the local warlord would take everything you owned.[1] Missionaries took up the challenge as well. A Franciscan, John of Montecorvino, set up the first Christian church in Beijing in 1294, the year of Kublai's death. Another Franciscan, Odoric of Pordenone, who arrived in 1322, wrote an account that became almost as famous as Marco's. In any event, from Marco, merchants and missionaries, news of Kublai filtered into public consciousness, where it stayed in a semi-fossilized state for another century and a half, like a seed waiting for spring.

[1] *Pratica della Mercatura.*

Spring was a long time coming. In 1368 the Mongols were thrown out of China, and for the next 250 years foreigners were left dealing with the Ming, a dynasty that was the very opposite of the Yuan: shut off, introverted, utterly convinced that foreigners had nothing to offer. Across Central Asia, ex-Mongol sub-empires collapsed into squabbles and vanished in revolutions. Islam divided East from West. Old links broke, memories faded; few could testify to the truth of Marco's book, and more doubted it. For two generations, Marco's travels became what Rustichello had intended: a book of unbelievable marvels.

His resurrection as a guide to the real world was due to two factors. The first was the revival of learning in the first half of the fifteenth century. It was the Church that kick-started the process, because Rome had an urgent desire to unite a Christendom long divided into East and West, Roman and Orthodox, with other schismatics in control in Ethiopia. In 1439–43 a General Council in Florence brought hundreds of churchmen together, among them an astrologer and physician named Paolo dal Pozzo Toscanelli. At this conference Toscanelli met a brilliant Byzantine scholar, Gemistus Pletho, who had somehow acquired a map that showed Norway, Iceland and part of Greenland, long forgotten (if ever known) in mainland Europe, but still remembered by Scandinavians as a Viking base from the tenth century. Also at the conference was one of the most brilliant men of his age, Nicholas of Cusa, who owned a copy of Marco's book. A few years later,

Nicholas became a mentor to a Portuguese cleric named Fernão Martins, later a canon of Lisbon and adviser to Portugal's king Afonso V. A traveller called Niccolò Conti, who had spent 25 years in the East (though not in China), wrote up his own story in 1448, validating much of Marco's book.

Incidentally, Nicholas of Cusa was also, I believe, a friend of Johannes Gutenberg, who was already, with Cusa's encouragement, working on a way to capture script in a totally new way. Soon afterwards, in 1454, Gutenberg brought out his Bible, the first great work to be printed with moveable type. At the time, if you gathered all of Europe's hand-written books, they would have fitted into a few rooms. Fifty years later, printed books numbered some 20 million. One of them was Marco's book, printed in Germany in 1477.

So here we have a number of significant elements all brought together: a desire to solve the problem of a divided Christendom, a map that showed land way out in the Atlantic, a man who took Marco seriously, another man who could personally vouch for Marco, a sort of intellectual freemasonry of scholars all in contact with each other, a king interested in exploration. These were the nerves which, once the connections had been made, would spark new ways of thinking about the world – how to understand it, how to explore it, how to share knowledge about it, how to control it.

At virtually the same time – 130 years after Marco's death – the door to the route pioneered by his father and uncle, already almost closed, was slammed and

locked. The Turks, who had been moving west for 1,000 years, seized Constantinople. All the lands that had once owed allegiance of some sort to the Great Khan – where once a virgin carrying gold, or at least a man with the right credentials, could be helped from camp to camp and city to city in safety – fell to the Muslims.

So Europe's merchants turned to the sea routes, along which flowed silks, precious stones and spices, brought by Chinese junks to Malaysia and Arab ships to India and the Middle East. But this was a galling arrangement. Eastern pepper, for instance, underwent a 50-fold increase in price on its journey to Europe's kitchens. Obviously the thing to do was for European merchants to fetch these goods themselves, and cut out the middlemen. Hence the race in the late fifteenth century to discover and sail round southern Africa; and hence Columbus's big idea – to reach the East by sailing round the world the other way, westward.

His aim was to get to China and the land of the Great Khan. But we are now in the 1490s, getting on for two centuries after Marco's book first appeared – and the Great Khan is thought to be still alive? Of course he couldn't be. But when the Muslims slammed the door on the overland route it was as if China became fossilized in European minds, as if the Great Khan had become one of the immortals. As John Larner puts it, 'For Europe, the last Great Khan [not Kublai himself, but the last Yuan emperor] still lived and reigned 130 years after his expulsion from China.'

It has often been said that Columbus, inspired by Marco, was aiming to make contact with the Great Khan and had a copy of the travels with him to use as a sort of guide when he arrived on the coast of Cathay, as if he would recognize Hangzhou from Marco's description and then journey up the Grand Canal to the imperial court. Nothing so simple. Columbus did indeed own a copy of Marco's book – Pipino's Latin one, printed in 1490 – in which he made notes; but – as John Larner argues – he acquired it only after returning from his second voyage in 1494 to check what it was that he had discovered.

Probably Columbus's direct inspiration was a letter written by the Florentine astrologer Toscanelli, a leading member of the network of scholars that included the Portuguese cleric Fernão Martins, now a canon in Lisbon and adviser to King Afonso V. In 1474, at the king's request, Toscanelli sent Martins a map and a letter, in which he makes Marco-esque references and uses Marco-esque language and refers to the Great Khan, unaware that the khans had been expelled over a century before. Here is part of his letter, with the Marco links and other comments bracketed:

> I have spoken with you elsewhere about a shorter way, travelling by sea, to the lands of spices than that which you are taking by Guinea [i.e. West Africa] . . . It is said that in a most noble port called Zaiton [Marco's name for Quanzhou] there is such an abundance of navigators with goods that in the whole of the rest of the world

there are not so many. It is said that a hundred great ships each year unload pepper [about which Marco gives many statistics] there, not to mention other ships bearing other spices. The country is heavily populated, most rich in a multitude of provinces and kingdoms and in cities without number, under a prince who is called the Great Khan, which name in Latin means 'King of Kings', whose palaces and residences are for the most part in Cathay . . . His ancestor [a reference to Kublai] desired the friendship of Christians, and over two hundred years ago sent ambassadors [i.e. the elder Polos] to the Pope, asking for many men learned in our faith that they might preach; but those sent, hindered on the way, turned back . . .

From the city of Lisbon to the west there are [marked on the map] twenty-six spaces, each of which contains two hundred and fifty miles [that's 6,500 miles; in fact the distance to China from Lisbon is over twice that], as far as the most noble and very great city of Qinsay [where did he get that from, if not Marco?]. This city is one hundred miles in circumference, and has ten bridges [ten! What happened to the 12,000? Surely proof that there was some copying error along the way] and its name means City of Heaven [as Marco said] . . . and from the island of Antillia [the Antilles?] known to you, to the very noble island of Cipangu [as Marco spelled Japan, otherwise unknown to Europeans] there are ten spaces. This land is [as Marco said] most rich in gold, pearls and precious stones, and the temples and royal palaces are covered with solid gold.

Then there was the map. Previous maps had been re-statements of traditional ideas, with the continents as mere blobs. But this one was different. It was a *mappamundi*, a world map, done in 1457–9 by a Venetian monk, Fra Mauro, commissioned by Afonso V. This is the first map to take Marco seriously, which is perhaps not surprising given that Mauro was a fellow-Venetian. What is surprising is its quality, and the amount of detail taken from Marco. Look at the illustration in the plate section: there are the Yangtze and the Yellow River (with a hint of its Great Bend), and a mass of cities (idealized in the European fashion, symbolizing wealth), and a host of names familiar from Marco's book – Cathay, Manzi, Quinsai, Khan-baliq, Zaiton, the Desert of Lop, and even 'Zimpagu', a version of Cipangu (Japan). This is the first time Japan was included in any western map.

As John Larner says, Fra Mauro's map and Toscanelli's letter represent 'powerful leaps of faith in the honesty of Marco Polo'.

The links are so close you can almost feel them touching. Columbus, though in his own words 'a simple unlearned sailor', was in Lisbon, seeking backing from Afonso. He had access to a map, also commissioned by the king, which showed Marco's China crammed with cities. He had a copy of Toscanelli's letter. Indeed, his diary quotes from it.[2] In its prologue, he speaks about 'a

[2] As always, academics dispute both the nature of the evidence and the conclusions. I summarize the most widely accepted version. For details see Larner, *Marco Polo and the Discovery of the World*, who uses the translation by O. Dunn and J. E. Kelly in their edition of Columbus's *Diario*.

prince who is called Grand Khan, which in our Spanish language means "King of Kings", [and about] how many times he and his predecessors had sent to Rome to ask for men learned in our Holy Faith'. So Columbus knew Toscanelli's conclusions, which were based on Marco's book. It was Marco, at one remove, who inspired Columbus with his Big Idea.

But that idea did not convince Afonso. He had Toscanelli's letter, he had Fra Mauro's map, and he had also invested heavily in exploration round Africa. Toscanelli's estimates of the size of the earth did not convince. It could well be that off the edge of Fra Mauro's map there lay an extremely big ocean in which ships would vanish. So when Afonso's explorers rounded the bump of west Africa, it looked as if the investment was about to pay off. Further explorers found that Africa extended way south, and Afonso, like a corporate boss, was left wondering whether he should throw more money at the problem, or give up. In 1484 he died, leaving Columbus needing to convince his successor, John II, of the value of a full-scale expedition westward. John also hesitated – until 1488, when Bartholomew Diaz made it around the southern tip of Africa into the Indian Ocean. With the way eastward opened, John decided against Columbus's transatlantic venture. Perhaps one other factor in his decision was Columbus's character: deceitful, coarse, greedy, he could well have seemed more liability than asset.

Columbus, his hopes dashed after fourteen years of waiting, stormed off to Castile and presented his idea to

the ambitious Spanish rulers, Ferdinand and Isabella. His timing was good: Spain was newly unified, the ten-year reconquest of the Muslim south just over, the expulsion of 200,000 Jews about to begin. Seeing the Portuguese investment about to pay off, they felt under pressure to compete. The only way they could do so – other than challenge Portugal directly – was to gamble on Columbus. He may not have been the ideal man, but he was energetic, he was hungry, he was willing to take risks. Luckily for him, he was in the right place at the right time.

Of course, the Big Idea turned out to be both wrong and, by pure luck, also right beyond anything dreamed of by Marco, Toscanelli, Mauro or Columbus. The distance to China was indeed vast, the gamble immense. Luckily, America was in the way, and Columbus's journey rather short, just five weeks. It still did not occur to him that he had stumbled on a new world. He thought one West Indian island 'must be Cipangu', as he recorded in his diary. 'I have already decided to go to the mainland and to the city of Qinsay and to give your Highness's letters to the Great Khan.' A few days later he was in Cuba and, despite the rather obvious lack of cities, thought it was China, referring to the 'city of Cathay' (which, given that Cathay was a kingdom not a city, is evidence that he had not yet read Marco's book).

Through all this – the mindset, the assumptions, the words – runs the spirit of Marco. Columbus did not need to read Marco's book before his first voyage for, as Larner says, 'by then its contents were part of the

mental climate'. Marco is the ghost hovering over Columbus's shoulder. Someone from Europe would have stumbled on America sooner or later, of course. But without Marco, who would have headed west? Not Columbus. And when? Not in 1492.

The printing press opened a new chapter for the book. Twenty-four new editions between 1500 and 1600, and another curious sequence of translations, from Pipino's Latin version into Portuguese, back into a new Latin edition and from this into French, each introducing its own errors, changes, cuts and additions. In his home town, Venice, there were six republications of the Venetian text that century.

It was in Venice, too, that Ramusio – a senior city bureaucrat, curator of the great Marciana Library, multi-linguist – researched and produced his own influential edition, included in a compilation of travel narratives. His work of 1559 drew on Pipino's Latin version and another source now lost, but as authentic as the Latin text (the one known as Z) in Toledo. His preface, with its racy but unprovable tales, like the one about the Polos' arrival home unrecognized, reveals his agenda: to have Marco set upon a pedestal as a hero and explorer greater than the world's most famous Genoan, Columbus.

Often in my own mind, comparing the land explorations of these our Venetian gentlemen with the sea explorations of the aforesaid Signor Don

Christopher, I have asked myself which of the two were really the more marvellous. And if patriotic prejudice delude me not, methinks good reason might be adduced for setting the land journey above the sea voyage. Consider only what a height of courage was needed to undertake and carry through so difficult an enterprise, over a route of such desperate length and hardship. (Yule's translation)

Columbus had been merely blown by the wind, and was easily followed by other ships *ad infinitum*. Marco had fought every inch of the way, and no one dared go in his footsteps. These are tortured arguments, of course. Difficulty does not equate with significance. It was precisely because Columbus's achievement was considered so much easier and therefore more significant than Marco's that people followed in Columbus's wake.

Ramusio's campaign didn't really work, because over the next century the truth became clear. America became the new world, not a part of the old one. Marco's erratic descriptions of the East gave way to more accurate ones. Reprints continued, in Latin, Venetian, German, Dutch, Spanish and English, but the book was now more a curiosity than a source. Polo scholarship made its appearance, with one editor collating two versions of the Latin text and another pointing out interpolations and errors.

Yet those westerners who settled in China – most notably Jesuit missionaries – still respected Marco for his reportage. One Jesuit, Martino Martini, wrote in

1655: 'I hold it a duty to free the most noble patrician from the accusation of mendacity and from the other calumnies to which he has been subject.' Of course, there were those who doubted, a few who claimed he had never been to China at all. But always he remained as a sort of bedrock, the first and therefore unassailable as a commentator.

When the British sent a huge but totally useless mission to China under Lord Macartney in 1792–4, Macartney's friend George Staunton wrote an account of the expedition in which he gave the first detailed description of the Great Wall. By then, it was the Wall as we know it today, a vast curtain of stone created by the Ming dynasty mainly in the early seventeenth century. The implication was that it ran all across north China, and always had done. Staunton therefore felt impelled to explain away Marco's failure to refer to it by saying that he had come into China through Tibet. He hadn't, of course; and anyway this was not a sufficient explanation because, as Staunton should have known, having travelled through the Great Wall himself, Marco would inevitably have noticed it. It did not occur to him that the reason Marco didn't mention it was because he didn't see it, because it was hardly there: it was at worst totally eroded and at best a wreck not worthy of his attention.

Though it failed in its official aim, the mission inspired renewed interest in Marco. William Marsden, who had served the East India Company for eight years in Sumatra, produced the first scholarly edition of

Marco's book, based on Ramusio's text. He was also much impressed by the Macartney mission, and compared Macartney's reception by the emperor Qianlong with the Polos' reception in Xanadu. By chance, both emperors were at their respective summer palaces, Xanadu and Jehol (today's Chengde), when the foreign emissaries arrived. At both a boy was presented to the emperor: Marco, of course, to Kublai; and Staunton's twelve-year-old son, George, who had undergone a crash course in Chinese, to Qianlong.

Marsden admitted that Marco lacked literary skills, but argued forcefully that he had to be taken seriously as a source. And so he has, with Polo scholarship turning into an industry. France acquired its definitive edition in 1865, edited by their leading Sinologist M. G. Pauthier, which was followed in 1871 by the astonishingly detailed English edition by Sir Henry Yule.

Yule is worth a digression. His Scottish relatives were empire men through and through. His father, a Bengal Army major, collected Arabic and Persian manuscripts; a brother died in the 1857 Indian Mutiny; another stopped recording the number of tigers he killed when he reached 400; he himself was an officer, gentleman and scholar, serving in the Bengal Engineers through the Indian Mutiny and as a member of an embassy to Burma. As a friend of two Governors-General, he was responsible for India's canals and railways. All this he accomplished by the age of 42. Having resigned his commission, he found himself back home without employment and turned to scholarship, as well as

remaining a member of several military and diplomatic councils. With a huge network of friends across the British empire and China, no one could have been better placed to produce an edition of Marco that is a wonder to rival Marco's book itself. Yule's address book included T. G. Montgomerie, brother officer, Royal Engineer, model for Colonel Creighton in Kipling's *Kim*, the man who devised the system by which Indians were sent in disguise to make secret maps of Central Asia; Francis Younghusband, invader of Tibet in 1901; Colonel Mark Bell VC, Director of Military Intelligence in the Indian Army; and William Johnson, the first to reach the Taklamakan desert from India.

Yule could also draw on the upsurge of interest in Central Asia among European explorers in the second half of the nineteenth century. Baron Ferdinand von Richthofen had just coined the term 'Silk Road' for the ancient (but previously unnamed) network of routes that linked China to the Black Sea. Sven Hedin (Swedish), Aurel Stein (formerly Hungarian, now British) and Petr Koslov (Russian) were busy mapping, recording, writing and getting their hands on as many artefacts and manuscripts as they could, opening up lost worlds. Yule quoted them all. The result is that Marco's 100,000 words are vastly exceeded by Yule's footnotes, 750,000 six-point words of them. Some of the footnotes are essays in themselves, running on for pages, with minute, four-point footnotes of their own. Yule's work was extended in later editions, all superseded by one of 1929 that included 160 extra pages by Henri Cordier

and a 144-page memoir on Sir Henry by his daughter Amy. The whole thing amounts to a million words – an extraordinary attempt to anatomize their subject, as if Marco and his book were butterflies that could be pinned down and dissected by words. The two huge volumes are also a tribute to Marco's appeal, and to the fascination he inspires – and continues to inspire, for the *Travels* have been republished, unabridged.

And meanwhile, for English-speakers, there is Coleridge's poem, which occupies a backwater of its own. Marco's book came via Ramusio's Italian edition and an English translation of 1579 to an English compiler of voyages of discovery, Richard Hakluyt, whose massive three-volume work appeared in 1598–1600. This, plus Hakluyt's unpublished work, plus additional material, was then edited by his colleague Samuel Purchas into an even larger work, published in various editions, concluding in 1625 with *Hakluytus Post-Humus, or Purchas His Pilgrimes*. This includes the words which I quoted back in chapter 6: 'In Xamdu did Cublai Can build a stately Palace, encompassing sixteen miles of plaine ground with a wall, wherein are fertile Meddowes, pleasant Springs, delightful Streames, and all sorts of beasts of chase and game, and in the middest thereof a sumptuous house of pleasures.'

Compare this with Marco's words: 'Moreover at a spot in the park where there is a charming wood he has another Palace built of cane . . . It is gilt all over, and most elaborately finished inside.' It goes on, of course,

but mainly with the specifications examined in chapter 6. So note that both mention two palaces, a wall, and a wild area. In terms of description, that's all that links them.

Now fast forward 170 years to an evening in June 1797. The scene is an isolated hillside farm on Exmoor near the coast between Porlock and Lynton. Enter the poet Samuel Taylor Coleridge, who is staying here. He has been out on a long walk and has been suddenly taken short with a terrible stomach upset – dysentery, he calls it. He takes some opium, picks up his copy of Purchas, reads the passage about Kublai Khan, falls asleep and dreams a wilder version of what he has just read. What happened next he described later in a third-person prologue to the poem: 'On awakening he appeared to himself to have a distinct recollection of the whole, and taking his pen, ink, and paper, instantly and eagerly wrote down the lines that are here pre-served . . .': the 54 lines that every schoolboy used to know – 'Kubla Khan: or a Vision in a Dream: A Fragment' – beginning:

> In Xanadu did Kubla Khan
> A stately pleasure-dome decree:
> Where Alph, the sacred river, ran
> Through caverns measureless to man
> Down to a sunless sea.

And ending with a vision of an Abyssinian maid singing and playing on a dulcimer.

Could I revive within me
Her symphony and song,
To such a deep delight 'twould win me,
That with music loud and long,
I would build that dome in air,
That sunny dome! Those caves of ice!
And all who heard should see them there,
And all should cry, Beware! Beware!
His flashing eyes, his floating hair!
Weave a circle round him thrice,
And close your eyes with holy dread,
For he on honey-dew hath fed,
And drunk the milk of Paradise.

'At this moment,' his account continues,

he was unfortunately called out by a person on business from Porlock, and detained by him above an hour, and on his return to his room, found, to his no small surprise and mortification, that though he still retained some vague and dim recollection of the general purport of the vision, yet, with the exception of some eight or ten scattered lines and images, all the rest had passed away like the images on the surface of a stream into which a stone has been cast, but, alas! without the after restoration of the latter!

It was all the fault of the infamous, anonymous 'person from Porlock', which has since become a metaphor for an unwelcome interruption to the creative

process. That's the accepted version of events. On the other hand, some sceptics have suggested that the person from Porlock was made up to explain why he couldn't finish the poem. I don't think so, because it's unnecessary. It was Coleridge who decided this was a fragment. All he had to do was say it was complete and there would have been no need for any explanation at all.

What we have is a weird, surreal dream of a poem, most of which has absolutely nothing to do with Purchas, Marco, Xanadu or Kublai. Xanadu never had chasms, a river with the non-Chinese name of Alph or caves of ice, and the sea, when the river finally reached it 300 kilometres away, was no more nor less sunny than the Pacific today. The vision owed everything to the Quantock hills and the wild Somerset coast, Coleridge's love of nature and a growing addiction to opium.

Marco's shade might be gratified. But I think Rustichello's would be delighted. Real Shangdu, which for Marco was fabulous enough, has escaped reality to become surreal Xanadu, a place of marvels, and now haunts us all.

EPILOGUE: THE
LAST WORD

OF COURSE MARCO, XANADU AND THE REST OF HIS BOOK do not have the clout they once had. The book's information content has been deflated to near zero. Back then, it took years for one person to get a fraction of the information millions of us now get instantly at a mouse-click. No one today would much admire Marco's impersonal yet self-important style. There's a strong story-line, but not one that sits easily with modern art forms. A 1938 movie, *The Adventures of Marco Polo*, had Gregory Peck in the title role and Princess Kokachin as the love interest; it bombed – 'a thinly scripted pantomime', remarks *Halliwell's Film Guide*. As I researched this book, *The Venetian aka Marco Polo* was 'in development', with a script by William Monahan (*Kingdom of Heaven*, *The Departed*) and Matt Damon as Marco. As we go to print, on-line

references have vanished. Perhaps someone realized the fundamental flaw in Marco's story as he tells it: no conflict. Deeply flawed as it is, the book has provided endless opportunities for 'towering but somehow unvital erudition', as Larner puts it. Marco's marvels and China's millions are miraculous no longer. So why does it stay in print? Why Marco's enduring reputation?

Five reasons: he lived a fairy-tale; yet he was the first to bring China into the real world; he ranges widely; he is a good source for what he saw with his own eyes; and he is likeable.

In the words of Sir Henry Yule, he was 'the first Traveller to trace a route across the whole longitude of Asia, naming and describing kingdom after kingdom which he had seen with his own eyes'. Yule continues with a litany of the places Marco first described, never mind that he did not see them all – the deserts of Persia; the jade-bearing rivers of Khotan; China, in all its wealth and vastness; Burma, with its golden pagodas; Laos, Siam and Japan; Java, the pearl of islands; Sumatra, with its many kings; the naked savages of Nicobar and Andaman; Ceylon, the isle of gems; India, once a fabled dreamland, now a real country of virtuous Brahmins, ascetics, diamonds and searing heat; Ethiopia with its secluded Christians; Zanzibar and Madagascar; and the Arctic world of dog-sledges, white bears and reindeer-riders.

Marco also emerges, despite everything, as a great character. No intellectual, of course. But he was tough, never complaining about the demands of travel and his

own occasional ill-health. Practical, in the way he specifies times and distances. Shrewdly aware of the benefits to be derived from local products. Tolerant of religions that were not his own. Charming, surely, with friends everywhere and no enemies. He was, I think, a moral man, in awe of Kublai, not simply for his power but also for his good intentions. A lover of women, open to advances in the right circumstances, but never licentious; and thus a good master to his concubine, assuming she existed, and a good husband when back in Italy. A lover of hunting, too, and a skilled rider. A great talker, unfailingly polite. I'm not sure that the exaggerations tell us much about him, given that he lived in an age that welcomed marvels and that he had an editor and publicist nudging him towards exaggeration. He was in the end a living paradox: a man with the greatest story of his time, but with an innate restraint. He had the traits of an anthropologist, patient, objective, always open to new experiences, never judgemental, never taking offence. Perhaps the 'certain indescribable smack of the Tartar both in air and accent' mentioned by Ramusio was more than that of a man alienated from his homeland. Perhaps, working for so long among civil servants, he had acquired high standards of service, standards that could be fitted to life in both China and Italy. It was as if he had become something of a Confucian.

His reputation has brought him a sort of immortality. Marco Polo lives on in restaurants, a swimming-pool game popular in the Americas, a European Union

project to get freight off the roads and on to trains and boats, Chinese hotels, travel companies, a cruise ship, an online store (Marc O'Polo) and – of course – Venice's international airport.

Xanadu, always a symbol of opulence, has acquired new meanings. In Orson Welles' *Citizen Kane*, the mansion created by the power-mad newspaperman John Foster Kane is a nightmare of opulence, the 'costliest monument a man has built to himself', an impossible place of vast staircases and looming towers, ominously swathed in fog. The mansion was said to caricature the estate of the most powerful newspaper mogul of the day, William Randolph Hearst, a comparison that damaged young Welles' career (he was only 25). A pseudo-documentary voiceover evokes Xanadu's grim magnificence: Set on a bare and craggy eminence 'on the deserts of the Gulf coast', the mansion is a mountain made of 100,000 trees and 20,000 tons of marble, containing paintings and statues enough for ten museums, with the biggest private zoo since Noah, a golf course and a Venetian-style canal, all in an estate measuring 49,000 acres, entered through a gateway with the letter 'K' written above it. Kane is the khan – indeed *kane* is a spelling of 'khan' in some editions of Marco's book – but this is a prison in which he dies alone, muttering the word 'Rosebud' that drives the plot.

Another Xanadu draws on not Kublai's creation but Coleridge's – Project Xanadu, the 'inspiration for the World Wide Web', as its originator Ted Nelson puts it in the project's website. But here the symbolism is

obscure, its reference point no palace or dome but what is not there in the poem, the forgotten part that was driven out of memory by the man from Porlock. 'We chose the name . . . to represent a magic place of literary memory and freedom, where nothing would be forgotten.' The idea Nelson dreamed up in 1960 has become what sounds like a cyberspace equivalent of the sub-atomic universe, with every word, sentence, document – whatever these may be in a universe without paper – floating free for re-use, but always with a memory-tag marking its origin. Fifty years later, Nelson is still working on the idea.

There are many other Xanadus: a Scottish fashion house, a Madrid leisure centre, clubs, travel agencies, restaurants and that 1980 film with Olivia Newton-John, so derided for its batty plot (goddess comes to earth, falls in love and sings in a nightclub called Xanadu) and yet so admired for its dances and its songs – 'Xanadu', among others – that it has a serious cult following. It was, after all, the last film of one of Hollywood's immortals, Gene Kelly, star of *Singing in the Rain* and, with Rita Hayworth, *Cover Girl*, made 36 years previously, of which *Xanadu* was a remake.

We have come a long way from the real Xanadu, in a sense full circle, because the real one is a lot closer to us now than it was even ten years ago, let alone 700. A plane ticket, a car ride and you're there in a couple of days. Or seconds, if you wish. You too can zoom in on Google Earth, as I often do, wander the city's nested squares, and see the base of the palace where Marco

knelt to Kublai Khan. East and west, past and present are all one now, with Marco's words for company if you wish. Let him have the last word, puffed up ever so slightly by Rustichello:

> There was never a man, be he Christian or Saracen or Tartar or Heathen, who ever travelled over so much of the world as did that noble and illustrious citizen of the City of Venice, Messer Marco, the son of Messer Nicolo Polo.
>
> Thanks be to God! Amen! Amen!

BIBLIOGRAPHY

Of the thousands of books and articles on Marco Polo, these are the ones I relied on. Of the many editions, Yule and Cordier is still without rival, mainly for its astonishing notes. As a text, Moule and Pelliot is the most rigorous, but no popular edition is available. The best bibliographies are in Haw, Larner and Wood.

Abu-Lughod, Janet L., *Before European Hegemony: The World System AD 1250–1350*. Oxford: Oxford University Press, 1989.

Alexander, Caroline, *The Way to Xanadu*. London: Weidenfeld & Nicolson, 1993.

Atwood, Christopher, *Encyclopedia of Mongolia and the Mongol Empire*. New York: Facts on File, 2004.

Bretschneider, Emil, *Archaeological and Historical Researches on Peking and its Environs*. New York:

Elibron/Adamant Media Corp., 2005: facsimile of the original, publ. Shanghai and London, American and Presbyterian Mission Press, 1876.

Bushell, S. W., 'Notes of Journey Outside the Great Wall of China', *Journal of the Royal Geographical Society*, London, vol. 44 (1874).

Campbell, C. W., 'Journeys in Mongolia', *Geographical Journal*, vol. 22, no. 5 (Nov. 1903).

Cannadine, David, and Price, Simon, eds, *Rituals of Royalty*. Cambridge: Cambridge University Press, 1992.

Ch'ên Yüan, *Western and Central Asians in China under the Mongols, Monumenta Serica Monograph XV*. Berkeley: University of California at Los Angeles, 1966.

Cleaves, Francis Woodman, 'A Chinese Source Bearing on Marco Polo's Departure from China and a Source on his Arrival in Persia', *Harvard Journal of Asiatic Studies*, vol. 36 (1976).

Clements, Jonathan, *Marco Polo*. London: Haus, 2007.

Curzon, George Nathaniel, 'The Pamirs and the Source of the Oxus', *Geographical Journal*, vol. 8, nos 1–3 (July–Sept. 1896).

Dalrymple, William, *In Xanadu: A Quest*. London: Collins, 1989.

Delgado, James, *Khubilai Khan's Lost Fleet*. Vancouver: Douglas & MacIntyre, 2008; London: Bodley Head, 2009.

Harada, Yoshito, 'Shang-tu, the Summer Capital of the

Yuan Dynasty in Dolon Nor, Mongolia',
*Proceedings of the Far Eastern Archaeological
Society*, 1941.

Hare, John, *Mysteries of the Gobi*. London: Tauris,
2009.

Haw, Stephen G., *Marco Polo's China: A Venetian in
the Realm of Khubilai Khan*. London: Routledge,
2006.

Hedin, Sven, 'Dr Sven Hedin's Travels in Central
Asia', *Geographical Journal*, vol. 5, no. 2 (Feb.
1895).

Impey, Lawrence, 'Shangtu, the Summer Capital of
Kublai Khan', *Geographical Review*, vol. 15, no. 4
(Oct. 1925).

Jackson, Peter, 'Marco Polo and his "Travels"',
*Bulletin of the School of Oriental and African
Studies*, vol. 61, no. 1 (1998).

Jackson, Peter, *The Mongols and the West*. Harlow:
Pearson-Longman, 2005.

Jackson, Peter, trans. and ed., with David Morgan,
The Mission of Friar William of Rubruck. London:
Hakluyt Society, 1990.

Jagchid, Sechin, and Hyer, Paul, *Mongolia's Culture
and Society*. Boulder, Colo.: Westview; Folkestone:
Dawson, 1979.

Juvaini, Ata-Malik, *Genghis Khan: The History of the
World-Conqueror*, trans. and ed. J. A. Boyle.
Manchester: Manchester University Press/UNESCO,
1958; 2nd edn 1997.

Kates, G. N., 'A New Date for the Origins of the

Forbidden City', *Harvard Journal of Asiatic Studies*, vol. 7 (1942–3).

Larner, John, *Marco Polo and the Discovery of the World*. Harvard, Mass.: Yale University Press, 1999.

Latham, Ronald, trans. and ed., *The Travels of Marco Polo*. London: Penguin, 1958.

Liu Yutang, *Imperial Peking*. London: Elek, 1961.

Lynn, Richard John, trans., poems on Shangdu. Personal communication.

Man, Edward Horace, *On the Aboriginal Inhabitants of the Andaman Islands*. London: Royal Anthropological Institute, 1932.

Man, John, *Kublai Khan*. London: Bantam, 2006.

Marsden, William, ed., *The Travels of Marco Polo*. London: Cox & Baylis, 1818.

Morgan, David, *The Mongols*. Oxford and Malden, Mass.: Blackwell, 1986.

Morgan, David, 'Marco Polo in China – or not?', *Journal of the Royal Asiatic Society*, 3rd ser., no. 6 (1996).

Mote, F. W., *Imperial China 900–1800*. Cambridge, Mass.: Harvard University Press, 1999.

Moule, A. C., *Quinsai, with other notes on Marco Polo*. Cambridge: Cambridge University Press, 1957.

Moule, A. C., and Pelliot, Paul, *Marco Polo: The Description of the World*, 2 vols. London: Routledge, London, 1938. The second volume is the so-called Z text, found in Toledo in 1932.

Needham, Joseph, *Science and Civilisation in China*, vol. 4. Cambridge: Cambridge University Press, 1971.

Norwich, John Julius, *A History of Venice*. London: Penguin, 1982 (first publ. in 2 vols, 1977 and 1981).

Olbricht, Peter, *Das Postwesen in China unter der Mongolenherrschaft im 13. und 14. Jahrhundert*. Wiesbaden: Harrassowitz, 1954.

Olschki, Leonardo, *L'Asia di Marco Polo*. Venice: Istituto per la Collaborazione Culturale; Florence: Sansoni, 1957. Publ. in English as *Marco Polo's Asia*, University of California Press, Berkeley and Los Angeles, and Cambridge University Press, 1960.

Pelliot, *Notes on Marco Polo*, ed. L. Hambis. Paris: Imprimerie Nationale, 1959–73.

Polo, Marco. For versions of the text see Latham, Marsden, Moule and Pelliot, Ramusio, and Yule and Cordier.

Rachewiltz, Igor de, 'Marco Polo Went to China', *Zentralasiatische Studien*, vol. 27 (1997). For a summary see http://rspas.anu.edu.au/eah/marcopolo.html

Rachewiltz, Igor de, 'Marco Polo Went to China: Additions and Corrections', *Zentralasiatische Studien*, vol. 28 (1998).

Rachewiltz, Igor de, trans. and commentary, *The Secret History of the Mongols: A Mongolian Epic Chronicle of the 13th Century*. Leiden and Boston: Brill, 2004.

Ramusio, Giovanni Battista (Giambattista), *Navigazionni e viaggi*, ed. M. Milanesi, vol. 3. Turin: Einaudi, 1980. Facsimile, ed. R. A. Skelton

and George B. Parks (vol. 3 of 3 vols). Amsterdam, Theatrum orbis terrarum, 1968.

Ratchnevsky, Paul, *Genghis Khan: His Life and Legacy*, ed. Thomas Haining. Oxford: Oxford University Press, 1991.

Rossabi, Morris, *Khubilai Khan: His Life and Times*. Berkeley and Los Angeles: University of California Press, 1988.

Rouleau, Father Francis, SJ, 'The Yangchow Latin Tombstone as a Landmark of Medieval Christianity in China', *Harvard Journal of Asiatic Studies*, vol. 17, nos 3–4 (Dec. 1954).

Silverberg, Robert, *The Realm of Prester John*. New York: Doubleday; London: Orion, 1972, 2001.

Stein, M. Aurel, *Sand-Buried Ruins of Khotan*. London: Fisher Unwin, 1903.

Steinhardt, Nancy Shatzman, *Chinese Imperial City Planning*. Honolulu: University of Hawaii Press, 1990.

Timkowski, George, *Travels of the Russian Mission through Mongolia to China*. London: 1827. Publ. in French as *Voyage à Péking, à travers la Mongolie*, Paris, 1827.

Weatherford, Jack, *Genghis Khan and the Making of the Modern World*. New York: Crown, 2004.

Wei Jian, *Yuan Shang Du* (in Chinese). Beijing: Encyclopedia of China Publishing House, 2008.

Wood, Frances, *Did Marco Polo Go to China?* London: Secker & Warburg, 1995.

Wood, John, *A Journey to the Source of the River Oxus*. London: John Murray, 1872.

Yule, Henry, and Cordier, Henri, *The Travels of Marco Polo: The Complete Yule–Cordier Edition*, 2 vols. New York: Dover, 1993.

PICTURE ACKNOWLEDGEMENTS

The photos in the picture sections are © John Man except for the following:

First section

Sculpture of Marco Polo, gilded wood sculpture, Chinese, sixteenth century: Museo Correr, Venice, Italy/The Bridgeman Art Library

Wakhi woman and her children, Wakhan corridor, Afghanistan: Beth Wald/Aurora; a group of Marco Polo sheep: Beth Wald/Aurora

Caravan in the Taklamakan desert: Michael Yamashita/Aurora

Second section

Sketch and diagram: © Tom Man

Reconstructions: © Bend Godber (Expedition), Tom Man, John Man

The pass at Badaling: South Photo China

Kublai Khan Hunting, attributed to Liu Kuan-tao, ink and colour on silk, Yuan dynasty: National Palace Museum, Taipei/Bridgeman Art Library; Cambuluc, detail of Fra Mauro's map of the world: © The London Art Archive/Alamy

Marco Polo's fleet from *The Book of Ser Marco Polo* . . . by Henry Yule, 1871: © North Wind Picture Archives /Alamy; *The Rukh which fed its young on elephants* by Edward Julius Detmold: © British Library, London, UK/British Library Board. All Rights Reserved/The Bridgeman Art Library; detail of a portrait of Chabi, wife of Kublai Khan: National Palace Museum, Taipei; *On the Aboriginal Inhabitants of the Andaman Islands* . . . by Edward Horace Man, 1884

INDEX

Golden Horde 31
Golden Lotus Advisory
 Group 112
Golden Lotus grasslands
 166, 167, 168
Golden Lotus Plain 121
Google Earth 176
Grand Canal 240, 250–3,
 301
Great Buddha Temple
 (Zhangye) 92
Great Game 49, 56
Great Stone Bridge 243
Great Wall of China 89–90,
 92, 101, 109–10, 182,
 225, 331, 355
Greeks 32
Greenland 345
Gregory X, Pope (Teobaldo
 Visconti) 37, 39
Guazhou 252–3
Gubeikou pass 165, 180, 182
Guo Shoujing 160, 190,
 253–5
Gutenberg, Johannes 346
gyrfalcons 140–2, 225

Haiphong 293
Hakata Bay 282, 283, 284
Hakluyt, Richard 144, 358
Hami 93
Han 187
Hangzhou (Quinsai) 195,
 240, 252, 303, 350, 352
 conquest of by Mongols

 (1276) 206–8, 256
 location 255–6
 Marco's description of
 255–61
 prostitutes in 264
 venue for Euro-Asia forum
 274
Hanoi (Thang Long) 292
Harada, Yoshito 118–19,
 134
Hare, John 83
harem 21–2, 227, 275–6
hashish 46
hats, women's 269–70
Haw, Stephen 21, 171, 232,
 238, 247, 271, 277
hawks 225
Hayashida, Kenzo 285
Hazara 43
He Sheng 233
Hearst, William Randolph
 365
Hedin, Sven 60, 72n, 87, 357
Helan mountains 100
Hindu Kush 49, 53
Hiroshima 284
Hormuz (Bandar-e Abbas)
 41, 44, 45, 315–16
Hosseini, Khaled
 The Kite Runner 43
Huanzhou 166–8, 169–70
Huayan (Flowery-Severe)
 school 138
Hulegu 31, 34, 35, 42, 196,
 197

relationship with Mei Li
274–9
relationship with princess
Cocachin thesis 271
reputation for truthfulness
332–3
role in Europe's rediscovery
of America 341–54
taken prisoner by Genoese
326–7
and Tartar silver belt
238–9
Travels see Travels
will and inventory of
possessions 238, 269,
339
and women 248, 262–79,
364
Polo, Niccolò (father) 18, 26,
137, 297–8, 333, 339 *see
also* Polo brothers
pony express 93–5, 197
Prester John 91
printing 244–5
Project Xanadu 365
prostitutes 264–5
Ptolemy 63
Purchas, Samuel 144, 358

Qaragunas 43
Qianlong, Emperor 356
Qinsay *see* Hangzhou
Quanzhou *see* Zaiton
Quinsai *see* Hangzhou

Rachewiltz, Igor de 220
Ramusio, Giambattista 16,
301, 320–2
edition of Marco's book
268, 338–9, 353–4
Rashid al-Din 82, 97,
112–13, 133, 182–3,
197n, 288–9
Red Turbans 181
Ren, Benjamin 125–6, 128
Richthofen, Baron Ferdinand
von 357
rituals 213–18, 276
Rouleau, Francis 278
ruc (bird) 314–15
Russia 29, 30, 31, 49
Rustichello 268, 327–9, 336
as Marco's ghost–writer on
Travels 199, 221–2,
237, 268, 328–30, 333,
334–5, 336
Méliadus 327–8, 329

Samarkand 63, 64, 80
Sanggan river (Yongding)
241–2
Sarai 30–1, 40
Sarghis (Sergeius) 232
Sarikol, Lake 53, 56, 58
Scott, John A. 239
Secret History, The 9, 98,
141–2, 220
Shache *see* Yarkand
Shandian river (Shangdu)
130, 166, 180

Kublai Khan
The Mongol King Who Remade China
By John Man

KUBLAI KHAN, THE thirteenth-century Mongolian prince who became warrior emperor of China, was perhaps the most powerful man who ever lived.

Grandson of the great Genghis Khan, he inherited the largest land empire in history – and doubled it. Driven to fulfil his grandfather's destiny and ensure Mongol supremacy, Kublai's realm would embrace over half of all Asia: a staggering one-fifth of the world's inhabited land area.

But Kublai Khan was not born to rule. It was his brilliant, scheming mother who placed him in line for the throne. Seizing power when in his forties, he perceived China rather than Mongolia as the key to empire and, after twenty years of war, became the first 'barbarian' to conquer all China. Bringing together vast wealth, military strength and shrewd government, he was to transform his dominion into the prototype of today's superpower.

Drawing on his own travels through Mongolia and China, best-selling historian John Man brings the remarkable world of Kublai Khan to vibrant life.

'One could not wish for a better storyteller or analyst than John Man'
SIMON SEBAG MONTEFIORE

'One of the great strengths of this book is to rescue Kublai Khan from myth . . . Man knows his subject, and his desire to share it is infectious . . . it is rollicking stuff'
DAILY TELEGRAPH

'Man has become a recognised authority on the history of Mongolia and its countrymen. Kublai Khan is a worthy successor to his book on Genghis Khan . . . a remarkable story'
TIMES LITERARY SUPPLEMENT

9780553817188

The Great Wall

By John Man

CHINA'S GREAT WALL north of Beijing is one of the world's most famous sights. Millions every year climb the line of stone snaking over mountains.

Myths surround the wall. Many believe that the stone barrier marches across all China, that it has been in existence for over 2,000 years, and that it is the only man-made structure visible from the Moon. In fact, most of it is made of earth, and much of it is not there at all. It cannot even be seen from earth orbit, let alone the Moon. Estimates of its length vary from 1,500 to 5,000 miles. Even its name is deceptive – it is not an *it*, a single entity, but many walls (hence the uncertain length), built at different times.

For this riveting account, John Man travelled the wall from the far western deserts to the Pacific, exploring the grandest sections and many 'wild' ones. He is the first writer to describe two unknown walls in Mongolia. He covers two millennia of history, from the country's first unification to the present day, when the Great Wall, built and rebuilt over centuries of war, has become a symbol of tranquillity – the history of the Great Wall is, in many ways, the history of China.

9780553817683

The Terracotta Army

By John Man

IN 1974 LOCAL farmers digging a well near present-day Xian unearthed parts of clay figures, opening the way to one of the greatest archaeological discoveries of all time. The Terracotta Army was a total surprise – some 8,000 life-size clay warriors and horses buried in 210 BC as a 'spirit army' to guard the tomb of the First Emperor. They had been lying forgotten in their three pits for over 2,000 years.

The First Emperor, the brilliant and ruthless ruler who united China and built the first Great Wall, was beset by paranoia and a desire to dominate in the afterlife, as he had in this one. Around his giant tomb-mound, as yet unopened, other pits concealed a whole spirit world of officials, entertainers, armour, and bronze chariots.

1,000 of the warriors now stand with many other finds in a site that attracts some two million visitors a year. As work continues, there are surely more surprises to come. As John Man suggests, there could even be more warriors still to be discovered. One day, perhaps, the tomb-mound itself will be opened and its legendary treasures revealed.

Weaving together history and first-hand experience from his travels in China, John Man tells the story of how and why these astonishing artefacts were created. In doing so, he sketches vivid portraits of the 'spirit army' and the man who formed the roots of China today.

'One couldn't wish for a better storyteller or analyst
than John Man'
SIMON SEBAG MONTEFIORE

9780553817188

Genghis Khan:
Life, Death and Resurrection
By John Man

'Absorbing and beautifully written . . . a thrilling account'
TIMES LITERARY SUPPLEMENT

GENGHIS KHAN IS one of history's immortals: a leader of genius and the founder of the world's greatest land empire – twice the size of Rome's. His mysterious death in 1227 placed all at risk, so it was kept a secret until his heirs had secured his conquests. Secrecy has surrounded him ever since. His undiscovered grave, with its imagined treasures, remains the subject of intrigue and speculation.

Today, Genghis is by turns scourge, hero and demi-god. To Muslims, Russians and Europeans, he is a mass-murderer. Yet in his homeland, Mongols revere him as the nation's father; Chinese honour him as dynastic founder; and in both countries, worshippers seek his blessing.

This book is more than just a gripping account of Genghis' rise and conquests. John Man uses first-hand experiences to reveal the khan's enduring influence. He is the first writer to explore the hidden valley where Genghis may have died, and one of the few westerners to climb the sacred mountain where he was probably buried.

The result is an enthralling account of the man himself and of the passions that surround him today. For in legend, ritual and controversy, Genghis lives on . . .

'A first-rate travel book, not so much a life of the khan but a search for him . . . a rattling good read'
INDEPENDENT

'A fine, well-written and well-researched book'
MAIL ON SUNDAY

'Fascinating . . . history doesn't corne much more enthralling than this'
YORKSHIRE EVENING POST

9780553814989

Attila The Hun
And the Fall of Rome

By John Man

'Superb, as compellingly readable as it is impressive in its
scholarship . . . the Huns and their king live as never before'
SIMON SEBAG MONTEFIORE

ATTILA THE HUN is a household name – a byword for barbarism and
violence – but to most of us the man himself, his world and his
place in history have remained elusive. Until now.

For a crucial twenty years in the early 5th century AD, Attila held
the fate of the Roman Empire and the future of Europe in his
hands. In numerous raids and three major campaigns he and his
warriors earned an undying reputation for savagery, and his empire
briefly rivalled that of Rome, reaching from the Rhine to the Black
Sea, the Baltic to the Balkans.

Attila's power derived from his astonishing character. He may have
been capricious, arrogant and ruthless, but he was brilliant enough
to win the loyalty of millions: his own people thought him
semi-divine while educated Westerners were proud to serve him.
From his base in the grasslands of Hungary, this 'scourge of God'
so very nearly dictated Europe's future . . .

Drawing on his extensive travels in the barbarian heartland and his
experience with the nomadic traditions of Central Asia, John Man's
riveting biography reveals the man behind the enduring myth of
Attila the Hun.

'Racy and imaginative . . . sympathetically and readably puts flesh
and bones on one of history's most turbulent characters'
SUNDAY TELEGRAPH

'Meteoric and momentous . . . fascinating reading'
GUARDIAN

9780553816587